# SACRED PLACES

# Sacred Places

## AMERICAN TOURIST ATTRACTIONS
## IN THE NINETEENTH CENTURY

John F. Sears

New York   Oxford
OXFORD UNIVERSITY PRESS
1989

Oxford University Press

Oxford   New York   Toronto
Delhi   Bombay   Calcutta   Madras   Karachi
Petaling Jaya   Singapore   Hong Kong   Tokyo
Nairobi   Dar es Salaam   Cape Town
Melbourne   Auckland

and associated companies in
Berlin   Ibadan

Published by Oxford University Press, Inc.,
200 Madison Avenue, New York, New York 10016

Oxford is a registered trademark of Oxford University Press

Library of Congress Cataloging-in-Publication Data
Sears, John F., 1941–
Sacred places: American tourist attractions
in the nineteenth century/John F. Sears.
p.   cm.   Includes index.
ISBN 0–19–505350–8
1. United States—Description and travel—1783–1848.
2. United States—Description and travel—1848–1865.
3. United States—Description and travel—1865–1900.
4. Tourist trade—United States—History—19th century.
5. Travelers—United States—History—19th century.
I. Title.
E164.S43 1989
917.3′04—dc 19   88–39861   CIP

9 8 7 6 5 4 3 2 1
Printed in the United States of America
on acid-free paper

*For Maggy*

# Preface

WHEN I WAS GROWING UP, my family lived in New Orleans, where my father taught French. We spent our summers on a former hill farm in Massachusetts, and every spring and fall we drove the sixteen hundred miles between those very different places. There were no interstates then. We followed Route 11 most of the way, passing through Hattiesburg, Mississippi; Birmingham, Alabama; Chattanooga, Tennessee; Pulaski, Virginia. It took us five or six days to reach our destination. We suffered heat, boredom, irritability. But those long journeys gave me great pleasure. Both my parents loved history and took us on excursions to see the sights along the way—Monticello, the battlefield at Gettysburg, the Smoky Mountains. All those places stand out in my memory of that period, as do details of the vernacular landscape that allured us along the way: the gas stations that figured in our counting games; the cabins, motor courts, and motels; the Burma Shave signs we tried to read backwards as we passed them going the wrong direction; the "See Rock City" signs painted on a hundred barn roofs. When I was five or six I had a small stool on which I perched in the middle of the front seat and from which I could take in this changing scene. The emotional roots of this book lie in those biannual pilgrimages, which instilled in me a love of travel and an enthusiasm for the varied wonders of this country.

Intellectually this book has evolved over a long period, beginning in 1966 when I took a seminar on the American landscape at Harvard University that was taught by Kenneth Lynn. That course alerted me to the many interactions between nature and culture in America and to the central role which the American landscape played in the development of a national identity in the

nineteenth century. My first work on tourism, which was supported by a grant from the American Philosophical Society, focused on the history of Mauch Chunk, Pennsylvania. That project grew into a traveling exhibition entitled "Tourists in an Industrial Scene: Mauch Chunk, Pennsylvania" and funded by the Pennsylvania Humanities Council. Before embarking on a broader study of tourist attractions, I was fortunate to be able to spend a stimulating semester studying in the American Civilization Program at the University of Pennsylvania. For this opportunity I am indebted to the Andrew W. Mellon Foundation and to the faculty committee at Vassar College, which awarded me a Mellon Grant for Faculty Development. Finally, a fellowship from the National Endowment for the Humanities allowed me to complete a substantial portion of the research and writing of *Sacred Places*. This grant came at a critical point in my career, and the book would never have been written without it.

Earlier versions of the chapters on Niagara Falls, the Willey Disaster, and Mauch Chunk appeared in the catalogue for the Corcoran Gallery's exhibition, *Niagara: Three Centuries of Changing Attitudes*, in *American Literature*, and in *Landscape*.

The staffs of many libraries and historical societies offered expert assistance during the course of my research. These institutions included: The New York Public Library, the Pennsylvania Historical Society, the Pennsylvania Prison Society, and the National Park libraries at Mammoth Cave, Yosemite, and Yellowstone. I would particularly like to thank Mary Vocelka of the Yosemite National Park Library, Stanley Brown of the Dartmouth College Library, William Copeley of the New Hampshire Historical Society, Donald Loker of the Niagara Falls Public Library, Janet Leban and Geneva Borger of the Pennsylvania Prison Society, Mary Bell of the Buffalo and Erie County Historical Society, Noreen O'Gara of the Boston Public Library, and Robert MacKimmie of the California Historical Society. Edward Nygren of the Corcoran Gallery, Nancy MacKechnie of the Vassar College Library, Kevin Gallagher of the Adriance Memorial Library in Poughkeepsie, and Frank Castella of Harmon and Castella Printing generously assisted in the process of reproducing illustrations. Special thanks are also due to Shirley Maul of the Vassar College Library for helping me obtain the books I needed.

The ideas and suggestions of many friends and colleagues have sustained me along the way. Harvey Flad introduced me to the work of Yi-Fu Tuan and other geographers whose ideas have been useful to me in thinking about landscape perception; Jerry Bastoni and Bruce Conrad were enthusiastic and able partners during the

production of the Mauch Chunk exhibition; Janice Radway helped me think through my approach to the subject of tourist attractions; and Philip Seitz assisted me in mining the resources of the Library of Congress. The published work of Alfred Runte, Elizabeth McKinsey, and Jeremy Adamson and my discussions with them during preparations for the Niagara exhibit at the Corcoran Gallery stimulated my thinking about Niagara Falls and the National Parks. Clyde Griffen's critique of "Prisons, Asylums, Cemeteries, Parks" helped me strengthen that chapter. I am especially indebted to Sharon O'Brien, Frank Bergon, and John Seelye, all of whom read the manuscript carefully and critically. I am grateful to them not only for their thoughtful suggestions but also for their encouragement throughout the process of writing the book.

One of the greatest rewards of this project was the opportunity to take the Great American Family Trip across the continent with my sons, Will and Jack, who, if not always as responsive to scenic wonder as their parents, were wonderful companions. I hope they will find in this book some reflection of our common experience.

Finally, I would like to thank my wife, Maggy, who has always been my first and best reader and an unfailing guide to better writing. This book is dedicated to her with the deepest appreciation.

*Poughkeepsie, New York*                                            J. F. S.
*November 1988*

# Contents

# SACRED PLACES

# Introduction

Tourism had become well established in Europe, and particularly in England, by the last quarter of the eighteenth century. Stimulated by the popularity of landscape gardening and painting, and by the publication of a series of widely read essays on the sublime, the beautiful, and the picturesque, well-to-do English people were seized by a mania for traveling in search of picturesque and sublime scenery.

For several reasons, this delight in scenery was not to grip America intensely until the 1820s and 1830s. Tourism requires a population with the money and the leisure to travel, an adequate means of transportation, and conditions of reasonable safety and comfort at the places people go to visit. It also demands a body of images and descriptions of those places—a mythology of unusual things to see—to excite people's imaginations and induce them to travel. These requirements were not fully met in America until the 1820s. Throughout much of the eighteenth century the English colonies in America were engaged in wars against the French and Indians to the north and then in the struggle for independence against England. Americans were preoccupied with the task of clearing the wilderness and founding towns. Roads, where they existed at all, were poor. A few wealthy people began visiting resorts like Saratoga Springs in New York and White Sulphur Springs in Virginia for health and recreation, but very few visited natural wonders like Virginia's Natural Bridge or Niagara Falls.

Several factors served to change this situation in the first decades of the nineteenth century. The construction of turnpikes led to improved stagecoach service. Robert Fulton's successful experiment with a steamboat on the Hudson River in 1807 introduced

3

faster and more reliable transportation on the nation's waterways. The building of canals, ushered in by the opening of the Erie Canal in 1825, was quickly followed by the construction of railroads beginning in the 1830s. This revolution in transportation made tourism possible. It also spurred the development of the country's urban, commercial, and industrial centers, encouraging the growth of a prosperous middle class and thus creating a potential body of tourists.

The incentive to travel came partly from the forms of transportation themselves. "The wonderful facilities for locomotion furnished by modern ingenuity," wrote James Kirke Paulding in 1828, "have increased the number of travellers to such a degree, that they now constitute a large portion of the human family. All ages and sexes are to be found on the wing." A standard itinerary, or American Grand Tour, which encompassed the Hudson River, the Catskills, Lake George, the Erie Canal, Niagara Falls, the White Mountains, and the Connecticut Valley, was quickly established. Tourism became fashionable for the well-to-do, so fashionable that Paulding's *The New Mirror for Travellers; and Guide to the Springs* (1828) satirized the phenomenon, poking fun at the hurry, pretensions, and superficiality of the tourists. Traveling, he wrote, is "the most exquisite mode of killing time and spending money ever yet devised by lazy ingenuity."[1]

But the development of American tourism had deeper cultural sources than the need for diversion. Tourism played a powerful role in America's invention of itself as a culture. The eighteenth-century English tradition of landscape gardening; the aesthetics of the sublime, the beautiful, and the picturesque; and the work of Romantic writers, like William Wordsworth, Sir Walter Scott, and Lord Byron, had identified culture and landscape so closely with each other that they seemed almost identical. Furthermore, from the beginning Americans had sought their identity in their relationship to the land they had settled. It was inevitable, when they set out to establish a national culture in the 1820s and 1830s, that they would turn to the landscape of America as the basis of that culture. America was still a new country in search of an identity. Educated Americans desperately wished to meet European standards of culture and, at the same time, to develop a distinct national image. Tourist attractions are a feature of all modern societies. But because of America's relationship to Europe and to its own past, because its cultural identity was not given by tradition but had to be created, tourist attractions have played an especially important role in America.

Americans found part of their national identity in the role they

played as tourists in Europe. Not only Washington Irving's *Sketch Book*, but Nathaniel Hawthorne's *The Marble Faun*, the novels and stories of Henry James, and Mark Twain's *Innocents Abroad* depicted American travelers as they defined themselves by interacting with European culture. American painters brought back images of European places. But these same writers and painters also participated in the self-conscious creation of America's own tourist attractions. Tourism provided a means of defining America as a place and taking pride in the special features of its landscape. From the 1820s until well after the Civil War American artists, like Thomas Cole, Frederic Church, Albert Bierstadt, and Thomas Moran, depicted American tourist attractions in their work, and often made their reputations on those paintings. Writers like Irving, Hawthorne, and James described their visits to the same attractions or incorporated them into their fictions. Sometimes these artists and writers chose famous places as the subject of their work; sometimes their work made the places famous. In either case, their work conferred value on the scenes depicted and helped shape the vision of tourists who visited them. The interest in tourist attractions and experiences permeated the work of both serious and popular writers and artists until the latter part of the nineteenth century, and they produced thousands of images and descriptions, or stories related to them, for the numerous guidebooks, gift books, magazines, picture books, and collections of stereographs devoted to travel in the United States during this period. Descriptions of tourist attractions even penetrated scientific journals like the *American Journal of Science and Arts*.

The writers who described their visits to tourist attractions in the nineteenth century often referred to themselves as "pilgrims." Tourists at Mammoth Cave squeezed through "Fat Man's Misery," crawled on hands and knees through "the Valley of Humility," crossed over the "Bottomless Pit," and passed along "Bunyan's Way" as they made a "subterranean pilgrimage" through the cave.[2] The use of such terms suggests that nineteenth-century American tourist attractions assumed some of the functions of sacred places in traditional societies. Protestants had rejected the pilgrimage as a religious rite. In America there were no actual pilgrim shrines. But as Victor and Edith Turner suggest, "Some form of deliberate travel to a far place intimately associated with the deepest, most cherished, axiomatic values of the traveler seems to be a 'cultural universal.' If it is not religiously sanctioned, counseled, or encouraged, it will take other forms." As the Turners point out, "The precincts of 'Old Faithful' in the Yellowstone Park irresistibly recall the cultural landscape of a major religious

5

shrine." Both tourism and the pilgrimage provide escape from the anxieties (and comforts) of everyday life; freedom from ordinary social relationships, hierarchies, and restraints; and hence evoke playfulness and a feeling of liberation. They both promise spiritual renewal through contact with a transcendent reality (the shrine of the saint or the sublime waterfall). Sometimes they offer the hope of physical regeneration as well through the aid of a sacred or medicinal spring. A tourist, write the Turners, is "half a pilgrim, if a pilgrim is half a tourist."[3]

In his article "Niagara as Jerusalem," Patrick McGreevy notes that medieval pilgrims regarded their destination—Canterbury, for example—as a sacred place where they would experience God more closely. They expected it to be fabulous. When they left home they stepped out of their usual routine. Their journey was a metaphor for their passage through life to heaven and their destination a porthole into eternity. Similarly, nineteenth-century tourists left their everyday worlds behind as they set out on their journey to Niagara Falls. Their destination was a waterfall rather than a cathedral, but as one of God's grandest, if not *the* grandest of His creations, Niagara revealed to the nineteenth-century tourist His power and glory.[4]

Although Niagara remained the most famous American destination for the nineteenth-century pilgrims, McGreevy's comparison of it to a medieval shrine applies equally well to other attractions, and not only to those which were primarily natural phenomena. Whether natural or man-made, tourist attractions stand apart from ordinary reality. They replicate in significant ways the function of sacred space in archaic societies. A sacred precinct, a temple, a sacred city, or a cosmic mountain, writes Mircea Eliade, was regarded in those societies as the center or navel of the world, the *axis mundi*. Such places represented an "irruption of the sacred into the world." Man was created at such "a central point" and paradise was located there. Sacred places were also copies of transcendent models. Thus Jerusalem reproduced the Heavenly Jerusalem; the Christian basilica, which inherited the earlier symbolism, imitated the Heavenly Jerusalem, Paradise, or the celestial world.[5]

The strong religious tradition of many Americans predisposed them to construct the symbolic landscape of their own country in a similar fashion. America was the Promised Land; God had guided people to its shores for some transcendent purpose; America was the place where the millennial expectations of Christians would be fulfilled. Given these conceptions of America, it is not surprising that Niagara Falls, the Willey House, Mount Auburn

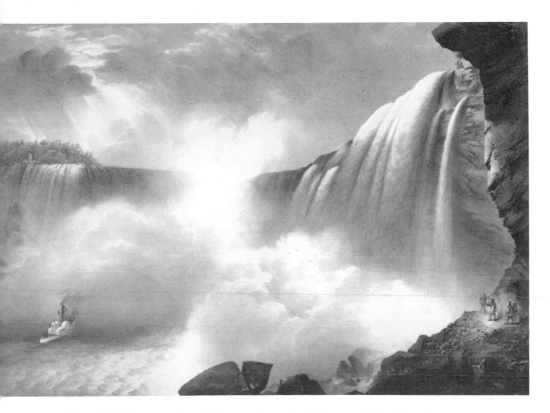

Adam Weingartner after Thomas Benecke, *Niagara Falls, Canadian Side*, 1856. (Courtesy of Buffalo and Erie County Historical Society)

Cemetery, and other tourist attractions suggested transcendent meanings and functioned as the sacred places of nineteenth-century American society.

But there was another reason why tourist attractions played such an important role in the cultural life of the nation. Nineteenth-century American society was composed of a wide variety of religious sects, and these sects continued to multiply in a country that provided the most fertile ground for religious experiment in the history of the world. Tourist attractions, however, are the sacred places of a nation or people, not a sect. Their religious meaning was broad enough to appeal to people of any persuasion. In a pluralistic society they provided points of mythic and national unity. The rural cemeteries, for example, although Protestant, were nondenominational. They functioned as cultural monuments and were proudly shown off to visiting Europeans as expressions of American refinement.

America's nineteenth-century tourist attractions also appealed to

members of both sexes. Annette Kolodny has demonstrated that the prevailing male and female fantasies about the American frontier were quite different from each other. Men sexualized the wilderness, seeing it as *"Paradise* with all her Virgin beauties," a fertile land to be ravished. They dreamt of transforming the land and extracting its wealth. Women, on the other hand, domesticated the frontier landscape. They fantasized about homes, communities, and gardens.[6] Did nineteenth-century men and women also respond to America's tourist attractions differently? This study did not address that question systematically, but no obvious differences stood out in the literature by male and female authors, and it would be very surprising if further analysis revealed differences as sharp as those described by Kolodny in the case of the frontier. Tourism, unlike hunting or plowing, tending a flower garden or caring for children, was never gender identified. Both men and women participated in it, often together, sometimes with children, and in doing so shared the same space. Furthermore, the tourist attractions described in this book, with the possible exception of Mauch Chunk, embody the fantasies of both men and women about the American landscape as they are described by Kolodny. Niagara Falls, for example, represented the seemingly inexhaustible resources of our continent, but with its walkways, staircases, and shops was highly domesticated. The Catskill Mountain House, the Willey House in the White Mountains, and the family plots in the rural cemeteries were symbolically tied to the homes that tourists left when they went to see these sights and to the idealized image of Home that many of them shared. Finally, both male and female travel writers wrote disapprovingly of the American obsession with utilitarian ends. Tourism, they hoped, would encourage a greater regard for beauty and for the leisure to enjoy it. In other words, tourism seemed to offer a cultural check on aggressive fantasies of exploiting America's resources to the fullest extent possible. The establishment of the parks at Yosemite and Yellowstone in the 1870s and 1880s finally institutionalized this impulse toward recreation and aesthetic contemplation. These parks both preserved a part of the wild, untamed land—the virginal paradise about which men had fantasized—and domesticated it. Now free of Indians and the hardships of settlement, the parks offered the delights of recreational camping to those with the leisure to "rough it" for pleasure. If tourist attractions were nondenominational, they were also free of being identified as either male or female space. They offered a common ground to all.

The capacity of tourist attractions to serve the needs of a diverse

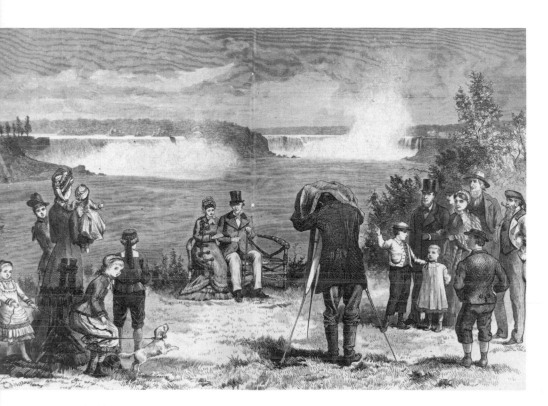

J. W. Champney, *The Season at Niagara Falls*, from *Harper's Weekly*, August 18, 1877. (Courtesy of Vassar College Library)

people may derive in part from the fact that they do not reflect one harmonious set of values. They often embody the contradictions of a society in a concentrated visual form. They unify opposing poles of value. Like the sacred places of earlier periods, tourist attractions embrace both the religious and the secular. In medieval times fairs and markets invariably crowded the great pilgrim churches, and shops and circus entertainment often surrounded nineteenth-century tourist attractions as well.[7] Niagara Falls, for example, became surrounded by a "fixed fair" which provided entertainment for the visitor that was often totally unrelated to the Falls themselves.

But the tourist attractions that emerged in the nineteenth century were not merely accompanied, like the shrines of the medieval world, by commercial activity on their perimeters. The tourist attractions themselves strongly reflected the more secular, bourgeois culture which was developing in America, a culture increasingly oriented to consumerism. The process of industrialization and urbanization that enabled well-to-do people to travel

9

also affected their values. Although the culture of consumerism did not fully develop in the United States until the latter part of the nineteenth century, it began to emerge even before the Civil War in the establishment of such institutions as the department store and the exposition, in the glorification of woman's role as homemaker, and in the tourist industry itself. The nation's tourist attractions were consumer products, promoted by the railroads which carried the tourists to them and organized to satisfy the customers who had the leisure to enjoy them, but their role as products was often marked by religious rhetoric or behavior. Tourism helped reconcile religious values with the desire to buy new products and experiences. If Niagara Falls, the Willey House, Mount Auburn Cemetery, and the other popular sights absorbed some of the functions of sacred space, they integrated those functions into a new form that yoked the sacred and profane, the spiritual and the commercial, the mythic and the trivial, the natural and the artificial, the profound and the superficial, the elite and the popular in a sometimes uneasy combination.

This study focuses on famous sights that tourists went to see, rather than on resorts like Saratoga Springs or Coney Island where the emphasis fell on activities other than sightseeing. The subject is American tourist attractions rather than the European sights, which Americans also went to see, because I seek to understand the way Americans developed an image of their own land rather than the way they responded to European places or the way Europeans experienced tourist attractions in their own countries. Finally, this study deals with the period from about 1825 to 1885 when tourist travel was dominated by a genteel elite, when America's tourist attractions were celebrated by its writers and painters, and when the categories of the sublime and the picturesque, inherited from Europe, shaped the way tourists viewed the landscape. Most tourists before the Civil War were well-to-do and they were encouraged by the genteel culture of the period to draw moral lessons from their experience, to aspire to refined behavior, and to cultivate their aesthetic sensibilities. As railroad fares fell, however, and America's urban population increased, clerks, bureaucrats, and others of modest means were able to go on excursions.[8] At the same time the romantic and religious enthusiasms of the first half of the century waned. As a result, tourism had become by 1885 more of a mass phenomenon and more commercial. Tourist attractions lost some of their conscious and explicit religious resonance.

These changes led to conflict, particularly at Niagara Falls where commercialization provoked one of the first successful

efforts to protect the environment. The case of Niagara Falls also inspired the establishment of National Parks in the West where mass tourism had not yet penetrated. A debate began between those who wished to preserve certain places from exploitation and those who saw this as the effort of an elite to restrict the free use of America's resources. The reverence for nature, which before the Civil War usually took the form of a Romantic love of sublime scenery, was gradually replaced by the reverence for the complex system of nature articulated by writers like John Muir and John Burroughs. As these and other genteel writers recognized, the commercialization of American culture increased rather than diminished the need for sacred places accessible to all Americans. Tourist attractions continued to play this important role, but not always in the ways approved by the arbiters of genteel taste. They increasingly catered to the desire for excitement and escape, as well as to the wish for edification and spiritual revitalization.

Today, tourism is an activity in which almost everyone but the poor participates. It is a nearly universal cultural experience. This was not true in the 1820s, but it was becoming true by the end of the century. The following chapters chronicle the development of the major nineteenth-century American tourist attractions and explore the significant role that tourism played in the formation of America's national identity.[9] Tourist attractions remain a lively component of the American cultural landscape today, but they are never likely to figure as prominently in the artistic life of the nation as they did in the nineteenth century nor to form such a vital intersection between "high" culture and popular culture.

# ₴~ *One*

## "Doing" Niagara Falls in the Nineteenth Century

NIAGARA FALLS WAS, of course, the preeminent American tourist attraction in the nineteenth century. Already established as an important symbol of America before the opening of the Erie Canal in 1825, it quickly became the major stop on the American Grand Tour and the most popular destination for honeymooners. It attracted people from all sections of the country and abroad. Visiting the Falls became one of the primary rituals of democratic life in nineteenth-century America.

Elizabeth McKinsey dates the beginning of the Niagara honeymoon craze to the late 1830s, but no precise dating of this custom is possible and the golden age of the Niagara honeymoon appears to have begun after the Civil War and extended into the 1930s. Before the war, when Niagara, like Saratoga Springs, functioned as a fashionable resort, it probably served as much as a site where wealthy, young men and women could engage in the ritual of courtship as it did as the destination of honeymoon couples. In any event, Niagara's popularity as a honeymoon resort was not the cause of Niagara's wide appeal or of its symbolic importance to Americans. It was the result. Honeymooners went there because of its powerful hold on the imagination of so many people.[1]

Niagara's appeal depended in large part on its having no equal. As Europeans themselves recognized, it had absolutely no counterpart in the Old World. Moreover, its height and breadth, and the inexhaustible volume of water flowing over it made it an apt emblem for the resources of the new nation. The idea of sacred space is closely tied up with a sense of cultural preeminence. " 'Our world' is holy ground *because it is the place nearest to heaven,*" explains Eliade, "because from here, from our abode, it is possible

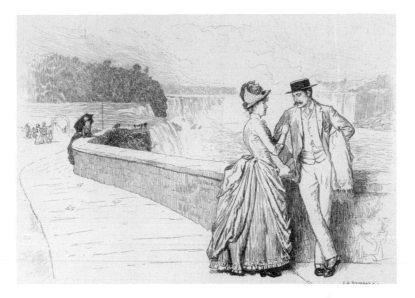

C. S. Reinhart, *Their Bridal Tour—at Niagara Falls,* from *Harper's Weekly,* September 29, 1888. (Courtesy of Vassar College Library)

to reach heaven; hence our world is a high place." In Hebrew tradition Palestine was regarded as the highest land.[2] Likewise, Niagara Falls was a prodigy of nature, which seemed to prove that in America Nature expressed itself on a grander scale than elsewhere.

Visitors to the Falls sometimes referred to themselves as "pilgrims." In "My Visit to Niagara," for example, Hawthorne buys what he calls a pilgrim staff from an Indian souvenir shop and approaches Niagara as if it were a religious shrine.[3] Once at the Falls tourists were introduced to the mysteries of the place by guides who ushered them behind Horseshoe Fall to Termination Rock and behind the American Fall to the Cave of the Winds. They descended staircases to the bottom of the Falls, crossed the rapids, and walked on trembling walkways to Terrapin Tower on the edge of Horseshoe Fall. They struggled over slippery rocks, were wetted with spray and buffeted by winds. Such tourist rituals recapitulate, if only faintly, the trials experienced by pilgrims on their journey toward Canterbury, Rome, or Jerusalem and their initiation into the mysteries of the sacred place.

More important than these rituals, however, was the expectation which tourists brought with them that the Falls would provide them with an intense emotional and religious experience. The

pilgrim tourists of the nineteenth century believed that Niagara Falls would bring them closer to God. This expectation had its origin in Edmund Burke's widely influential work, A *Philosophical Enquiry into the Origin of Our Ideas of the Sublime and Beautiful* (1757). By providing a paradigm for the emotional experience that grand objects were supposed to evoke, Burke's work served, in effect, as the first guidebook to the Falls. By the time the Erie Canal brought the first large influx of tourists to Niagara, Burke's analysis of the experience of the sublime colored every description of the Falls. The early travel accounts and guidebooks are full of Burkean rhetoric about the astonishing height, enormous volume, stupendous force, and eternal sound of the Falls. The pleasurable terror created by these qualities led some people to abandon themselves physically to the experience. The ornithologist Alexander Wilson, for example, describes the way he and his companions threw down their baggage at the edge of the cliff opposite Niagara, descended a "slippery" and "tottering" ladder into the "Chaos" below, and eagerly courted every danger or sensation of danger in exploring the Falls.[4] It was more characteristic, however, to focus, as Burke had done on the psychological impact of the sublime. Timothy Dwight, the poet and Yale president, describes the profound and incapacitating "disturbance of [the] mind" that Niagara generated in the spectator: "The struggle within is discovered by the fixedness of his position, the deep solemnity of his aspect, and the intense gaze of his eye. . . . When he is spoken to, he is silent; or, if he speaks, his answers are short, wandering from the subject, and indicating that absence of mind which is the result of laboring contemplation." The "thoughts too great" which this laboring contemplation brought forth were thoughts of eternity and of the magnitude of creation.[5] In the immensity, force, and infinite duration of the Falls, the spectator confronted the power of God. As the guidebook writer J. W. Orr puts it, "Crowding emotions swell the bosom; thoughts that defy utterance, fill the mind. The power and presence of the Almighty seem fearfully manifest. You gaze, and tremble as you gaze!"[6] Moreover, because God spoke through the Falls, the experience had a moral effect on the visitor. "I felt the moral influence of the scene acting on my spiritual nature," writes Caroline Gilman in *The Poetry of Travelling* (1838), and while lingering at the summit alone, offered a simple and humble prayer."[7]

Burke's prescription for the emotional experience evoked by sublime objects placed a heavy burden on the spectator. Educated people knew what they ought to feel in the presence of the Falls, but it was inevitable that many of them did not respond with the full

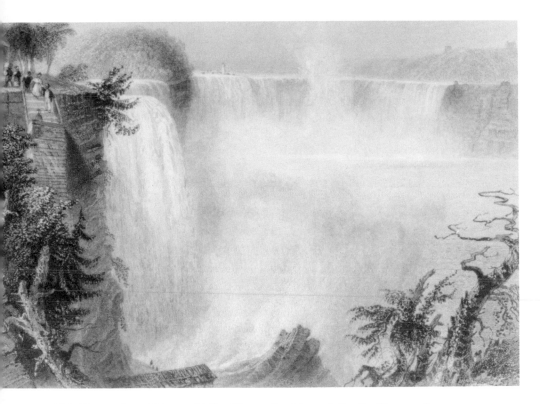

W. H. Bartlett, *Niagara Falls* (*From the Top of the Ladder on the American Side*), from *American Scenery*, 1840. (Courtesy of Adriance Memorial Library)

Burkean intensity. This was particularly true once the experience of Niagara had become a cliché, as it did by the 1830s. Anticipating the effect of the Falls—and perhaps anxious that they wouldn't be worthy of the experience—visitors often described a feeling of trepidation as they approached Niagara. Once they saw it they often felt disappointment, a word that appears in a remarkably high percentage of visitors' accounts and guidebooks. For the worshippers of Niagara Falls, however, disappointment could be regarded as a stage in the visitor's apprehension of the true wonder of the Falls. When travelers found themselves unmoved at first, it supported the widespread assertion that knowing the Falls required several days—often a week. Initial disappointment would give way to appreciation, even ecstasy, if the visitor took the time to contemplate the magnificent sight.

This process resembled the pattern of religious conversion so familiar to nineteenth-century Americans. In "My Visit to Niagara," for example, one of the most sensitive and perceptive ac-

counts of visiting the Falls, Hawthorne casts his whole experience in terms of a spiritual progress that closely parallels the conversion experience. His initial feelings of unworthiness and insignificance are replaced first by a period of struggle and contemplation and finally by an exhilarating sense of the sublimity of the Falls. "The beholder," he concludes, "must stand beside [Niagara] in the simplicity of his heart, suffering the mighty scene to work its own impression."[8]

But disappointment did not always end in ecstatic recognition of Niagara's sublimity. The vision of Niagara Falls as the most sublime and beautiful of God's creations, a sight that would have a profound moral impact on the spectator, was certainly very powerful in the nineteenth century, particularly before the Civil War. Even the most ordinary tourist must have been aware of this image since it permeated guidebooks, travel literature, paintings, and prints. But that does not mean that the ordinary tourist always stood in awestruck wonder before Niagara, humbled by the power of God, or felt that he had become a better person through the moral influence of the Falls. This ideal response to the Falls was promoted by America's cultural elite and foreign visitors, like Charles Dickens, but there is ample evidence, even in the literature which embodies this view, that many tourists encountered the Falls on less exalted terms. Despite the rhetoric of the sublime, nineteenth-century tourists appear to have been as susceptible as twentieth-century sightseers to boredom and irreverence.

Some of the tourists who recorded their observations in the albums kept at Table Rock during the first part of the nineteenth century, for example, mouthed the usual platitudes about the grandeur of Niagara and its moral influence, but others expressed a mischievous desire to undercut the worshipful pose of the pilgrims and reduce the Falls to the practical or trivial:

> The roar of the waters! sublime is the sound
>    Which forever is heard from the cataract's steep!
> How grand! how majestic! how vast! how profound!
>    Like the snore of a pig when he's buried in sleep![9]

Another wit attributed the following stanza to William Cullen Bryant:

> I came from Wall street
> To see this water sheet;
> Having seen this water sheet,
> I return to Wall street.[10]

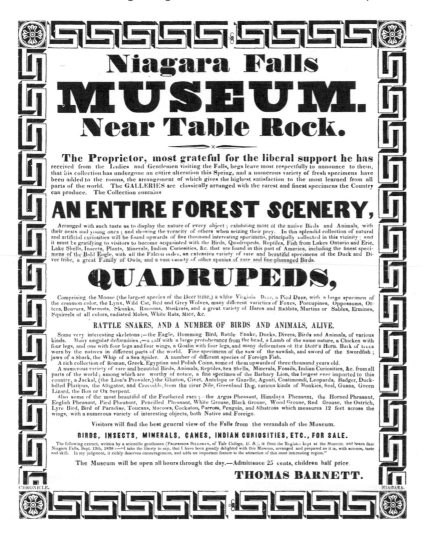

Niagara Falls Museum Near Table Rock, broadside, 1840s. (Courtesy of Library of Congress)

This sort of irreverence was no doubt encouraged by the distractions which surrounded the Falls. These include souvenir shops selling Indian bead work and feather fans; Barnett's Museum, and the circus entertainment provided by people like the famous French aerialist Blondin who performed on a rope stretched across the Niagara gorge. As Patrick McGreevy points out, such sideshows, like the fairs and markets surrounding the pilgrim churches of medieval times, marked off such places from

the everyday world and provided a powerful added attraction to the "pilgrims" who visited them.[11]

But the commercialization and sensationalization of the Falls did not remain only on the periphery. It invaded the spiritual experience of the Falls itself through the physical structures provided for tourists. Even as early as the 1820s, Niagara Falls had ceased to be solely a sublime natural phenomenon and had become instead a natural phenomenon constantly observed by groups of tourists. Although an artist might imagine the Falls stripped of its trappings as a tourist attraction, no visitor could avoid the consciousness of his fellow tourists, the guides, and the other manifestations of the tourist trade. Moreover, the physical structures constructed by the proprietors of the Falls and the guidebooks, which reinforced and elaborated on these structures, controlled their experience and transformed the Falls into a commodity to be consumed by them.

Tourism was one of the earliest activities in which consuming could be enjoyed as an end in itself rather than an effort to obtain necessities. This was probably because the aesthetic and moral motives associated with the contemplation of the sublime provided a justification for tourism as diversion in a society still devoted to the work ethic. The sublime masked but in a fundamental sense supported the commercial nature of tourism. It promised spiritual experience and moral improvement, but it contained within it an invitation to treat grand natural scenery purely as spectacle. Niagara did not always satisfy the tourists' appetite for astonishment, but the sublime raised consumer expectations, and the private individuals who owned Niagara Falls until the 1880s and the writers promoting the Falls made every effort to deliver the goods.

The land around Niagara Falls is exceedingly flat. Visitors usually approached Niagara along the American or Canadian shore at the top of the Falls, which makes a much less awesome first impression than Yosemite or even Mount Washington. Marketing the Falls as spectacle posed the problem of how to increase its appearance of height, power, and danger. The proprietors built staircases and walkways to take visitors to the foot of the Falls, behind the Horseshoe Fall to Termination Rock and behind the American Fall to the Cave of the Winds. They also erected a tower with a wooden walkway over the rapids on Terrapin Rocks at the edge of the Horseshoe Fall. In the 1840s the *Maid of the Mist* began carrying tourists into the spray and foam beneath the Falls so that they could experience the sensation of the tumbling waters above them.

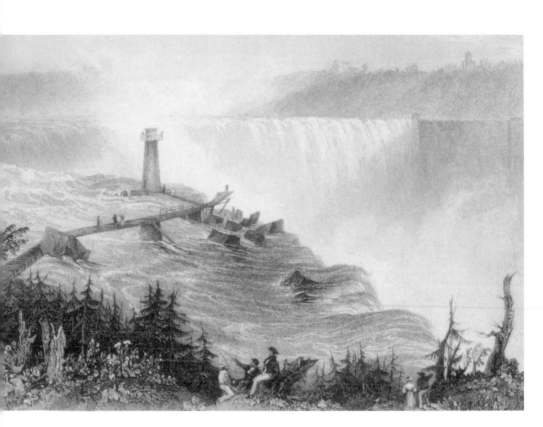

W. H. Bartlett, *Horse-shoe Fall, Niagara—with the Tower*, from
*American Scenery*, 1840. (Courtesy of Adriance Memorial Library)

To some extent these efforts supported the religious function of
the Falls. They contributed to the tourists' sense of being on a
pilgrimage on which they faced dangers, underwent hardships,
and were initiated into the mysteries of the sacred place. The ex-
cursions offered by the proprietors also provided access to the
sublime qualities of Niagara, but they emphasized the terrifying
aspect of the sublime rather than its contemplative and spiritual
elements. Sightseers who paid for these excursions were buying
sensation, including the thrill of being wetted with spray and
blown about by strong winds or of clambering over slippery rocks
and negotiating narrow walkways while the outpouring of Lake
Erie rushed beneath.

The physical structures that brought the thrilling aspects of the
Falls closer both sensationalized the Falls and broke up the land-
scape into numerous points of interest. The guidebooks devoted a
section to each attraction: Table Rock, Termination Rock, Pros-
pect Point, Goat Island, the Biddle Staircase, Terrapin Tower, the

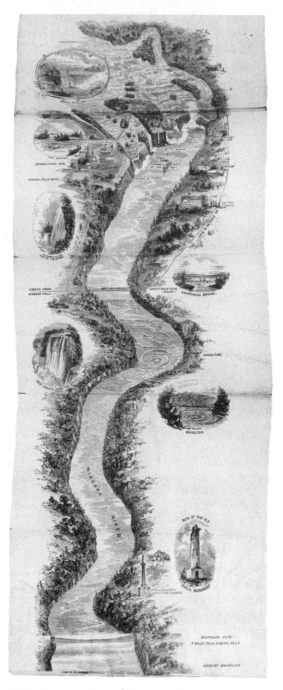

Fold-out map from *Hunter's Panoramic Guide
from Niagara Falls to Quebec,* by William S.
Hunter, Jr., 1857. (Courtesy of Local History
Department, Niagara Falls Public Library)

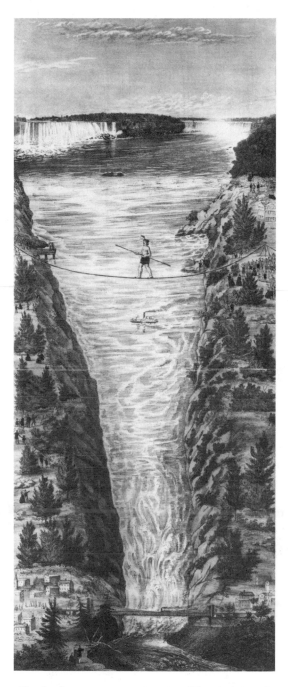

Charles Magus & Co., *Monsieur Blondin's Walk Across the Cataract*, 1859. (Courtesy of Library of Congress)

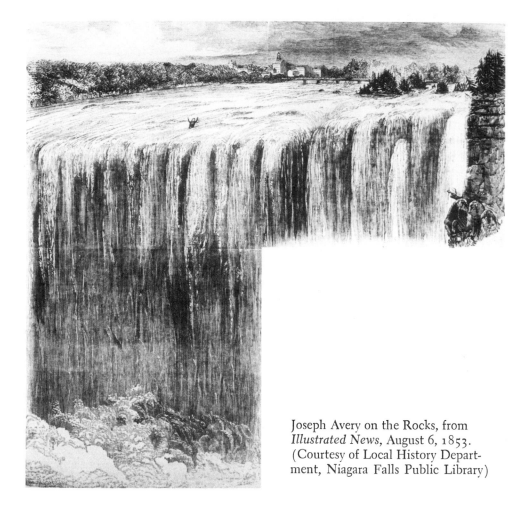

Joseph Avery on the Rocks, from
*Illustrated News*, August 6, 1853.
(Courtesy of Local History Depart-
ment, Niagara Falls Public Library)

Whirlpool, the Three Sisters, and so on. As the reading of any
able description of the waters, mists, rocks, rapids, and rainbows
of the Falls reveals, these points of interest in no way added up to
the Falls. Instead, the points of interest became objects in them-
selves. Naming and marking them off transformed Niagara into a
commodity, making it easy to market the Falls and easy to con-
sume them without the necessity of actually seeing them. Once all
the sights were set apart, usually by a fence, gate, ticket booth, or
other structure—and this happened very early in the history of the
Falls—the structures, guidebooks, popular literature, and hackmen
who took people about combined to make "doing the Falls" a
matter of covering all the bases. Tourists were told they hadn't
really seen the Falls unless they had visited all the major attrac-

tions. Because the Falls were divided into these attractions, each of which had an admission fee, visitors could consume the Falls bit by bit, until they felt they had "done" them.

The consumption of Niagara Falls did not stop there, however. Incidents that occurred at Niagara provided further opportunities to call attention to surrounding places and enhance the exciting qualities of the Falls. In 1829 Sam Patch made a celebrated leap from a one-hundred-foot tower at the base of the Falls, thus inaugurating a long series of stunts performed in the vicinity. The French tightrope walker, Blondin, performed on a rope stretched across the gorge below the Falls from 1859 until 1861; soon several other aerialists followed. The barrel craze began later in the century. Accidents and rescues also contributed to the site's sense of danger and excitement. One little girl leapt from the hands of her parents' friend into the rapids and, when he jumped in to rescue her, she was swept over the Falls with him. Incidents of this nature were commonly reported in the guidebooks, but they were also given a stamp of approval as part of the genteel experience of Niagara by popular writers like George W. Curtis and William Dean Howells. Howells, for example, wrote a poem called "Avery" about the day-long struggle and ultimate failure to rescue a man stranded on a log near the brink of the Falls.

Like the walkways, staircases, and boats which provided increased access to the Falls, these stories had both a profane and a sacred function. Victor Turner notes that pilgrim shrines function as "cultural magnets attracting symbols of many kinds both verbal and nonverbal."[12] Similarly, Niagara Falls gathered history, literature, legends, folklore, and visual depictions about it, both in elite and popular forms. The stories about incidents at the Falls, as repeated in guidebooks or recounted by guides, were part of what tourists consumed at the Falls, but the attention given to them reflects the power of the Falls to make ordinary experience universal. Most of these incidents, if they had happened somewhere else, would have merited a news item, and then been forgotten. But the grandeur of the Falls and its importance as a national shrine magnified their impact. Such incidents became part of history. This history included people who themselves transcended ordinary reality in deed or status: Patch and Blondin, for example, who became famous by performing feats at the Falls; the Prince of Wales; and well-known writers, like Dickens, whose accounts of their visits were widely circulated and quoted in the guidebooks. But it also included ordinary people—tourists and local people—who were rescued from the rapids or swept over the Falls or drowned in the Whirlpool. Most important, it included the tour-

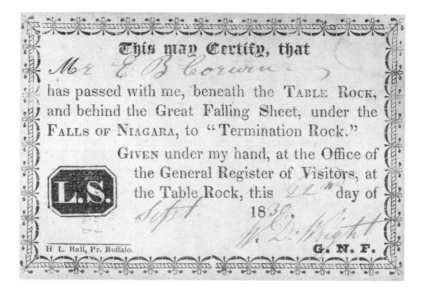

This may Certify, that Mr E B Corwin has passed with me, beneath the TABLE ROCK, and behind the Great Falling Sheet, under the FALLS OF NIAGARA, to "Termination Rock." GIVEN under my hand, at the Office of the General Register of Visitors, at the Table Rock, this 22nd day of Sept 1830.

L.S.

H. L. Ball, Pr. Buffalo.

G. N. F.

Termination Rock Certificate, September 22, 1830. (Courtesy of Buffalo and Erie County Historical Society)

ists who stepped out of their ordinary routines, their familiar and obscure surroundings, and stepped onto the stage of history. Going to Niagara Falls was usually recorded as a significant moment in a tourist's personal history. Souvenirs, letters home, photographs, a certificate from a trip to Termination Rock, and names carved in the trees on Goat Island or Table Rock were a means of securing a place in Niagara's ongoing history. Those who witnessed the aerialists' feats or happened to be present when an accident occurred or a piece of rock fell had that sense of participating in history further reinforced.

The attention given to such incidents and the need of travelers to record their presence at the Falls in some fashion suggest that tourists were seeking a place in public history. If yearly festivals have traditionally enabled residents to join in the ongoing life of their own communities, tourist attractions like Niagara Falls enabled the members of an emerging mass society to participate in a common national experience. The guidebooks, which devote nearly every section to some form of history—whether it be the recession of the Falls over time, the battles fought along the Niagara frontier, or the drowning of some unfortunate tourist—are above all democratic. They equalize all points of interest and all events and memorialize the ridiculous along with the sublime. A description

of the Cave of the Winds, the leap of Sam Patch, the story of Avery on the log, the Battle of Lundy's Lane (a bloody encounter during the War of 1812), and a description of Barnett's Museum received roughly equal treatment—all became incorporated into the popular history of the Falls.

Perhaps the story that best illustrates the power of the Falls to mix the mythic and the trivial is the story of Francis Abbott, the Hermit of the Falls. Abbott arrived in 1829 with a flute, a portfolio, and a large book and settled close by the Falls. His story was often given more space in the guidebooks than any other and was repeated in visitors' accounts even after the Civil War. He was a caricature of the romantic tourist of the age: sensitive, artistic, and highly emotional when it came to scenery. He was "perfectly infatuated" with the Falls and settled down to worship them. His attitudes were not different from those of other tourists, however he adopted the worshipful pose of the pilgrim tourist as his whole identity: "The fascination, which all minds of sensibility feel in the presence of that glorious work of the Creator," wrote William Hunter in his guide to Niagara, "grew strongly upon him, and he was heard to say that six weeks were insufficient to become acquainted with its beauties. At the end of that period he was still unable to tear himself away, and desired to 'build there a tabernacle,' that he might indulge in his love of solitary musings and admire at leisure the sublimity of nature."[13] Perhaps part of his appeal was in the way he literally lived the clichés of tourist experience: "It was hard to tear ourselves away from the magnificent sight," "A week is not sufficient to appreciate all the beauties of Niagara," "I could have stayed there forever." While other tourists took away souvenirs, photographs, or other relics of their pilgrimage, he escaped mundane life altogether to become part of the universal history of the Falls.

Abbott's background was mysterious, but he appeared well educated (one account said that he wrote in Latin and then tore up his work). He was rumored to have suffered some disappointment in love and was said to have traveled widely in Europe and the Middle East. He struck romantic poses. "In the darkest hours of the night," according to one guidebook, "he was often found walking alone, in the wildest and most dangerous places near the falls; and at such times he would shun the approach of men."[14] He provided the Falls with the picturesque touch which people seemed to crave, apparently playing the role of pseudo-hermit deliberately. "On some of the great estates in England," he reportedly said, "where the proprietors seek to give a romantic interest to their possessions, a forest or some retired glen is chosen, where a hermit-

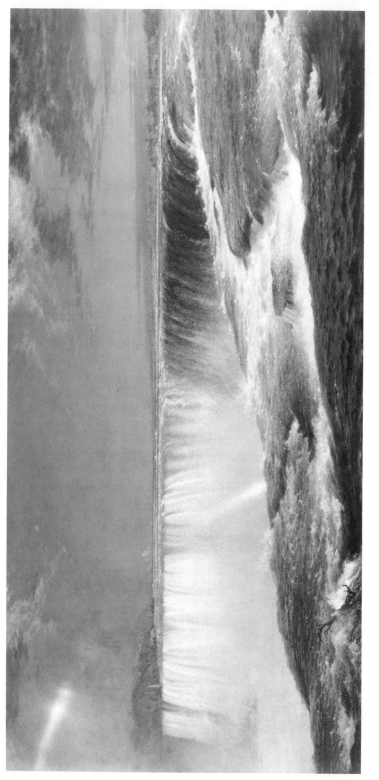

Frederic Church, *Niagara*, 1857. (In the Collection of The Corcoran Gallery of Art, Museum Purchase, Gallery Fund, 1876; © Corcoran Gallery Art)

age is erected, and a man hired to play the hermit. When the owner passes over his estate with his friends, the hermit, with his flowing beard, and dressed in antique costume, receives them at the hermitage."[15] At Niagara Falls, however, it was impossible to be a true hermit even to this limited extent. Being a hermit at the Falls was not only a pose but a contradiction. The transcendentalist Margaret Fuller, who was intrigued by Abbott's story and wondered why more people "do not oftener attach their lives to localities of great beauty," found Abbott's role totally false: "There is something ludicrous in being the hermit of a show-place, unlike St. Francis in his mountain-bed, where none but the stars and rising sun ever saw him."[16]

In 1831 Abbott's body was found in the gorge below the Falls. No one knew whether he was the victim of an accident or a suicide, but as Howells remarks in *Their Wedding Journey*, his novel celebrating the traditional honeymoon journey to Niagara: "This public character they suspected of design in his death as in his life."[17] On the one hand, Abbott's story was just another sideshow, a diverting incident in the popular history of the Falls, but similar to other events in that history, it also reinforced Niagara's role as a shrine to which tourists were making a pilgrimage. It raised ordinary tourist experience to a quasi-mythic level.

The manner in which the cultural content of Niagara Falls—its scenic points of interest and its popular history—was delivered and consumed closely resembles the methods of several other institutions in nineteenth-century America: the public museum, the exposition, and the popular resort. All these institutions offered diverse attractions under the umbrella of a unifying spectacle, functioned as instruments of the mass consumption of culture, and provided a democratic stage on which the obscure and famous could share the same experience and where, increasingly as the century progressed, members of all classes could mingle as they would also do at Coney Island.[18]

Although early American museums ranged in seriousness from P. T. Barnum's American Museum in Manhattan to the Western Museum in Cincinnati to the cabinet of the American Philosophical Society in Philadelphia, most of them began as cabinets of curiosities with extremely diverse collections that included oddities as well as objects of scientific or artistic interest. One nineteenth-century English visitor wrote:

A "Museum" in the American sense of the word means a place of amusement, wherein there shall be a theatre, some wax figures, a giant and a dwarf or two, a jumble of pictures, and a few live

Indian Beadwork Souvenir, late nineteenth century. (Courtesy of Iroquois Brands Ltd. Collection, Greenwich, Connecticut)

snakes. In order that there may be some excuse for the use of the word, there is in most instances a collection of stuffed birds, a few preserved animals, and a stock of oddly assorted and very dubitable curiosities; but the main-stay of the "museum" is the "live art," that is, the theatrical performance, the precocious mannikins [sic], or the intellectual dogs and monkeys.[19]

This is not a bad description of Niagara Falls as it was presented to tourists: the phenomena of rapids, falls, and whirlpool mixed indiscriminately with the diversion provided by leapers, tightrope walkers, a hermit, trips behind the Falls, stories of accidents and rescues, souvenir shops, Barnett's Museum, and the camera obscura that depicted a "miniature and moving Niagara, animated and lifelike."[20] (P. T. Barnum's museum had, in fact, a working model of the Falls, featuring "real water.")

Likewise, the way the proprietors structured the Falls for the tourist anticipates the structure of the expositions made popular by the Crystal Palace Exposition in London in 1851 and imitated with great success in America at the Centennial Exposition in Philadelphia, the Columbian Exposition in Chicago, and the Pan-American Exposition in Buffalo in 1901 at which Niagara Falls itself was a major attraction. Like these expositions and the amusement parks at Coney Island and Atlantic City, Niagara Falls provided a varied group of attractions in a relatively concentrated space through which the tourist was directed. The spectacle as a

whole was supposed to awe the tourist, and its grandeur provided an ever-present context in which to examine its various parts.

Niagara Falls created the illusion of drawing the diversity of modern knowledge together. The guidebooks stress comprehensiveness and touch, superficially of course, on history, art, poetry, geology, and sometimes hydraulics. Niagara was, and is, encyclopedic. In a world growing increasingly complex, it provided a point of convergence for the world's variety.

Niagara embodied both the values and the contradictions of the society for which it served as the principal shrine. On the one hand, Niagara was the most sublime and beautiful of God's creations, a sacred place, which was supposed to have a profound moral influence on the spectator. On the other hand, it was an emporium of culture where the tourist shopped for Niagara's wonders and for little replicas of the Falls in the form of souvenirs.

The manner in which the sacred and profane, the mythic and the trivial, the solemn and the irreverent were mixed at Niagara Falls is a common feature of tourist attractions. But at Niagara Falls the commercial and industrial activities on the periphery intruded so much on the sight of the Falls themselves that they became obnoxious to genteel visitors. The problem was not that religious apprehension of the Falls and souvenir shopping were incompatible. The poet Lydia Sigourney, for example, had no difficulty integrat-

Indian Beadwork Souvenir, late nineteenth century. (Courtesy of Iroquois Brands Ltd. Collection, Greenwich, Connecticut)

ing her experience of the Falls as a "living personification" of God's power with the pleasure of shopping for "Indian fancy-work, in beads, bark, and porcupine quills."[21] But some visitors noted as early as the 1830s that the landscape surrounding the Falls was being destroyed by commercialization and industrialization. By the 1860s many felt that the multiplication of shops and the aggressiveness of guides, souvenir sellers, and photographers had spoiled the Falls. Henry James complained in 1871 that the Falls had become "choked in the horribly vulgar shops and booths and catchpenny artifices which have pushed and elbowed to within the very spray of the Falls. . . . The importunities one suffers here, . . . from hackmen and photographers and vendors of gim-cracks, are simply hideous and infamous."[22] After the Civil War when lower railroad fares made it possible for more people to travel, the situation became even worse. But it was not until after the establishment of Yosemite and Yellowstone parks that a movement to remedy the problems of Niagara would be successful and its sacred space given a new structural and visual form.

# 𝕰𝕰 Two

## Mammoth Cave: Theater
## of the Cosmic

NIAGARA FALLS WAS BRIGHT, noisy, and spectacular. Tourists shared their visit to that shrine with many other people. Kentucky's Mammoth Cave, on the other hand—an enormous cave system believed to be the longest in the world—though no less sacred and no less profane, was dark, silent, and mysterious. Tourists experienced it in a more intimate and more festive way. The cave was also far less accessible to the ordinary traveler. Before the Civil War, it was one of the most difficult of the popular attractions to reach. A writer for the English journal *All the Year Round* reported that the stagecoach which carried passengers from the nearest point on the Louisville and Nashville Railroad to the cave passed through

> damp reeking woods, not unfrequented by 'possums and rattle-snakes, over a rough road with rude plank bridges here and there where water-courses or deep ditches had to be traversed. Four strong large-limbed Kentucky horses drew that ark of a stage, which held some twelve people inside, and I am afraid to say how many outside. . . . How we bounced, and bumped, and tilted, and groaned, as we were dislocated over the deep rutted road. . . .[1]

Another visitor wrote that "a young tree or two, blown down, and lying across the road, was considered no impediment by our invincible half-alligator driver."[2] These accounts were probably colored a bit for the folks back home, but there is no doubt that such journeys demanded fortitude.

Traveling under rudimentary conditions, however, could yield some Thoreauvian rewards. The American travel writer Nathaniel P. Willis, who visited the cave in 1852, recorded both the rough-

ness and the glories of his trip to Mammoth Cave: "Under miles of beech trees, every third one an unsung monarch—through orchestras of mocking-birds and thrushes—over rocks, stumps, and gullies, and through streams and quagmires—we made our varied way. It was an interesting ride—for one never tires of the primitive wilderness with its fragmented sublimities and splendid accidents of beauty."[3]

The existence of Mammoth Cave had been known for some time before it became a tourist attraction. One half of the saltpeter used by America during the War of 1812 had been dug from the floor of the cave. It became nationally known in 1816 when Nahum Ward, a traveler from Massachusetts, published a description of the cave and of an Indian mummy which he had seen there and taken with him. His article, which appeared in the Worcester, Massachusetts *Spy*, was reprinted in the Boston *Daily Advertiser* and in other newspapers throughout the United States. In 1817 it was published in England and in 1823 reprinted there.[4] The mummy, which Ward described in some detail and which was later displayed in Scudder's Museum in New York, satisfied the hunger of Americans for evidence of ancient civilizations in America that might compare to those unearthed in Egypt and Italy. Because of the unusual garments, beads, and other artifacts found with the mummy, Ward and others assumed she belonged to an extinct race which had lived in the area between one and two thousand years before.

Ward's description made Mammoth Cave famous, and its fame was kept alive by the many writers who visited it. Enthusiastic accounts of Mammoth Cave appeared in British and American magazines throughout the century. Bayard Taylor, who, like Willis, was one of the popular American travel writers of the mid-nineteenth century, wrote that "It is the greatest natural curiosity I have ever visited, Niagara not excepted." Nevertheless, because it was beyond the circuit of the American Grand Tour and distant from the centers of population, only a small number of tourists made the journey. Taylor reported in 1860 that only 2,000 people visited it each year.[5] H. C. Hovey's guide to the cave reported that 2,000 to 3,000 people visited it each year according to the hotel register.[6]

For this and other reasons, Mammoth Cave retained the intimacy which was characteristic of many tourist attractions in their early years for a longer time than other places. Visitors found themselves in small groups and many of them were guided through the cave by the renowned Stephen Bishop (1821–57) whom they might have read about in a guidebook or travel account before they arrived. Bishop, who began his career as guide at the age of

seventeen, was a slave belonging first to Franklin Gorin who bought the cave in 1838 and then to Dr. John Croghan who acquired him along with the cave in 1839. Bishop, according to Taylor, was "quick, daring, enthusiastic, persevering, with a lively appreciation of the wonders he shows." He was by all accounts extremely intelligent and resourceful and learned the current theories about the formations in the cave, its unusual inhabitants, and other phenomena from the scientists whom he guided through it. "He will discourse upon the various formations in the Cave," wrote Taylor, "as fluently as Professor Silliman himself" (Benjamin Silliman, professor at Yale, was the leading American scientist of the day).[7] His investigations of unexplored passages opened large, new areas of the cave to visitors. He was said to have learned to read and write by asking tourists to spell their names which they liked to scratch on the walls or smoke with lamps or candles on the ceilings of the cave. Bishop cut a romantic figure. In the words of Willis:

> He is a slave, part mulatto and part Indian, but with more of the physiognomy of a Spaniard—his masses of black hair curling slightly and gracefully, and his long mustache giving quite a Castillian air to his dark skin. He is of middle size, but built for an athletic—with broad chest and shoulders, narrow hips, and legs slightly bowed, and he is famous for the dexterity and bodily strength which are very necessary to his vocation.[8]

Accounts of Bishop's feats of exploration, memory, and physical endurance, and of his calm, assured manner appeared in virtually all the descriptions of the cave written during his career. Several other guides assisted him, notably Mat and Nick, who were also mentioned in travelers' accounts, but he was the one most closely identified with the experience of the cave and therefore most requested as a guide by tourists.

Tourists could only see Mammoth Cave with the aid of a guide. The tour groups were usually very small—Taylor's consisted of eleven people—and this reinforced the intimacy already created by knowing beforehand the personality of the guide through written accounts of the cave. Charles Moreno, who visited the cave in 1857, wrote in his journal, "It is a customary thing that each member of a cave party must make himself or herself as sociable as convenient for the time being, as it greatly enhances the pleasure of all. Our party broke through the rules of etiquette, that is, in so far as introductions were concerned, and each contributed to make the time pleasant."[9]

These small groups moved through the cave with the aid of lard

33

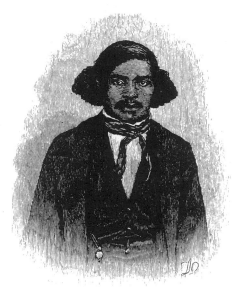

*Stephen Bishop, The Guide*, from *Scribner's Monthly*, 1880. (Courtesy of Vassar College Library)

oil lamps—small tin trays with a wick in the center, which were suspended by four wires from a tin cover. The visitor carried the lamp by slipping a finger through the ring at the top. Since the tour through the cave required a certain amount of clambering over rocks and squeezing through narrow, dirty passages, the cave proprietor provided male visitors with mustard-colored flannel frocks and caps, women with "short-skirted petticoats" and trousers of the same material and a skull cap stuffed with material to cushion the head when it bumped against the ceiling of the cave.[10]

The appearance of other tourists often constituted an important element in the scenery that nineteenth-century tourists went to look at. Tourists often appear in the foreground of popular prints and engravings of American scenes, gazing at the landscape, sketching, or struggling up trails. According to the principles of picturesque composition, human figures, like the gypsies and banditti in the paintings of the seventeenth-century landscape artist, Salvator Rosa, or the Indians and frontiersmen of James Fenimore Cooper's novels, added visual interest to a picture. They also suggested human stories to the mind of the spectator. In his account of a visit to Trenton Falls, Willis writes:

> You know how much any romantic scene is heightened in its effect by human figures. Every new group changed and embellished the glorious combination of rock, foliage and water below me, and I studied their dresses and attitudes as you would criticize

them in a picture. The men with their two sticks of legs, and angular hats, looked abominably; of course, I was glad when they were out of the perspective. But the ladies of each party with their flowing skirts, veils lifted by the wind, picturesque bonnets and parasols, were charming outlines as heighteners to the effect.[11]

Nowhere were tourists themselves of greater importance to the scene than at Mammoth Cave. In the gloomy underground darkness which offered little material out of which to compose a picture, a procession of tourists, each carrying a lamp, produced a dramatic effect. Several writers speak of the pleasure of lingering behind their group so that they could enjoy the sight of it moving slowly through the chambers of the cave. "How unique the scene as they appear and disappear among the knolls, rocks, and hollows, their lights chasing for a moment the shadows, now there, now yonder, streaming upward and athwart with fitful gleam."[12] For some writers the special costumes worn by the tourists visiting the cave added to the effect. The ladies, wrote one, in 1861, were "equipped in Bloomer fashion with scarlet cloaks and turbans, which acted as a foil to the darkness of the cave, and produced a highly picturesque effect."[13]

Boat trips on the cave's underground rivers also yielded romantic images. Willis writes of watching a honeymoon couple as they

*Mammoth Cave—"The Fat Man's Misery,"* from *Scribner's Monthly,* 1874. (Courtesy of Vassar College Library)

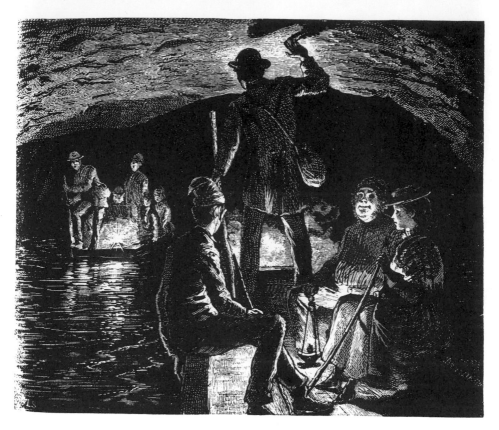

*Mammoth Cave—The Boat Ride on Echo River,* from *Scribner's Monthly,* 1874. (Courtesy of Vassar College Library)

stand for a moment on one of the riverbanks as Willis's boat moves off into the darkness:

> As they stood with their swinging lamps on the receding shore, the lovely bride, smiling and joyous, and with one little foot already turned from under her steps, I thought lights, groupings and all, I never had seen a more dramatic picture. We dropped silently down the stream, with our lamps hidden in the bottom of the skiff—Steven's slouched beaver, raven mustache and large melancholy eyes looking even more poetical than old Charon, as he shoved from shore—and in the next minute we were hidden from view, afloat and alone on a breathless and rayless river.[14]

The names of the rivers (Styx, Echo, and Lethe), the attribution of the name Charon to Stephen, the initiation into the mysteries of the cave by a guide possessing extraordinary powers, the processions of tourists passing through its solemn precincts, the

need to squeeze through narrow passages, and the difficulty of the journey to the cave all bespeak a rich religious symbolism and suggest that visiting Mammoth Cave possessed ritualistic meaning. This religious symbolism was reinforced by the way tourists actually experienced a distinct division between the world above ground and the cave itself. In summer cool air rushes out of the cave and in the winter it rushes in. When you enter the cave you pass a palpable barrier between two climates. Near the entrance to the cave you can step in and out of the cool stream of air flowing out of the cave close to the ground. The air in the cave has no odor and after spending several hours in the cave, visitors noted the shock of breathing again the atmosphere above ground, laden with "the rank odors of the vegetation."[15] Some found this sensation oppressive. To Taylor the air outside seemed "like that of an ill-ventilated greenhouse in Winter."[16] But to others the return to the world of green and living things was exhilarating, part of the regenerative experience of visiting the cave. "To me," wrote Willis, "the strongest sensation of 'rising again' was the luxury of once more being in the world of things to *smell.* . . . I walked to the hotel . . . enjoying the perfume of the pines, hemlocks, and moist earth, with a zest worthy of the first breath at a thrown-up window in the morning."[17]

Once tourists had crossed the threshold of the cave, they entered an atmosphere which never changed. The temperature stands at a nearly constant 54 degrees and the air is pure and dry. In this atmosphere, nothing in the cave decayed. The wooden pipes and vats used in the manufacturing of saltpeter during the War of 1812 remained preserved where they had been and, in fact, can be seen today. Since there was no wind or rain to disturb them, wagon tracks and the footprints of the oxen who pulled them remained visible. The fire beds and brands of cane left there by the Indians also remained, and the Indian mummy that became identified with the history of the cave had not been embalmed bu had slowly dried, unaffected by the agents of decay in the work above ground.

People believed that the purity and dryness of the air, the uniformity of temperature, and the presence of nitrates in the cave promoted well-being. Like the sacred spaces of archaic religions, America's nineteenth-century tourist attractions were frequently cited for their healing powers, and this was particularly the case with Mammoth Cave. Dr. Robert M. Bird wrote in *The American Monthly Magazine* that the saltpeter miners who suffered from some illness when they went to work in the cave were soon cured.[18] When Dr. Croghan took over management of the cave, he con-

structed stone cottages in it and invited consumptives to take up residence there. Several of them died in the cave or soon after they left, and the project was abandoned. "The attempt to bury people in order to preserve them had been unsuccessful," reported a writer for *The Knickerbocker*.[19] The cottages remained, embellishing the cave with mournful associations for future tourists: "Imagine the long hours round those lurid stones in that great sarcophagus," suggested one writer, "the nightmare dreams, the spectral-creeping sense of alarm and isolation, the slowly-fading hopes as the chances of recovery began to recede into the darkness."[20] Although this experiment failed, people continued to believe in the vitalizing effects of the cave atmosphere. People didn't get tired in the cave. Women could perform feats of exertion which astounded nineteenth-century gentlemen.

In a place without sunlight, without the sounds and smells of nature, without wind or rain, where the temperature never varied and matter did not decay, tourists felt they had taken farewell of their everyday lives and entered "a world to itself."[21] They left behind both the natural cycles of day and night and the mechanical time of clocks. The time of the cave was, in a sense, paradisiac time. "Time ceases to be," wrote Taylor, "no thought of labor, no sense of responsibility, no twinge of conscience, intrudes to suggest the existence you have left."[22]

Like Niagara Falls Mammoth Cave had no equal. It was, reported Bird, "the monarch of caves; none that have ever been measured can at all compare with it even in extent; in grandeur, in wild, solemn, severe, unadorned majesty, it stands alone. 'It has no brother, it is like no brother.' "[23] The cave represented, moreover, in Eliade's terms, "a break in the homogeneity of space." "This break," writes Eliade, "is symbolized by an opening by which passage from one cosmic region to another is made possible (from heaven to earth and vice versa; from earth to the underworld)." Such places put all three worlds in communication with each other. "Being an *axis mundi*, the sacred city or temple is regarded as the meeting point of heaven, earth, and hell."[24] Visitors to Mammoth Cave associated it with all three regions. First, the enormous halls of the cave reminded people of Gothic churches— the giant domes of St. Sophia, St. Peter's, and St. Paul's, or "the moorish domes in the Alhambra"[25]—and the structure of the walls and ceilings of columns, arches, pilasters, friezes, and cornices. Two-hundred-foot-high Gorin's Dome appeared to one writer as "a sharp cone, ribbed like a groined vault, and polished by that persevering architect, water."[26] Traditionally the cathedral "reproduces the Celestial Jerusalem" or paradise, and this belief clings to

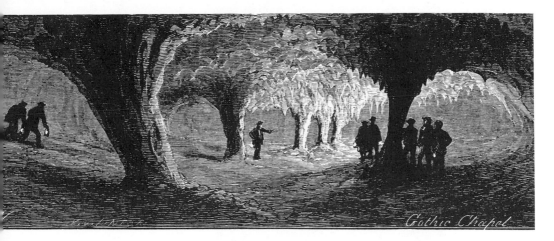

Alfred R. Waud, "Gothic Chapel," vignette from *Scenes in Mammoth Cave*, from *Picturesque America*, II, 1874. (Courtesy of Vassar College Library)

the natural cathedral of the cave.[27] In Mammoth Cave America might not only boast of architectural wonders which made the man-made creations of the Old World appear puny, but of sanctuaries which were closer to heaven because God created them. "What are the galleries of the Vatican, the Louvre, Versailles, and the Crystal Palaces of London and Paris to this gigantic vault hewn in the living rock?" wrote Taylor in describing the Main Cave. Exploring the cave seemed to Willis "like a visit to a just created and more brilliant planet, where God has not yet said, 'Let there be light,' but where Adam and Eve for whom a sun is to shine on this darkness, are to find themselves lodged in ready-built palaces, gem-studded and crystal roofed—a dwelling house growing wild like an apple-tree."[28] It was as if he had fulfilled the ancient religious dream described by Eliade, the desire *"to live in a pure and holy cosmos, as it was in the beginning, when it comes fresh from the Creator's hands."*

Although the sacred city or temple imitated the heavenly or paradisiac world, it was built over the underworld. "The rock of the Temple in Jerusalem," writes Eliade, "reached deep into the *tehom*," which symbolized the "chaos of waters," and the "world of death."[29] Thus it is not surprising to find the gloomy halls and domes of Mammoth Cave evoking images of Hades. Willis wrote that the scenery of the cave could furnish material for a new Dante's *Inferno*: "It is a Western prairie of imagination—still wild and unoccupied."[30] Entering the cave recapitulated the descent of classical heroes into the underworld. Among its attractions, the

*Mammoth Cave—In "The Devil's Arm-Chair,"* from *Scribner's Monthly,* 1874. (Courtesy of Vassar College Library)

cave included Purgatory, the Devil's Armchair, the Bottomless Pit, the River Styx, and the River Lethe. Its landscape provoked references to Milton's description of "chaos and ancient night."[31] Illuminated by sulfurous Bengal lights, the hall known as Chief City appeared to Taylor like "Martin's picture of Satan's Council-Hall in Pandemonium."[32]

Mammoth Cave's sublimities were those of the underworld. Among the conditions Burke mentioned as evoking the emotion of sublimity in addition to the great size and power of objects like Niagara Falls, were obscurity (we cannot perceive the bounds of an object, and privation (vacuity, darkness, solitude, and silence).[33] Since the lamps which the tourists carried with them and the pieces of oiled paper and burning lengths of cane the guides tossed into the corners of the cave only penetrated a small part of the darkness, the nineteenth-century tourists did not see the larger chambers of the cave clearly. The obscurity of their boundaries exaggerated their size and made them mysterious. Even the brighter Bengal lights illuminated the halls and domes only momentarily in a lurid blue smoky light. At some point in the tour, the guide would extinguish all lights in order to allow the visitor to experi-

ence absolute darkness. "How little I ever before conceived of blindness!" wrote "Barnwell," the author of an article on Mammoth Cave that appeared in *The Knickerbocker*. "Oh! the oppressive, stunning weight! the feeling of unknown, unavoidable, invisible danger!"[34] Some visitors enjoyed the Gothic thrill of such darkness: "The very air seems petrified—condensed into a stratum of coal, in which we sit encased like toads or insects."[35] Moreover, it was so quiet in the cave that, as Willis put it, "The grass must stop growing, and the stars hold their breath, to give you, above ground, any idea of that silence."[36]

This kind of sublimity often horrified rather than inspired. Ward wrote that "to be buried several miles in the dark recesses of this awful cavern" produced in him "a shivering horrour [sic]."[37] The

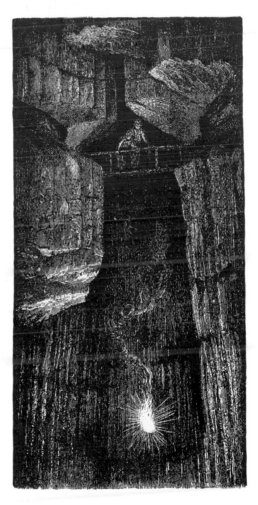

*The Bottomless Pit, Mammoth Cave, from Scribner's Monthly,* 1880. (Courtesy of Vassar College Library)

sensation of being buried alive evoked by the darkness, silence, confinement, and dirtiness of the cave caused Lady Emmeline Stuart Wortley, an English poet and playwright, to remark that when you leave the cave you need to "ungravelize one's self; in short, to carry off a little of the superabundant earthliness that one feels has been acquired by walking below ground, where should be nothing but graves and gas-pipes, and cellars and worms, and Guy Fawkeses, and sorcerers and mummies, and trains of gunpowder, and fossil Ichthyosauruses."[38]

The nineteenth-century tourist associated the chambers of Mammoth Cave not only with cathedrals and Hades, but, most important, with creation. The cave naturally aroused curiosity about its origin. What forces had created its long winding passages, domes, gypsum crystals, stalactites and stalagmites, and when? In archaic societies it was the function of myth to tell how something had been created. "Myth," Eliade writes, "tells how, through the deeds of Supernatural Beings, a reality came into existence, be it the whole of reality, the Cosmos, or only a fragment of reality."[39] By the nineteenth century science had begun to assume some of the function of myth, and before the publication of Charles Darwin's *Origin of Species* (1859), the science which functioned most successfully in this way was geology. Geology reigned as the supreme science, the field of scientific inquiry that seemed most capable of yielding conclusions about the ultimate nature of the universe. After Darwin, it would be succeeded by biology and later physics, but in the first half of the nineteenth century, it was geological theories that most stimulated the minds of educated people. Geology furnished nature with a history. It suggested the world was far more ancient than people had formerly thought and that prodigious geological forces had transformed it in startling ways over time. Alexander von Humboldt, whose *Cosmos* excited the imaginations of many people about the physical history of the earth, wrote that we cannot understand the present state of inorganic things "without looking back on the mode of their formation. It is not organic matter alone that is continually undergoing change and being dissolved to form new combinations. The globe itself reveals at every phase of its existence the mystery of its former conditions." Thus geological formations "animate the scenery by the associations of the past which they awaken—acting upon the imagination of the enlightened observer like traditional records of an earlier world. Their form is their history."[40] The gorge of the Niagara River below the Falls told the story of their gradual recession over time as they wore their way upstream toward Lake Erie

and this story was recorded in the nineteenth-century guidebooks along with other aspects of Niagara's history.

Many of the travel writers who visited Mammoth Cave before 1860 echoed the theories of the catastrophist school of geology and attributed the formation of the cave to some sudden, violent cause like the Deluge or an upheaval of the strata: "The whole country is one bed of limestone, with as many caverns below as there are hills above, both seeming to have been formed at the same moment, and by the same cause, some primeval convulsion by which the rocky substratum was torn to pieces, and the knobs heaped up."[41] At least by 1849, however, Bishop had absorbed the alternative and correct theory from one of the visiting geologists and was reporting to tourists that the cave was " 'caverned out' by a stream." It was difficult for people to believe that water alone could excavate such enormous quantities of rock. Barnwell's companion remains convinced that the cave was caused by "some great uprising of nature," despite Stephen's assertion.[42]

The debate between the two theories wasn't settled even among geologists until later on, but the prevailing view was stated by Benjamin Silliman, Jr., in 1851, who wrote that the agent which formed the cave was "decidedly *water* and no other cause."[43] This idea of gradual change could appeal to the imagination as effectively as the notion of a violent eruption. Geologists, reported W. P. Fishback in the *Indianapolis Daily Journal* in 1871 in a lucid summary of the uniformitarian theory, "find conclusive evidence that the same agencies are at work and the same changes in progress to-day that have been slowly, steadily and quietly, through vast periods of time, accomplishing the marvelous wonders that now astonish the beholder."[44] Even those who held to the violent theory of the origin of the cave itself, agreed that it was the slow action of water over a long period of time that created the gypsum formations and the stalagmites and stalactites in the cave.

Tourists enjoyed the idea that they were observing the creative energies of nature at work when they visited Mammoth Cave. "I saw something of the process of creating the natural globe in the depths of the largest explored cave in the world," wrote Harriet Martineau. "In its depths, in this noiseless workshop, was Nature employed with her blind and dumb agents, fashioning mysteries which the earthquake of a thousand years hence may bring to light."[45]

The sense of the enormous amounts of time needed to produce even one small roseate of gypsum or a stalactite continued to fascinate tourists throughout the nineteenth century. "Try to think for

43

a moment of a million years;—ten thousand times as long as the centennial of our American independence!" wrote Ralph Seymour Thompson in 1879. "And yet those who have studied it most carefully consider that the formation of the Mammoth Cave must have occupied much more than a million years, and any one who will stop for a moment and consider the process of growth, notice that these great pillars of solid rock can only be formed by the very slow dropping of clear water, will recognize at once the immensity of time that must have been required for their formation."[46]

The eyeless fish that inhabited the underground rivers of Mammoth Cave added a biological mystery to its geological wonders. To some they exemplified "divine skill" which, "economical in all its workings," had "denied them organs which would here have been useless."[47] Later, after the publication of the *Origin of Species*, they became the object of scientific debate. Had these fish lost their eyes in direct response to the total darkness in which they moved, or through the process of natural selection described by Darwin?

Although Mammoth Cave possesses some stalagmites and stalactites, its most striking features are its other forms of redeposited limestone—columns, drapery, and flowstone—in varying shades of white, red, yellow, orange, and black; and, particularly, its displays of gypsum crystals which assume a rich variety of forms. The gypsum crystals seem to recreate the forms of living nature. Ralph Waldo Emerson, whose visit to the cave inspired the evocative opening of his essay "Illusions" (ca. 1851), wrote of the crystals: "I remarked especially the mimetic habit with which nature, on new instruments, hums her old tunes, making night to mimic day, and chemistry to ape vegetation."[48] Taylor found Cleaveland's Cabinet, one of the most popular chambers of the cave, to be "a subterranean conservatory fitted with the flowers of all the zones, for there are few blossoms expanding on the upper earth but are mimicked in these gardens of Darkness."[49] The cave appeared to be a womb of all creation where, like the sacred center described by Eliade, there was "the prodigious outpouring of energy, life, and fecundity that occurred at the Creation of the World."[50]

Writers never attributed any moral influence to Mammoth Cave the way they did to Niagara Falls. Its sacred function expressed itself instead in the way it instilled a festive mood in people, as if they partook of the creative energies that had produced it and were still at work in its chambers. When people visited the cave, they let their fantasies loose. Aside from descriptions of Hades, there were no precedents for looking at the cave's underground

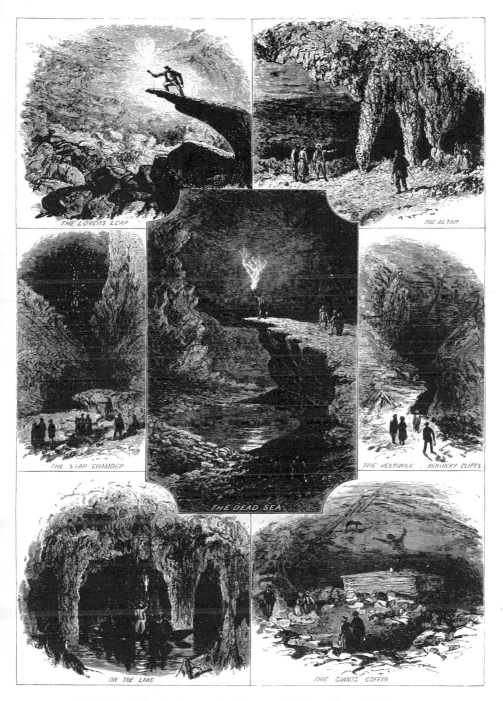

The images are labeled: THE LOVERS LEAP, THE ALTAR, THE STAR CHAMBER, THE DEAD SEA, THE VESTIBULE . KENTUCKY CLIFFS, ON THE LAKE, THE GIANTS COFFIN

Alfred R. Waud, *Scenes in Mammoth Cave*, from *Picturesque America*, II, 1874. (Courtesy of Vassar College Library)

scenery, no literature or paintings of similar sights to use to shape it into a composition. As a place that recreated the world out of different materials, it could only be related to other places through analogy. The gypsum and limestone formations provoked a passion among visitors to discover likenesses. Analogies tumbled out of people. "In one place," wrote Taylor, "there is a huge ant-eater, very perfect; in another an Indian chief wrapped in his blanket; then a giant, with his wife and child; finally, a charcoal sketch, in which the imaginative can see Napoleon crossing the Alps."[51] In Martha's Vineyard people saw bunches of stone grapes, and in the Bacon Room, hams, hanging from the ceiling. Others found resemblances to such things as vanilla cream candy and umbrellas. Like Henry Thoreau observing the melting bank of sand and clay in the "Spring" chapter of *Walden*, people were "driven for analogies," as Alexander Clark Bullit put it.[52]

The imaginations of visitors overflowed into an orgy of naming as well. The names of the different parts of the cave have now been fixed, but in the nineteenth century new names kept being added as new parts of the cave were explored or tourists identified new features in the known parts of the cave. Some names didn't stick, were replaced by other names, or simply forgotten. By discovering resemblances or, like Adam in Paradise, naming the features of the cave, tourists joined in creating the cave. The names visitors used reflected the most common analogies they made between the cave and the world above ground: the architecture of the Old World (particularly cathedrals and temples), the journey to Hades or the afterlife, and the organic forms of nature. Sometimes the names recorded an incident in the cave's history. In addition to those already mentioned, the chambers of the cave included: Cascade Hall, the Great Western, Ole Bull's Concert-Room, the Pass of El Ghor, Hanging Rocks, Black Hole of Calcutta, Elindo Avenue, Washington Hall, the Rotunda, Kentucky Cliffs, Gothic Galleries, Infernal Regions, and Bunyan's Way, to name only some of them. Sometimes the names expressed a desire to secure a bit of immortality by having some feature of the cave named after the visitor or a sweetheart.

The playfulness of finding analogies and inventing names found expression in other forms of behavior, too. John Burroughs amuses himself by wading in and out of the "fountain" of cool air as it rose out of the cave and flowed down the hill toward Green River.[53] Visitors noted that the air of the cave induced high spirits and exuberant emotions. "The pure air of the cavern now began to act upon our frames," wrote Henry Howe, "and rendered us buoyant and elastic to a high degree. We could not repress our ex-

uberance of feeling, and ran, jumped, and halloed, like boys just let out of school."[54] As they floated on underground Echo River, visitors and guides shot off pistols, let out Indian yells, slapped the water with their paddles, or played the zither. Then they listened to the wild reverberations these sounds set in motion. Bishop could create a chorus with the echoes, reported Taylor, singing in "a voice marvellously sweet, but presently joined by others sweeter still, taking up the dying notes ere they faded into silence, and prolonging them through remoter chambers."[55] Among the songs which guides or visitors sang while in the cave were: "Rock of Ages," "Wake up, Mose!," "Last Rose of Summer," "Dixie," "Home Sweet Home," and "O! Susanna." When the famous singer Jenny Lind visited the cave, she entertained visitors by singing in its reverberating halls. The guides liked to play on the emotions of visitors by manipulating the sights and sounds of the cave. After setting up a savage howling and screaming, wrote Barnwell, "the guide struck up a familiar negro melody of the South, . . . at once converting our feelings into those of hysterical mirth. We knew the chorus, and rarely did those subterranean labyrinths ring to a merrier peal poured forth by more powerful voices."[56]

Some writers complained about the way the proprietors of Kaaterskill Falls dammed the stream at the top of the falls to increase its volume and then released it for tourists who paid a fee to see a simulation of the way the falls looked after the spring thaw. But such manipulations of the scenery seemed to tally perfectly with the character of Mammoth Cave. There was no "natural" way to see or hear the cave since its natural state was absolute darkness and absolute silence. The cave had to be "created." The high point of the cave tour was the moment in the Star Chamber when the guide took away the visitors' lamps. "On looking upwards," Emerson reports, "I saw or seemed to see the night heaven thick with stars glimmering more or less brightly over our heads, and even what seemed a comet flaming among them. All the party were touched with astonishment and pleasure. Our musical friends sung with much feeling a pretty song, 'The stars are in the quiet sky,' etc."[57] This illusion of stars was caused by crystals of gypsum shining through a layer of black oxide of manganese on the ceiling of the cave and catching the light of a concealed lamp. After this revelation of new heaven, the guide moved the hidden lamps still further away, leaving the visitors in utter darkness. "Such must have been the primal chaos before Space was, or Form was, or 'Let there be light!' had been spoken," wrote Taylor. Finally, the guide imitated the crowing of a cock and "After a while a golden

nebulous glow stole upon the darkness, seemingly brighter than the sunrise radiance of the East, and increased until our guide and lamps rose above the horizon."[58]

As artificial as this was, it represented a survival of the ancient, annual rites in which the world comes symbolically to an end and is created anew. The touristic version of this ritual made Emerson uneasy: "I own I did not like the cave so well for eking out its sublimities with this theatrical trick," he wrote. But he admitted that this illusion was "the best thing which the cave had to offer." Moreover, he transformed the experience into a new myth of creation by making it a metaphor for the way our "senses interfere everywhere and mix their own structure with all they report of." For him Mammoth Cave demonstrated the role of our senses in creating the world we see. "In admiring the sunset we do not yet deduct the rounding, coordinating, pictorial powers of the eye."[59]

Among the attractions which the nineteenth-century tourist visited, Mammoth Cave seemed particularly suited to meeting the persistent need for sacred spaces that churches, cities, and other centers of earlier times had provided. It was the largest explored cave in the world. Its features and the way they were manipulated suggested images of Hades, Heaven, and the creation of the world. The time it had taken to make the cave and all its formations seemed cosmic in its duration. When visitors entered the cave they entered a mysterious other world, a chamber of creative energy, and returned from it revitalized. Finally, the desire for religious inspiration and the desire for recreation, which sometimes came into conflict at Niagara Falls, were perfectly integrated at Mammoth Cave.

# ৯ু *Three*

## Panoramas of American Civilization:
## The Connecticut and the Hudson

WHEN NINETEENTH-CENTURY Americans visited the Old World
they expected to encounter the great productions of European
civilization—its paintings, sculpture, cathedrals, and other works
of art—and to immerse themselves in its history by visiting the
places where important historical events had taken place. When
they traveled in the United States, on the other hand, they turned
toward a world which the European cultural tradition had only
begun to touch. America had an abundance of wild scenery, but
few works of architecture and art, and very little history.

The Connecticut and Hudson river valleys were among the
earliest tourist regions in the United States not only because they
offered varied views of mountain, plain, and river and were easily
accessible to the country's centers of population, but because they
featured the most civilized of American landscapes. Niagara Falls
and Mammoth Cave, whose scale Europe could not match, offered
tourists samples of the magnificence of Nature in the New World;
the Connecticut and the Hudson river valleys offered them domes-
ticated, even refined landscapes that reflected the progress of
America in meeting European standards of culture. Both valleys
had been settled early and the fertile lands along their banks had
been cultivated for a long period of time. Their scenery included
prosperous farms, fine homes, and thriving villages, as well as
dramatic mountain views. Much of this scenery embodied the
pastoral ideal of rural peace and prosperity which, as Leo Marx
pointed out in *The Machine in the Garden*, appealed to the
imagination of many educated Americans. Its special importance
for the tourist lay in the fact that the Connecticut and Hudson
valleys were among the few places in the United States where

W. H. Bartlett, *View of Hudson City and the Catskill Mountains*, from *American Scenery*, 1840. (Courtesy of Adriance Memorial Library)

Americans might hope to match the cultivated landscapes of the English countryside, celebrated by English poets and painters and admired by lovers of picturesque scenery. Moreover, the villages had a history of pioneer struggle and wars with the Indians, the French, and the British. That history was now behind them, and although it was nowhere near as long or rich as the history of many English villages, it gave them a faint aura of antiquity.

If the varied landscapes of the Connecticut and Hudson river valleys nicely satisfied the requirements of picturesque scenery, they also mirrored the experience provided by a new and popular form of art: the cycloramas, and panoramas exhibited in Europe and America during the nineteenth century. The cycloramas, dioramas, and panoramas consisted of a series of paintings depicting a particular place which were either mounted on the walls of a circular room which the spectator walked around or were made to move in front of him as he remained stationary. It is fitting that Robert Fulton brought the first diorama to Paris in 1800, giving Parisians a chance to view the scenery of the New World in de-

tail,[1] for this technological innovation in art neatly matched his contribution to the field of transportation in the form of the steamboats he introduced a few years later. While the steamboat transformed the Hudson and other scenic waterways into living panoramas, the panoramas themselves provided the illusion of travel. Panoramas also conveyed information about strange and distant places. Their tremendous success is itself an indication of the cultural importance of tourism during this period. Panoramas were democratic in their easily understood format and cosmic in scope. The geographer, Alexander von Humboldt, wrote in his influential work *Cosmos* (1849): "Panoramas are more productive of effect than scenic decorations, since the spectator, enclosed as it were within a magical circle, and wholly removed from all the disturbing influences of reality, may the more easily fancy that he is actually surrounded by a foreign scene." Like Mammoth Cave, the panorama provided the sensation that the tourist seemed to be looking for of being no longer in the mundane world, but in the presence of the sacred. "I am of the opinion," Humboldt went on, "that the knowledge of the works of creation, and an appreciation of their exalted grandeur, would be powerfully increased if, besides museums, and thrown open like them, to the public, a number of panoramic buildings, containing alternating pictures of landscapes of different geographical latitudes and from different zones of elevation, should be erected in our large cities."[2]

In fact, a museum had opened in Paris for the sole purpose of displaying dioramas. One of its founders was Daguerre, who later became a pioneer in the field of photography. Other cities, including New York, followed suit. For many Americans, panoramas provided their first extensive view of such features of the American landscape as Niagara Falls and the Mississippi River. John Rowson Smith painted the first panorama of the Mississippi in 1839 and seven more panoramas of the river were produced between 1845 and 1850. The most famous of these was designed by John Banvard and was three miles long. Godfrey Frankenstein's 9' × 1,000' moving panorama of Niagara Falls constructed in 1853, which consisted of 100 different views and went on tour throughout the United States in the mid-1850s, was the most heralded depiction of the falls before Frederic Church painted his *Niagara* in 1857.[3] These works both informed Americans of the nature of these places and encouraged the touristic habit of consuming scenery as a series of views, a habit which would be reinforced later on by the stereoscope and the kodak.

The panorama reinforced the interest in geography stimulated by Humboldt and by the reports of travel writers and explorers. It

expressed the excitement that people felt at the increased oppor-
tunities for travel which the new transportation technology was
making possible. Like the art, geography, and travel literature of
the period, the panorama embodied a desire to embrace the full-
ness and variety of creation. It also fitted very well into the cul-
tural enterprise to which tourism was so central: the process of
identifying, naming, and illustrating scenic attractions and estab-
lishing a common national geography in which certain places, like
the Connecticut and Hudson river valleys, would come to charac-
terize America. As one anonymous commentator put it:

> Panoramic exhibitions possess so much of the magical deceptions
> of art, as irresistibly to captivate all classes of spectators, which
> gives them a decided advantage over every other description of
> pictures; for no study or cultivated taste is required fully to ap-
> preciate the merits of such representations. They have the further
> power of conveying much practical, and topographical informa-
> tion, such as can in no other way be supplied, except by actually
> visiting the scenes which they represent, and if instruction and
> mental gratification be the aim and object of painting, no class of
> pictures have a fairer claim to the public estimation than pan-
> oramas.[4]

If panoramas were democratically instructive, they were also the-
atrical. They assumed that scenery, like drama, could entertain.
"The panorama," writes Barbara Novak, "with its geologic and
scientific certitudes and overtones of documentary edification, was
a careful visual encyclopedia of travel fact. It made little pretense
of being anything but a kind of theatricalized *National Geo-
graphic*."[5] The panorama was also very well suited to capturing the
epic qualities of America because of its large scale and capacity to
document the details of vast landscapes.

Panoramas mimicked the actual experiences of tourists moving
through the landscape and complemented the descriptions by
travel writers which prepared tourists for those experiences. A river
valley lent itself particularly well to panoramic experience and
description because the river furnished a linear element along
which a series of scenes could be viewed either from the river
itself, as the tourist moved along it by boat, or from an elevated
point above the river. The Connecticut Valley was one of the first
places in the United States to be appreciated in these panoramic
terms.

For Timothy Dwight, whose *Travels in New England and New
York* (1821–22) helped establish many of the major attractions

on the American Grand Tour, and other writers the Connecticut
embraced the best which American civilization could offer. Dwight
said of the Connecticut that no river in the United States or pos-
sibly in the world was more remarkable for "those objects which
arrest the eye of the painter and the poet. . . . The beauty and
the grandeur . . . are finished by a hand operating in a superior
manner." The varied beauty of the river's banks in which the
rough and the smooth were nicely intermixed and contrasted con-
formed prefectly to the picturesque ideal: "Here a smooth and
winding beach, there covered with rich verdure, now fringed with
bushes, now crowned with lofty trees, and now formed by the
intruding hill, the rude bluff, and the shaggy mountain."[6]

But Dwight's concerns were not purely aesthetic. The pattern
of settlement revealed in the landscape reflected America's reli-
gious and political achievements and were of equal importance to
the picture made by the scene: "The numerous towns, villages,
and hamlets almost everywhere exhibiting marks of prosperity
and improvement, the rare appearance of decline, the numerous
churches lifting their spires in frequent succession, the neat school-
houses everywhere occupied, and the mills busied on such a multi-
tude of streams."[7] He valued these elements not for their pic-
turesque effect but because they added up to the pious, educated,
and prosperous New England village that in Dwight's view was
the cornerstone of America's well-being.[8]

Dwight disliked the scattered farms and the freer and more
democratic ways of the frontier. He rejected the Jeffersonian ideal
of the self-sufficient farm and admired instead the New England
village built around a church and school and set in a domesticated
landscape. In this respect he was carrying on the tradition of his
forebears. Like the Puritan historian Edward Johnson before him,
Dwight felt that the battle against the wilderness should be waged
town by town, rather than on an individualistic basis, so that con-
tinuity with the ideas and patterns of the original New England
settlements would be insured.[9] This version of pastoral social order
harmonized perfectly with the picturesque.

Dwight helped to establish Mount Holyoke, situated near North-
hampton, Massachusetts, as the most famous tourist attraction in
the Connecticut Valley. It provided, he wrote, "the richest pros-
pect in New England, and not improbably in the United States."[10]
Viewing the landscape from a hill or mountain like Mount Holy-
oke had its roots in the English landscape tradition. It was encour-
aged by English prospect poems, like John Denham's "Cooper's
Hill" (1640) and John Dyer's "Gronger Hill" (1726), in which
the poet meditates on a familiar landscape from an elevated posi-

53

tion. Dwight had imitated the form in "Greenfield Hill" (1794), a description of the Connecticut town and surrounding country-side where he had his first ministry. Looking at nature from a high place insures the aesthetic and emotional distance which the picturesque required. It enables the observer to take in a large stretch of open country and remain outside of nature, master of what he surveys. It is the position of the spectator in the gallery, the same position assumed by visitors to the cycloramas or pano-ramas, but it is also a position slightly elevated above the mun-dane, a faintly sacred point of vision that recalls Moses's view of the Promised Land from Mount Pisgah.[11]

The prospect from Mount Holyoke displayed both the elements of picturesque beauty which Dwight delighted in and the evidence of economic prosperity and social order that indicated to him a

Thomas Cole, *View from Mount Holyoke, Northampton, Massachu-setts after a Thunderstorm (The Oxbow)*, 1836. (The Metropolitan Museum of Art, Gift of Mrs. Russell Sage, 1908)

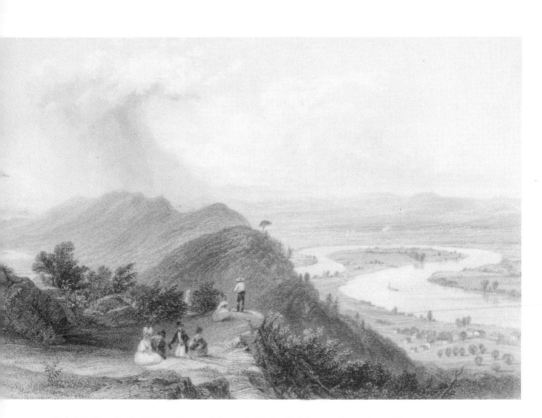

W. H. Bartlett, *View From Mount Holyoke*, from *American Scenery*, 1840. (Courtesy of Adriance Memorial Library)

high degree of civilization. The fields along the fertile intervals of the river were "formed like terraced gardens" and planted with a variety of crops. "A perfect neatness and brilliancy is everywhere diffused," wrote Dwight, "without a neglected spot to tarnish the luster or excite a wish in the mind for a higher finish."[12] The Connecticut River itself meandered back and forth through this tidy, domesticated landscape, forming just below the mountain the double bend which became known as "the Oxbow." Towns and churches dotted the landscape, forests provided a contrast to the open land, and mountains lent grandeur to the scene.

Elevated positions, like the summit of Mount Holyoke, allowed the tourist to encompass an entire civilization of towns and farms in one view, but they also offered opportunities for a more exciting form of touristic experience. From such commanding vantage points, the landscape could become a theater. In Vermont Dwight watches a magnificent storm from a hill looking out at a long stretch of the Green Mountain range. He and his friends are safely

sheltered in a building and, despite the wild disorder without, they have the sensation of watching something "slow, majestic, and awful." The deep gloom that the storm at first brings with it is suddenly broken up by the sun appearing through the gaps in the clouds and forming "brilliant spots of gold of various figures and sizes" which move across the valley floors and up the sides of the mountains. Dwight describes this scene as if he were watching a painting in motion, noticing as he does so how the wilder elements are balanced off against the beauty of the light. The scene is cosmic in its scale and dramatic effect. What "interested the eye," he says, was the "contrast between the gloom and the splendor" and between the vivid beauty of the spots of light and "the wild and violent aspect of all above and beneath." Dwight finds the "prospect" the most "striking" and "complete" he has ever seen.[13]

Thomas Cole's 1836 painting, *View from Mount Holyoke* (*The Oxbow*), which celebrated the famous view of the Connecticut, adopted a similar perspective on the landscape. Nathaniel Willis's description of the view from Mount Holyoke in *American Scenery* (1840), which closely echoes Dwight's, is accompanied by a print by William H. Bartlett showing a group of tourists contemplating the picturesque scene. Cole, however, strips away the tourists and opts to take advantage of the theatrical possibilities of the prospect. The right half of the painting shows the bend in the river and the broad, well-cultivated fields along its banks brightly lit by the sun. The left half depicts a heavily forested mountain, topped by a blasted tree and the dark clouds of a receding storm. Like Dwight's word-painting of the scene in the Green Mountains, Cole's painting juxtaposes the sublime and the beautiful in a dramatic panorama of the Connecticut Valley.

By the time Cole painted *The Oxbow*, the ascent of Mount Holyoke had become a regular feature of the American Grand Tour. It is a "fashionable climb for tourists, whose patronage of ginger-beer and sunrises maintains a shanty and a hermit on the top," wrote Willis.[14] It was typical of nineteenth-century tourist attractions that they could both satisfy the superficial needs of tourists—a fondness for ginger beer, sunrises, and hermits—and evoke the deeper reponse to the sacred qualities of Nature represented by Cole's painting.

Although the Connecticut Valley was an important part of the nineteenth-century tourist's itinerary, the Hudson Valley was the most important segment of the Grand Tour. As an arm of the sea, the Hudson provided the only navigable waterway on the

Atlantic seaboard that penetrated the barrier of the Appalachian mountains. Partly because of this, the river was of great strategic importance during the early wars between the French and British colonies in North America and was closely associated with the events of the American Revolution. The opening of the Erie Canal in 1825 established the river even more firmly as a gateway to the American continent. The Hudson also led to Saratoga—the nation's most fashionable watering place—to Lake George, and, via the Erie Canal, to Niagara Falls, America's most popular tourist attraction.

Not only the Hudson's position as the principal entrance to the interior of the country, but the nature of its scenery made it a symbol of America's power and mythic promise as a nation. Until the discovery of Yosemite and Yellowstone, only Niagara Falls surpassed the Hudson River in symbolic importance. "It chances felicitously that the traveller's first entrance beyond the sea-board is usually made by the steamer to Albany," wrote Nathaniel Parker Willis. "The grand and imposing outlines of rock and horizon answer to his anticipations of the magnificence of a new world."[15]

As a rich and dramatic panorama, the Hudson River had no peer, at least in the United States. It was much more open to navigation than the Connecticut, and most tourists who set out to see its scenery did so by steamboat. This means of travel allowed them to enjoy the landscape as it passed before them like a moving panorama. William Wade's *Panorama of the Hudson River from New York to Albany* (1845)—a narrow map, measuring twelve feet when folded out and showing both sides of the river—embodies this way of experiencing the river's scenery.[16] Wade's panorama located mountains and other scenic features—as well as the towns, steamboat landings, and ferry slips—along the river. Turned one way it allowed the tourist to identify all the sights on the eastern shore as it unrolled before him on the deck of a steamboat, turned the other he could identify those on the western shore. Wade's map underscores the revolution in sightseeing brought about by the new transportation technology. People on foot or horseback tend to look forward, and a carriage on a bad road provides limited opportunities for viewing scenery. The canal boat, the steamship, and the railroad, on the other hand, allow passengers to turn their attention to the passing scene as it unrolls rapidly, and almost magically, parallel to the direction of travel. As a form of art, the panorama was the perfect complement to this new sensation.

The scenery of the Hudson River which passed in front of the steamboat traveler was exceedingly varied. The many travelers

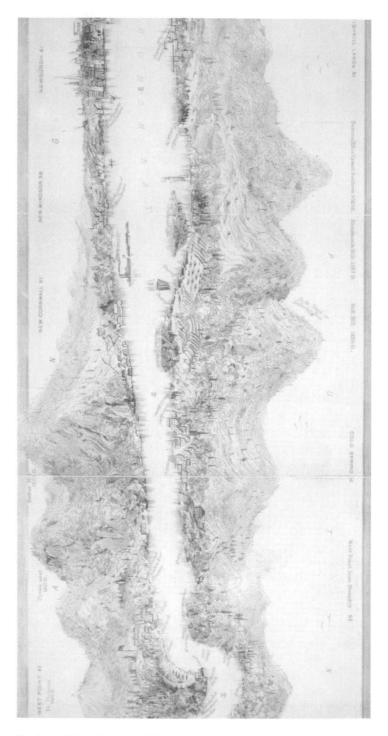

Hudson River between West Point and Newburgh, from William Wade's *Panorama of the Hudson River from New York to Albany* (1845). (Courtesy of Vassar College Library)

who recorded their impressions of the river in the nineteenth century emphasize the diversity of the Hudson's visual imagery: its rough, sometimes wild mountains, as in the Highlands; its orchards and farms; its cities and towns; and even the industries along its banks. As Fanny Kemble, the English writer and actress, wrote when she visited the Hudson Valley in 1832: "At every moment the scene varied; at every moment new beauty and grandeur was revealed to us."[17] The river expands and contracts, the shores rise and fall, the landscape appears at times wild and rugged, at times tame and well-cultivated. Wade's panorama shows villages, brickyards, quarries, and estates lining the river's shores. Sometimes cliffs thrust themselves straight out of the river, sometimes cultivated fields reach almost to the river's edge; in some places the river stretches out as far as the eye can see, at other times sharp bends in the river block the view. The satirical James Kirke Paulding assumes his most reverential style when writing of the pleasure of a voyage up the Hudson and captures the sense of liberation and wonder that the new age of travel evoked. The

Harry Fenn, *West Point and the Highlands*, from *Picturesque America*, II, 1874. (Courtesy of Vassar College Library)

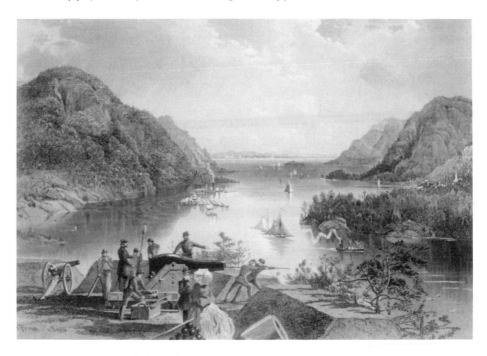

novel sensation of movement and change, which would not be equaled again until the invention of the cinema, was created by the steamboat. Thus, in one sense, the scenery was, like the panorama, artificial. A trip up the Hudson combined the thrill of the new technology with a delightful new perspective on nature. The traveler, Paulding says of the steamboat passenger on the Hudson,

> may indulge himself in contemplating the beautiful world expanding every moment before him, appearing and vanishing in the rapidity of his motion, like the creations of the imagination. Every object is beautiful, and its beauties heightened by the eye having no time to be palled with contemplating them too long. Nature seems in merry motion hurrying by, and as she moves along displays a thousand varied charms in rapid succession each one more enchanting than the rest.

The "long mural precipice" of the Palisades, "looking like the fabled creations of the giants," contrast with the "long graceful curving hills" of the eastern shore "animated with all the living emblems of industry; cattle, sheep, waving fields of grain, and whistling ploughmen."[18] Bayard Taylor, who, as a well-known world traveler, had the authority to pronounce on the relative merits of the many landscapes he had seen, wrote in 1860 that "there is one river which, from its source to the ocean, unrolls a long chain of landscapes wherein there is no tame feature, but each successive view presents new combinations of beauty and majesty . . . , and its name is, The Hudson."[19]

Writers frequently compared the Hudson to the Rhine and it fulfilled the same role in American culture that the Rhine played in German culture: it was a major commercial artery, the site of famous military campaigns, an important farming and winemaking district, and a popular tourist route. James Fenimore Cooper, who found much to criticize in American scenery, including the low altitude of its mountains when compared to the Alps, declared that the Rhine "in its best parts" was not equal to the Hudson "in its whole length," and that the other rivers of Europe bore no comparison at all.[20] And George William Curtis asserted in *Lotus-Eating* (1852) that:

> There is no littleness about the Hudson, but there is in the Rhine. Here every thing is boldly touched. What lucid and penetrant lights, what broad and sober shadows! The river moistens the feet, and the clouds anoint the heads, of regal hills. The Danube has, in parts, glimpses of such grandeur. The Elbe has sometimes such delicately pencilled effects. But no European river is so lordly in its bearing, none flows in such state to the sea.

60

The Rhine is lyrical, he wrote, the Hudson epic: "It implies a continent behind."[21]

The geographical, historical, and scenic advantages the Hudson River possessed as a tourist route were reinforced by the writers and painters who left the stamp of a national literary and artistic culture on it. Archibald Alison, whose *Essays on the Nature and Principles of Taste* (1790) became influential in America in the 1820s, argued that people react most strongly to places furnished with stories or historical events in their native countries. Sir Walter Scott's popular romanticizations of Scottish history in novels like *Kenilworth* (1821) and the poetry of Robert Burns reinforced this notion. The American landscape needed the associations of history, literature, and art. As Sarah Josepha Hale, editor of the *American Ladies' Magazine* and later of *Godey's Lady's Book*, put it, the "barrenness" of American scenery, "the vacancy, painfully felt by the traveller of taste and sentiment, arises from the want of intellectual and poetic associations with the scenery he beholds."[22]

Washington Irving, who had the most significant impact on the popular image of the Hudson Valley, shared Hale's disappointment in the American landscape. He "longed to wander over the scenes of renowned achievement—to tread as it were in the footsteps of antiquity—to loiter about the ruined castle—to meditate on the falling tower—to escape in short, from the commonplace realities of the present, and lose myself among the shadowy grandeurs of the past."[23] This desire inevitably drew him to Europe, and when he published his *Sketch Book* (1819–20), the vast majority of its picturesque tales, descriptions of historic places, and accounts of ancient customs were sketches of English life. The book helped generate a longing among Americans to visit the Old World, and during the course of the nineteenth century thousands of Americans would follow Irving to Europe as sentimental tourists in search of the past. But two of Irving's stories had a different effect. Given the craving for a storied landscape generated by Alison, Scott, and others, it was not surprising that the two most influential pieces in *The Sketch Book* were "Rip Van Winkle" and "The Legend of Sleepy Hollow." Even these were adaptions of German folk tales, but Irving tied them so effectively to American settings that they became lodged securely both in the American literary tradition and in the touristic imagination, providing the Catskills and Tarrytown with the "charms of storied and poetical association" Irving had gone to Europe to seek.

In "The Legend of Sleepy Hollow" Irving makes Sleepy Hollow a place apart from the bustling, competitive reality of American

61

life and casts over it a spell of romance. It is, he says, a "drowsy, dreamy" place where the people "walk in a continual reverie." He evokes a sense of the past, joking while he does so about the thinness of the history for which he seeks to compensate: "In this byplace of nature there abode, in a remote period of American history, that is to say, some thirty years since. . . ."[24] In "Rip Van Winkle" Irving makes Rip a man of leisure who resists the driving spirit of American society personified by his nagging wife. Rip creates imaginative space for himself by sleeping away the revolution in a Catskill hollow. In both stories Irving tries to establish a foothold for the imagination in a plain, practical nation by locating the events of the stories in out-of-the-way places that appear impervious to change and that have the illusion, at least, of possessing a history. Irving establishes this illusion partly by means of a kind of guidebook history. Ichabod Crane, for example, meets the headless horseman near Major André's tree, the supposed site of the arrest of the British officer who conspired with Benedict Arnold. Major André was a romantic figure to Americans and his story was repeated many times.

No one was as successful as Irving in inventing parts of the Hudson Valley for the tourist, but other writers also employed Hudson Valley scenes in their work, enriching the region's literary and historical associations. Cooper set his novel *The Spy* (1821) in Westchester and Putnam counties during the revolution and *The Last of the Mohicans* (1826) in the upper Hudson Valley region during the French and Indian Wars. Like Irving's tales Cooper's novels are remarkably self-conscious and external to the place they treat. They invent the region rather than express it. The works of later regional writers, like Robert Frost and William Faulkner, seem, by comparison, organic in their regionalism, emerging out of an intimate knowledge of the local landscape and people. "Rip Van Winkle," "The Legend of Sleepy Hollow," and the novels of Cooper do not draw on the folklife and language of the Hudson region. The characters seem to have walked out of the novels of Scott and other similar works of fiction. Although the places portrayed are often recognizable, the landscape functions as "scenery," a word deriving from the Latin *scaena*, meaning "stage." In the *Last of the Mohicans*, Glen Falls, on the upper Hudson, with its "high and cragged rocks . . . surmounted by tall trees, which appeared to totter on the brows of the precipice" becomes the stage for a battle between Major Heyward, Natty Bumpo, and their Mohican allies on the one hand and a party of Hurons on the other. Cooper reveals his awareness of the touristic nature of his setting in a footnote to Natty Bumpo's appreciative and ornate

description of the falls themselves: "The description of this picturesque and remarkable little cataract, as given by the scout, is sufficiently correct, though the application of the water to the uses of civilized life has materially injured its beauties."[25]

The touristic literary tradition initiated in the Hudson Valley by Irving and Cooper, as well as by lesser writers like Joseph Rodman Drake and Paulding, was carried on by popular writers like Willis (1806–67), Curtis (1824–92), and Taylor (1825–78) who reinforced the associations established by these earlier writers and by the Hudson River School of painters. Although they admitted that the Hudson could not compete with the Rhine on the score of history and poetry, all of these writers identified and developed the associations it did possess. They helped consecrate the battlefields of the revolution, Major André's tree, and the house in Newburgh which served as Washington's headquarters during the struggle for control of the Hudson. "It is customary among our tourists," wrote Taylor in describing the Hudson Highlands, "to deplore the absence of ruins on those heights— a very unnecessary regret, in my opinion. To show that we had associations fully as inspiring as those connected with feudal warfare, I related the story of Stony Point, and André's capture, and pointed out, successively, Kosciusko's Monument, old Fort Putnam, and Washington's Headquarters."[26]

Most important, the atmosphere of romance which Irving, Cooper, and the Hudson River School of painters had managed to cast over the Hudson Valley persisted throughout the nineteenth century. It could still be registered by Henry James when he made a return visit to the United States in 1905:

> Such accordingly is the strong silver light, all simplifying and ennobling, in which I see West Point—see it as a cluster of high promontories, of the last classic elegance, overhanging vast receding reaches of river, mountain-guarded and dim, which took their place in the geography of the ideal, in the long perspective of the poetry of association, rather than in those of the State of New York.

The "iridescence" of the Hudson, wrote James, consisted of

> a shimmer of association that still more refuses to be reduced to terms; some sense of legend, of aboriginal mystery, with a still earlier past for its dim background and the insistent idea of the River as above all romantic for its warrant. Helplessly analyzed, perhaps, this amounts to no more than the very childish experience of a galleried house or two round about which the views and

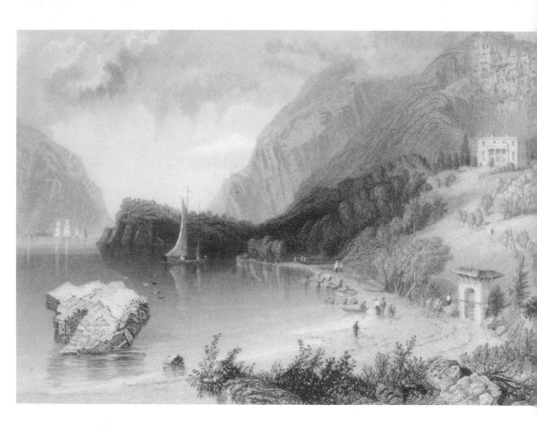

W. H. Bartlett, *Undercliff Near Cold-Spring* (*The Seat of General George P. Morris*), from *American Scenery*, 1840. (Courtesy of Adriance Memorial Library)

the trees and the peaches and the pony seemed prodigious, and to the remembrance of which the wonder of Rip Van Winkle and that of the "Hudson River School" of landscape art were, a little later on, to contribute their glamour.[27]

James's tribute to the Hudson identifies not only the associations with which its landscape was imbued, but also the highly domesticated quality of its landscape. While the Connecticut was best known for its neat, prosperous villages, the most characteristic feature of the Hudson was the country residences along the banks of the river. These, too, were elements of the varied panorama of the river. The large homes with their landscaped grounds embodied the aspirations of many Americans for the refined way of life associated with English and Scottish country houses. If Great Britain possessed Abbotsford, the home of Sir Walter Scott, America had Sunnyside, the home of Washington Irving at Tarrytown. Thus the Hudson Valley offered not only a fitting prelude to the

epic grandeur of America, but a touch of aristocratic European elegance. Its fine homes provided a contrast to the wilder stretches of the river. "Those Gothic, Tuscan, and Norman villas, with their air of comfort and home, give an attractive, human sentiment to the scenery, and I would not exchange them for the castles of the Rhine," wrote Taylor in 1862.[28]

The cultural importance of these homes was reinforced by the work of Andrew Jackson Downing (1815–52), who laid the practical and theoretical groundwork for the profession of landscape gardening in America. He was born and lived in the town of Newburgh and exerted his greatest influence on the landscape of the Hudson Valley. Downing celebrated the beauty of landscapes tamed by human labor. In his first published essay, he described the Hudson River valley as it looked from the top of "Beacon Hill" (Mount Beacon) which stands across the river from Newburgh. In this picturesque panorama, the natural and the cultivated achieve the sort of balance that spectators could enjoy only from Mount Holyoke and a few other places in the United States:

> In every direction the country is full of beauty, and presents a luxuriant and cultivated appearance, which is rare in mountain views in America, for the lands directly before us are the old agricultural counties of Orange and Dutchess. Neat farm-houses are profusely scattered over the green and fertile fields, and here and there along the river is seen the beautiful and costly villa, imbosomed in the thicket of trees and shrubbery, which looks from our high situation like a dark setting to the lustrous whiteness of the buildings. But ah! the eye wanders to that glorious spectacle, the noble chain of hills which forms the boundary, the frame, the setting to this superb picture.[29]

Here as in Timothy Dwight's description of the view from Mount Holyoke, the landscape represents in some respects the pastoral ideal as described by Leo Marx, the middle ground between nature and civilization. But the "beautiful and costly" villas excite Downing more than the homes of independent farmers. They do so not because they express a social ideal, like the farms and the villages admired by Thomas Jefferson and Dwight, but because they are the "lustrous" highlights of a "superb picture," a work of art. For Downing this landscape represents the highest expression of a refined civilization. The combination of natural features and human design which Downing praises was an ideal he believed Americans should strive for through artistic effort and he himself led the way by designing the grounds of country houses in the Hudson Valley. His books, particularly *A Treatise on the Theory*

*and Practice of Landscape Gardening Adapted to North America*
(1841), stimulated a tremendous interest in landscape gardening
throughout the United States. Like his friend, Willis, Downing
was one of the leaders of a movement among Americans to con-
sciously plan domesticated landscapes that would both soften the
rawness of American nature and provide an alternative to the
crowded conditions of urban living.

If part of the Hudson Valley reflected Downing's ideal of a
harmonious blending of cultivated land and natural features, its
most famous sight pointed up the more characteristic juxtaposition
in the American landscape of the savage and the refined and the
frequent absence of any "middle landscape" between wilderness
and civilization. The travelers who enjoyed the domesticated
scenes, framed by wooded hills and rugged cliffs, which unrolled
beside them as their steamboat made its way up the Hudson,
arrived at last at the village of Catskill. There they often boarded
a stagecoach for the twelve mile journey to the Catskill Mountain
House. Situated on the edge of the Catskill range, the Mountain
House provided luxurious accommodations in a wild setting. It
also provided a window on the infinite for those in search of the
transcendent elements of tourist experience.

The Catskill Mountain House was one of the most famous
hotels in the United States during the nineteenth century and
many well-known American and foreign travelers stayed there. It
opened as a small inn in 1823, added fifty rooms in 1825 and
eventually possessed over three hundred rooms with a capacity of
five hundred people. Although originally designed in the Federal
style, the roof, walks and gables of the Mountain House were
soon removed and it acquired the simple, templelike facade of the
American classical revival. Thirteen large columns stood along the
side facing the valley.[30] Many large wooden hotels were built in
the Catskills, the White Mountains, and other resort areas as the
demand for such accommodations increased during the nineteenth
century. Although they were big, these hotels retained many home-
like features. With their shuttered windows and white clapboard
walls, they appeared like enormous houses. The long porches,
which often ran the full length of the building, the walks, rustic
seats, and gazebos which surrounded them, and the way they were
sited to take advantage of the scenery, functioned, like the pano-
ramas and cycloramas, to turn the attention of the tourist outward
toward picturesque scenes. From the porches and grounds of the
Mountain House visitors enjoyed a dazzling view of the Hudson
River valley over one thousand feet below them. The appearance
of these hotels and their grounds reflected the domestic values

66

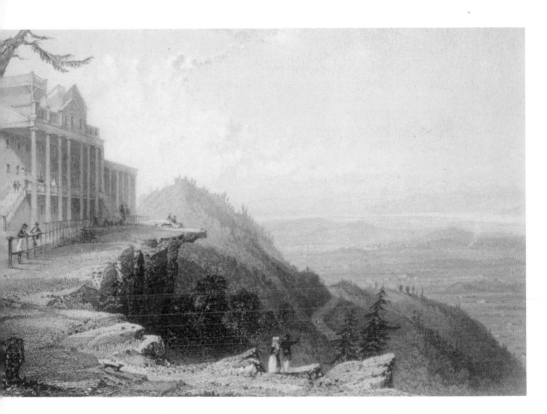

W. H. Bartlett, *View From the Mountain House, Catskill,* from *American Scenery,* 1840. (Courtesy of Adriance Memorial Library)

that tourists brought with them into the wildest settings. If one pole of nineteenth-century tourist experience was a romanticized nature, the other was an idealized home. This dual theme expressed itself not only in the Catskill Mountain House, but in more complex form in the Willey House in the White Mountains and in the rural cemeteries discussed in subsequent chapters.

In its early days, the Catskill Mountain House was accessible only by the four-hour stage ride from the steamboat landing at Catskill. The road climbed the almost vertical wall of the Catskill Mountain escarpment and carried visitors to the edge of the wilderness. There they found an oasis of luxury. You could choose " 'white' or 'red' Burgundias, Madeiras, French dishes, and French dances, as if you had descended upon Capua," wrote Willis in 1842. "How the proprietor can have dragged up, and keeps dragging up, so many superfluities from the river level to the eagle's nest, excites your wonder."[31] European visitors frequently criticized the shabbiness of American hostelries, but this was one

Jasper F. Cropsey, *Catskill Mountain House*, 1855. (The Minneapolis Institute of Arts, The William Hood Dunwoody Fund)

hotel in which Americans could take pride. Moreover, the dramatic contrast between the elegance of the hotel and the wilderness of the landscape surrounding it appealed to the Romantic sensibility. "On that little point," wrote William Cullen Bryant, "scarce visible on the breast of the mountain, the beautiful and the gay are met, and the sounds of mirth and music arise, while for leagues around the mountain torrents are dashing, and the eagle is uttering his shriek, unheard by human ear."[32] The Mountain House satisfied the wish of Americans to meet European standards of refinement and to remain distinctly American, to be civilized, yet to enjoy the primeval grandeur of American nature.

The Mountain House not only made the mountains available to tourists, but was in itself a principal part of the attraction. This temple of civilization, planted on the rim of the mountains, provided a vantage point from which to view the landscape, and, when looked at from a distance, a focal point in a picture of a raw, mountainous landscape. It was among the most popular subjects of American painting and its image was widely distributed in the

form of lithographs and engravings. Artists often painted it from the bend in the road three-quarters of a mile below the Mountain House from which tourists caught their first view of it looming above them. The other favorite spot from which to paint it was from the side of North Mountain looking back along the edge of the rugged escarpment. Both vantage points allowed the artist to capture the picturesque elements of the scene: the precipitous drop in front of the hotel, the broken rocks and twisted trees, the regular outline of the hotel against the irregular lines of the mountains, and often a human figure in the foreground.

Artists never painted the panoramic view of the Hudson Valley itself, which tourists enjoyed from the Mountain House. Such scenes, wrote Henry T. Tuckerman, were too vast for the artist to capture:

> Our scenery is on so large a scale as to yield sublime rather than distinct impressions. . . . As we stand on the top of Mount Washington, or the Catskills, the very immensity of the prospect renders it too vague for the limner; it inspires the imagination more frequently than it satisfies the eye. Indeed, general effect is the characteristic of American scenery; the levels are diffused into apparently boundless prairies, and the elevations spread in grand but monotonous undulations; only here and there a nook or a ridge, a spur, a defile or a cliff, forms the nucleus for an impressive sketch, or presents a cluster of attractive features limited enough in extent to be aptly transferred to canvas.[33]

But writers did try to record the "unbounded extent and magnificence" of the prospect from the Mountain House. They were not limited by the need to record their impressions within the confines of a canvas. One of the best known descriptions of this view appeared in Cooper's *The Pioneers* in 1823, the year in which the Mountain House opened. Along with "Rip Van Winkle," it fulfilled the tourists' need for a mythology of the Catskills. For Natty Bumpo the view encompassed "all creation":

> I was on that hill when Vaughn burned 'Sopus, in the last war, and I seen the vessels come out of the highlands as plain as I can see that lime-scow rowing into the Susquehanna, though only one was twenty times farther from me than the other. The river was in sight for seventy miles, looking like a curled shaving, under my feet, though it was eight miles to its banks. I saw the hills in the Hampshire grants, the high lands of the river, and all that God had done or man could do, far as the eye could reach.[34]

The popular travel writers, who viewed the scene later on, saw it as a lesson in the "insignificance of all created things" and as an

Harry Fenn, *The Catskills: Sunrise From South Mountain,* from *Picturesque America,* II, 1874. (Courtesy of Vassar College Library)

exciting panorama in action. "Crawling far below," wrote Paulding, "man is but an atom, hardly visible; the ox is but a mouse; and the sheep are little white specks in the green fields, which themselves are no bigger than the glasses of a pair of green spectacles. The traveller may judge of the insignificance even of the most sublime objects, when told that a fashionable lady's hat and feathers dwindles in the distance to the size of a moderate mushroom!"[35]

If human concerns seemed puny from this elevation, Nature seemed magnificent and sacred. The domestic world of the hotel seemed perched on the very edge of the infinite. In "The First Journey I Ever Made," Taylor remembered looking out at "the vast, mysterious deep" as he lay on his bed in one of the front rooms of the Mountain House on a moonlit night. And later in his visit Taylor watched the light fading from the valley until "the world below was as dark and strange and spectral, as if it were an unknown planet."[36]

Tourist attractions frequently demand attention themselves as spectacular natural phenomena like Niagara Falls and Mammoth Cave. Others, like Mount Holyoke, provide platforms from which to admire nature and civilization. At sites like these the visitor steps out of the immediate, particular, disordered continuum of life and contemplates the whole from a distance. The Catskill Mountain House reflected the achievements of mid-nineteenth-century America while furnishing a panoramic view of its civilization. It represented leisure and fashion in a country which many educated commentators found too practical and crude; it embodied the domestic on a grandiose scale; and it opened a view both of the cultivated landscape of the Hudson River valley and of the cosmic drama of nature.

# ɞ‿ Four

## The Making of an American Tourist Attraction: The Willey House in the White Mountains

NATURAL PHENOMENA, impressive as they may be, are not productions of culture in the sense that cathedrals are. They become the products of a culture only when transformed by human activities such as painting them, describing them, and building hotels near them. The cultural prominence of Niagara Falls in the nineteenth century depended to a large degree on the thousands of images made of it from the cheapest print to Frederic Church's great oil painting. Similarly, Mammoth Cave and the Connecticut and Hudson river valleys generated a body of images and descriptions that established them as important destinations on the tourist itinerary. In the case of the White Mountains this process of cultural production was accelerated by an incident known as the Willey Disaster which provided a dramatic human focus to the region and inspired its early literature and art. The history of the Willey Disaster and its role in attracting tourists to the White Mountains shows how hungry Americans were for places imbued with religious and nationalistic symbolism and how such places reflected the cultural preoccupations of a people both on a domestic and cosmic level.

On the night of August 28, 1826, numerous avalanches devastated the slopes of the White Mountains, stripping away trees, earth and rock, and leaving deep gashes in the mountainsides that remained visible for years afterward. One of these avalanches wiped out the entire family of Samuel Willey, Jr.: Mr. Willey and his wife, five children between the ages of five and thirteen, a hired man and a boy. The Willeys lived in what is now called Crawford Notch, a wild and lonely spot six miles from the nearest neighbor. They tended a small farm and they took in travelers

72

*The Willey Slide,* anonymous woodcut illustration for *Brookes Universal Gazetteer of the World,* 1847. (Courtesy of Dartmouth College Library)

who passed through the Notch on their way to the coast of Maine. On June 28, 1826, the Willeys had been frightened by another avalanche that descended close to their home and Mr. Willey had taken the precaution of constructing a shelter to which they could flee in case they were threatened again. They apparently tried to reach that shelter on the night of August 28, but fled right into the path of an oncoming slide. Their house, however, remained unharmed; had they stayed within it, they would all have been saved. One of the avalanches had originated at the top of the mountain above the Willey's house and descended directly toward it, but just before it reached the house it divided in two, passed by on either side—destroying the stable on its way—and reunited lower down in the valley. The next morning a rescue party found an empty house, with beds unmade and the family's clothing lying on chairs and on the floor, just as they had left it in their panicked flight. Three of the bodies were never recovered from the wreckage on the valley floor.

Such an event is always the stuff of news, and the Willey Disaster, as it came to be called, received extensive coverage in the

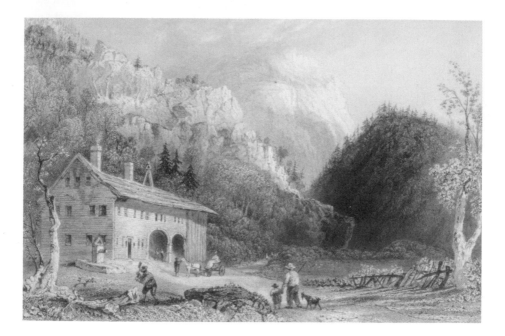

W. H. Bartlett, *The Notch-house, White Mountains,* from *American Scenery,* 1840. (Courtesy of Adriance Memorial Library)

New England press at the time.[1] But the Willey Disaster was not just news; it was a cultural event. The accidents which became part of the lore of Niagara Falls gathered cultural significance because they took place in the presence of such a famous and magnificent phenomenon. This was partially true of the Willey Disaster, too. It would not have attracted attention had it not occurred in such a dramatic setting. But the Willey Disaster was much richer in cultural meaning than any of the accidents which took place at the Falls and the incident itself helped establish the fame of the mountains.

Small groups of tourists had begun to visit the White Mountains in the early 1820s, but in the fall of 1826, as news of the accident quickly spread, hundreds of people flocked to the mountains. The numbers grew in the years that followed and the Willey House became one of America's first major tourist attractions. Many of the visitors stopped at Ethan Allen Crawford's farmhouse, and later inn, near the romantic entrance to the Notch and heard the details of the Willeys' story from its owner. They were guided to the summit of Mount Washington by Ethan or one of his sons on the path that Crawford had built. The accounts of travels in the White Mountains frequently described Crawford as

a romantic figure, a "hardy mountaineer," possessing an "uncommon simplicity of manners."[2] Like Stephen Bishop, the guide at Mammoth Cave, Crawford put the early tourists in intimate contact with the setting and became himself part of its story.

Among the visitors in these early years were many members of New England's cultural elite, and these men and women further publicized the Willey Disaster and shaped the public's perception of it by recording the story in a remarkably large body of literature and art. Benjamin Silliman, the leading American scientist of the day, inserted accounts of the avalanches and the destruction of the Willey family into his *American Journal of Science and Arts;* Lydia Sigourney, the "Sweet Singer of Hartford," and other poets wrote about the tragic death of the family; and ministers preached on the lessons to be drawn from the incident. Henry C. Pratt and Thomas Cole painted pictures of the Willey House or of the Notch; Thomas C. Upham, a well-known Bowdoin philosophy professor, wrote a long letter to the New Hampshire Historical Society on the moral and political significance of the event; and Theodore Dwight, Jr., included accounts of it in both *Scenery and Manners in the United States* (1829) and his widely used travel guide, *The Northern Traveller.* Finally, in 1835, Nathaniel Hawthorne fictionalized the story of the Willey family in "The Ambitious Guest," which remains the finest literary rendering of the tragedy.

The Willey Disaster occurred at just the right moment to appeal to the desires of well-to-do Americans who had just begun to travel as tourists and were eager for exciting places to see. But the strength of its appeal had to do with the precise ways in which the accident and the monument it left behind fitted the expectations of these early tourists.

For New Englanders, especially, the Willey Disaster presented a problem in the interpretation of the divine meaning of human history and natural phenomena. As Benjamin Silliman put it, the event was "*almost* a miracle," the avalanche circling the house "as if *repelled* by an invisible power."[3] Thus the story appealed strongly to a culture that had been studying the ways of Providence closely for two centuries. Had the Willey Disaster occurred in the seventeenth century, it would have found a place in Increase Mather's *An Essay for the Recording of Illustrious Providences* (1684). New Englanders were trained to draw a moral from such events, and they didn't hesitate to do so in this case.

The mystery of the Willey Disaster lay in the opportunity the family missed to remain within the magic circle formed by the avalanche around the house. But, if that was not strange enough,

the irony of their flight was intensified by an account of their salvation from the avalanche that had threatened them in June. That account was first published on August 4, 1826, then republished after the fatal night of August 28. In it, Joseph T. Buckingham, editor of the *Boston Courier* and *The New England Galaxy* had written: "The place from which this slide or slip was loosened, is directly in the rear of Mr. Willey's house; and were there not a special Providence in the fall of a sparrow, and had not the finger of that Providence traced the direction of the sliding mass, neither he, nor any soul of his family, would ever have told the tale!"[4] Where, then, was the finger of Providence in the later avalanche? Were the Willeys being punished for some transgression? None of the published commentaries on the event even hints that this was the case. On the contrary, the Willeys are presented as exemplary in every respect. "The whole intention of their lives was to live humbly, walk uprightly, deal justly with all, speak evil of none," wrote Lucy Crawford when she recounted the incident in 1846. Their fate had to be accepted, like Job's, as a mystery beyond the capacity of man to penetrate. As Crawford put it: "There is an overruling God who knows all things and causes all things to happen for the best, although we shortsighted mortals cannot comprehend them."[5]

Yet God also spoke through the Willey Disaster with perfect clarity. Hawthorne, who visited the scene of the tragedy in 1832 before writing his version of the event[6] and could detect God's voice in the wreckage of an avalanche as well as anyone else in New England, made that voice heard throughout "The Ambitious Guest." Modern readers, educated in the subtleties of the short story, commonly complain of the heavy-handed irony of "The Ambitious Guest,"[7] but Hawthorne's audience had been reared on the sermon, not the short story. From the jeremiad onward they had been schooled in the ominous. Thus they would have recognized the noisy tread of Fate that resounds through Hawthorne's story as the familiar drumming of the lesson, man is mortal. It is the same lesson that reverberates throughout the sermon on the Willey Disaster published in the *Christian Spectator* in December of 1826: "Let, then, as many of us, as are secretly indulging the thought that we 'shall never be moved,'—that our mortal structure is too strongly built to be dissolved, take a view of the scene among the white summits that skirt yonder horizon, where He who reared those mighty masses, has lately been exerting the terrible energies of his power."[8] And such events not only foreshadowed death but judgment as well. The "wailing and lamentation" of the wind that announces impending doom at the beginning of

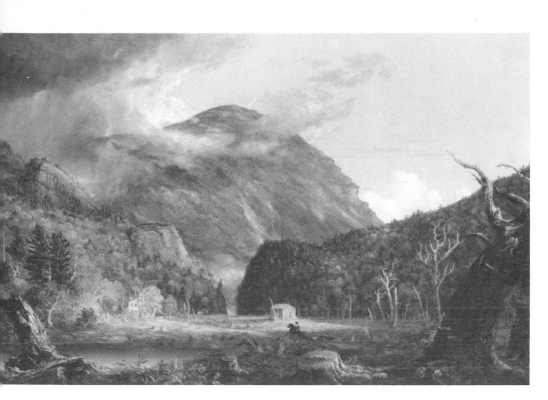

Thomas Cole, *The Notch of the White Mountains* (Crawford Notch), 1839. (National Gallery of Art, Washington, D.C., Andrew W. Mellon Fund)

Hawthorne's story, culminates at the end in the roaring of the descending avalanche: "The fountains of the earth seemed to be shaken, as if this awful sound were the peal of the last trump."[9]

If the intensity of response to the Willey Disaster reflected the puritan tradition of interpreting "Illustrious Providences" and blowing the trumpet of doom, it also expressed the fact that the event satisfied perfectly the contemporary demand for a storied landscape, the demand that had ensured the popularity of "Rip Van Winkle" and other works set in the Hudson River valley. As wild and romantic as the Notch in the White Mountains was, it needed the tragedy of the Willey family, and the literature and art which their story inspired, to make its effect on the emotions of the visitor complete.

For Upham, a proponent of Archibald Alison's associationist philosophy, and other literary nationalists of the day, the Willey Disaster provided the perfect opportunity for American writers to hallow their country's scenery with story and song as Scott and Burns had done in Scotland. If they didn't take advantage of such

opportunities, her mountains would remain, as Sarah Josepha Hale put it, "nothing but huge piles of earth and rocks, covered with blighted firs and fern" and her streams continue to be celebrated only for "affording fine fish, good mill-seats or safe navigation."[10] When Hawthorne, who was Upham's pupil at Bowdoin, went to the White Mountains in 1832 he appears to have set out quite consciously to rescue those "huge piles of earth and rocks" from their barrenness, and "The Ambitious Guest" and the other stories that resulted went far to answer the call of his contemporaries for a literature consecrating American scenes. In addition to "The Ambitious Guest," he produced "The Great Carbuncle," a story based on an old legend of the White Mountains, and "Sketches from Memory," an account of his own travels in the region. Later he added "The Great Stone Face." In reading "The Ambitious Guest," Hawthorne's contemporaries must have felt a twinge of patriotic pride when he says of the family: "Who has not heard their name? The story has been told far and wide, and will forever be a legend of these mountains. Poets have sung their fate."[11] America as well as Scotland had her storied mountains.

But it was not just the tragic event attached to a romantic spot that captured the imagination of New England, it was the fact that the avalanches had at last supplied Americans with ruins on a grand scale. On the whole, Americans had to be satisfied with reading about the ruins of the Old World and looking at pictures of them. The passing of the Indian and the remains of Indian civilization, like the mummy and artifacts found in Mammoth Cave, provided only a partial substitute for the vanished civilizations of Pompeii, Egypt, and other ancient places which the discoveries of archeology had recently made famous. In the surviving Willey House, painters and illustrators, like Pratt and Bartlett, found an emblem of desolation to fit the requirements of the European landscape tradition, but the mountains themselves, with whose sublimity the story of the Willeys had been mingled, were the family's ultimate monument. "These hapless sufferers will never need marble to perpetuate their memories," said Isaac McLellan. "This catastrophe may be always read on the rent-face of the mountain, a monument larger than the pyramids."[12]

Americans also had to depend on the Old World to feed their craving for catastrophe. As Curtis Dahl points out, Americans "had developed an almost morbidly avid appetite for the sublime terror of huge devastation." Between 1810 and 1845 American poets, novelists, and painters often chose the destruction of cities, nations, races, or the entire world as the subject of their work.[13] In the avalanches of 1826 and the death of the Willey family,

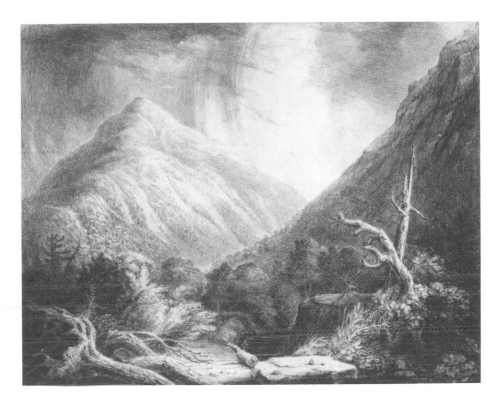

*Distant View of the Slides That Destroyed the Whilley Family,*
1830–35, Anthony Imbert, lithographer, after a lost painting by
Thomas Cole, 1828. (Collection of The Albany Institute of History
& Art)

many people found an American version of the destruction of an
ancient city, or at least an event that evoked the same associations.
The ruins left in the Notch led the author of the sermon in the
*Christian Spectator* to thoughts about the mutability of all things
and from them back to the ancient sites: "Where now the multi-
tudes which once thronged the busy streets, of Nineveh, Babylon,
and Palmyra?"[14]

Another favorite catastrophe among the writers and painters of
the period was the Deluge,[15] and here the connection with the
avalanches in the White Mountains was not merely through asso-
ciation. It was widely assumed not only that the Notch in the
White Mountains had been formed by the Deluge in the first
place, as some geologists theorized about Mammoth Cave as well,
but that the powerful forces responsible for that catastrophe had
been at work in the 1826 slides. Benjamin Silliman, whose *Outline
of the Course of Geological Lectures* (1829) was concerned largely

with the Deluge as a natural phenomenon, wrote that the cataclysm in the White Mountains represented "a very striking example of sudden diluvial action, and enables one to form some feeble conception of the universal effects of the vindictive deluge which once swept every mountain, and ravaged every plain and defile."[16] If the events in the White Mountains seemed modest compared, say, to the destruction of Pompeii, they were continuous with an event much more ancient and universal than the ruin of a single city, and one that affected the New World equally with the Old. As the author of the sermon in the *Christian Spectator* said, "There on that *spot* of earth, in that *point* of time, are epitomised the changes of all earth through all time."[17] Hawthorne makes no direct reference to the Deluge in "The Ambitious Guest," but when he wrote, "The foundations of the earth seemed to be shaken," and "Down came the whole side of the mountain, in a cataract of ruin"[18] his contemporaries would have been reminded of the ruin described in Genesis: "All the fountains of the great deep burst forth, and the windows of the heavens were opened."[19]

The curiosity about Providential happenings, the desire to furnish American places with legend, the passion for catastrophe, and the love of ruins, account for much of the literary and artistic interest in the story of the Willey Disaster, but there was another aspect of the event that outranks all the others in importance: the victims of the disaster were the members of an American family. They were not the residents of a decadent Pompeii or Nineveh or one of the sinful families destroyed by the Deluge, but a family in contemporary America whose virtue was emphasized in every version of the tragedy. Their house, which remained standing as an emblem of the Christian and republican values they embodied, was not a castle, the vestige of a feudal society, but a Home.[20] As the historian Nancy F. Cott has pointed out, home was becoming idealized for middle-class Americans in the 1820s and 30s as the garden of the gentler emotions, an "oasis" of "disinterested love" in a desert of ambition and competition.[21] The poems about the Willeys by Lydia H. Sigourney and Grenville Mellen emphasize the tenderness of the family: Farmer Willey "Shouting his harvest cheerily home!," "the prattling sound / Of children" in their "nest / Of the far Wilderness," both nature and the parents of the children instructing them in a love of God.[22] To Theodore Dwight, Jr., who, with his close friend Sigourney, helped to nourish the growing cult of domesticity, the Willeys' home "presented a gentle and tranquilizing contrast to the vast and sublime objects of nature" which "many a weary and many an almost perishing traveller has welcomed with joy."[23] The contrast that tourists

savored at the Catskill Mountain House between the civilized and the wild, the cozy and the cosmic, was here more touching and personal because it involved a virtuous home rather than an elegant hotel. Upham, who visited the Willey household just before the disaster, praises their home as a haven of "order, and peace, and cheerfulness," whose "moral loveliness" was "heightened to the imagination of those, who visited it, by being shut out as it were, from the rest of the world, and blooming in the midst of such vast and terrific solitudes."[24]

"Home" was also a very powerful metaphorical term for heaven during the nineteenth century, and it often appeared in American hymns of the 1830s and 40s in conjunction with images of mountains and storms, as in David Nelson's "My Days Are Gliding Swiftly By" (1835):

> Let storms of woe in whirlwinds rise
> Each cord on earth to sever,
> There—bright and joyous in the skies,
> There—is our home forever.

The fact that in the Willeys' case an entire household was transported, instantaneously, from their earthly home to their heavenly home was in itself appealing. To make it still more dramatic, this transposition took place amidst grand scenery and a terrifying storm—magnificent emblems of God's sublime power.

Hawthorne clearly recognized the power that the image of Home as a sacred place exercised over his contemporaries, and he exploits it to the fullest in "The Ambitious Guest." When he took up the tale, he knew that his audience was thoroughly familiar with the Willey Disaster from the numerous accounts that had already been written. Even though he does not name the Willeys in his story, any contemporary reader would have known before the end of the first paragraph who the family was and what was about to happen to them. Yet by fictionalizing the event Hawthorne was free to enhance the very qualities that made the story so appealing to his fellow New Englanders. He begins by doing everything possible to shape the family's home in the Notch into an emblem of warmth and security.

The story opens with the family gathered about a roaring fire at their home in the Notch, and it is clear that in raising the age of the eldest Willey daughter to seventeen and adding a grandmother, Hawthorne has sought to round out the family circle. When he says that the family "had found the 'herb, heart's-ease,' in the bleakest spot of all New-England," it recalls Upham's vision of the

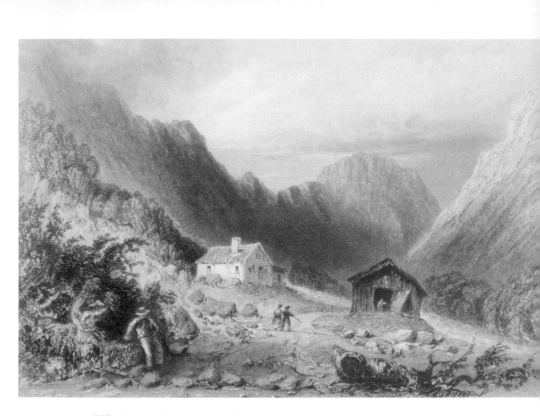

W. H. Bartlett, *The Willey House*, from *American Scenery*, 1840.
(Courtesy of Adriance Memorial Library)

"moral loveliness" of the Willeys "blooming in the midst of such
vast and terrific solitudes." Hawthorne's family, like Upham's, pos-
sesses the "warmth and simplicity of feeling, the pervading intelli-
gence of New-England, and a poetry, of native growth, which they
had gathered, when they little thought of it, from the mountain-
peaks and chasms."[25]

But one aspect of the cult of Home is especially relevant to
Hawthorne's story: it celebrated modesty. In Upham's account of
the Disaster, the Willey house is situated near "the unambitious
Saco," and the families he extols in his poetry are invariably "hum-
ble and secluded." In poems like "The Home in the Mountains,"
he praises the independent farmer, "all unnoticed in ambition's
strife," who remains "contented with his little flock of sheep" and
refrains from seeking "in glory's paths, her fading wreaths to reap."[26]

It is in response to this image of Home that Hawthorne gener-
ates the crucial innovation in his story. Into the garden of felicity
steps the snake of restlessness. The wind comes blowing through
the Notch with much "wailing and lamentation," the door opens,

and in comes a traveler as if he were the messenger of death. The traveler is a young man of "high and abstracted ambition."[27] One could not imagine a more ironic counterpoint to the values embodied in the Willey family.

If, as Barbara Berg says, "the exemplary home was a paradigm of serenity and harmony, a dramatic contrast to its tempestuous surroundings,"[28] then the ambitious guest is the representative of that surrounding field of competition. Hawthorne emphasizes that the family living in the Notch remains in daily contact with the world: "The romantic pass of the Notch is a great artery, through which the lifeblood of internal commerce is continually throbbing, between Maine, on one side, and the Green Mountains and the shores of the St. Lawrence on the other." The family's home serves as an oasis, soothing the loneliness of the traveler and providing the teamster on his way to the market in Portland, not just with food and lodging, but with "a homely kindness, beyond all price."[29]

When the ambitious guest enters, he brings with him the striving of the commercial world that streams past the family's door, but in an idealized form. Although he has accomplished nothing in his life so far, nor apparently even chosen a profession, he is obsessed by the desire to achieve a permanent and glorious place in human memory. He is willing to live his life in obscurity as long as he acquires this solitary splendor after his death. When he begins to talk about his obsession, he awakens the dormant ambitions of the members of the family. But his ambition is vague and centered on his own glorification, while their's are very specific and involve expressions of kindness between persons. Their ambitions are dreams of closeness; they reinforce rather than disrupt the set of values the family embodies. The father, for example, dreams of owning a good farm and serving a term or two in the General Court, "And when I should be grown quite an old man, and you an old woman, so as not to be long apart, I might die happy enough in my bed, and leave you all crying around me." He would settle for a slate gravestone with something on it "to let people know, that I lived an honest man and died a Christian." It is a measure of the warmth and human sympathy expressed in these wishes that during their confession the family and the stranger draw closer together around the fire until its light "caressed them all."[30]

Normally, the person in Hawthorne's stories undertaking a single-minded quest excludes himself from the circle of human sympathy. This course has been followed by the youth in "The Ambitious Guest" up until the evening in the Notch, but now he finds himself strongly attracted to the family, opens his heart to them

in an uncharacteristic way, and flirts with the eldest daughter, which is like flirting with domesticity itself. "It is better to sit here, by this fire . . . and be comfortable and contented, though nobody thinks about us," she says in reply to the young man's fantasies of immortality.[31]

The obvious irony of "The Ambitious Guest" is that the family achieves in death the immortality that the youth so passionately wished for. The story of the family "will forever be a legend of these mountains" while his name will remain "utterly unknown."[32] But it is also ironic that just before the members of the family acquire what the youth always wanted, he achieves the human closeness they had always enjoyed, but that he had foregone in the solitude of his quest. Their kindness redeems him from his isolation. When he first arrives he seems melancholy, almost despondent, but the warm sympathy of the family soon cheers him. Without his realizing it, they sustain his spirits as he enters the most desolate passage of his life. As Hawthorne told us at the beginning, that is the function of the family living in the Notch: "The wayfarer, with no companion but his staff, paused here to exchange a word, that the sense of loneliness might not utterly overcome him, ere he could pass through the cleft of the mountain."[33] Was Hawthorne, in the salvation of his hero from loneliness by absorption into the family circle, offering a more subtle justification of the ways of Providence than those suggested by the other commentators on the disaster? If so, he had discovered a Providence perfectly in tune with the contemporary worship of domesticity.

It is impossible to know how many tourists read "The Ambitious Guest" or thought of it when visiting the Willey House after the story's publication in 1835. But it is certainly of interest that Hawthorne chose to juxtapose the idealized peacefulness of the Willey home with the commercial world represented by the driven young man of his story, and then reconciled the two by uniting the man with the family. The cultural anxiety evident in Hawthorne's story is similarly expressed in the way tourist attractions like Niagara Falls embodied—uneasily, in most cases—both the commercial drives of American society and the desire for sacred places separated from the world of business.

One might well ask whether the Willey House and the Notch evoked in the average tourist all the associations that were proposed by the writers and artists who took up the story of the Willey family and that were then exploited so brilliantly by Hawthorne. Perhaps not. The tale could be enjoyed merely on the level of a gory accident, and a number of accounts did provide details about the smashed heads and broken limbs of the bodies that were

recovered from the debris. According to the *Boston Courier*, for example, "nearly half [of Mrs. Willey's] head, from the forehead to the back part, was gone, literally torn off! and there she lay, naked, with her brains scattered around, a most hideous spectacle."[34] Nevertheless, it seems unlikely that it was only images like these which brought so many tourists to the White Mountains after the tragedy had occurred. The class of people who could afford to travel as tourists before the Civil War were not only well-to-do; many of them were well-educated. The literature and art about the Willey Disaster appeared in popular journals like *The Token* and the *Ladies Magazine* which were easily available to them. Moreover, the guidebooks to the White Mountains published in the 1840s and 50s expressed many of the same sentiments found in the work of earlier writers and artists. The description of the Willey House in *The White Mountain and Winnepissiogee Lake Guide Book* (1846), for example, told the tourist that "the traveller here treads upon the very earth that, in its devastating course, buried forever from the light of life the family that nestled, in seeming security, in this wild spot." This thrill could now be enjoyed with increasing ease, the guidebook informs its readers, since the Willey House was being improved "to accommodate the public with every comfort and convenience," but the lesson to be drawn from the disaster was the familiar one: "How often do the greatest strongholds of man's power and defence but prove their utter weakness at the approach of death, whether he comes in the pestilence or in the whirlwind!"[35]

Most of the middle-class tourists who came to the mountains in the 1860s and 70s would not have remembered the Willey Disaster nor read the literature and seen the images published soon after the event. Moreover, the cultural preoccupations which had produced the Willey House as a tourist attraction were no longer pressing. The tradition of interpreting history in providential terms had faded, the need for a literature and art employing American scenes and events had been satisfied, and the idealized American home had become commonplace. To the later tourists the Willey House must have had much less resonance. A photograph of the house taken in the late nineteenth century indicates how easily a visitor might have experienced it as an ordinary, disappointing tourist attraction: "The Real Plymouth Rock"; "The Original Willey House." For those poetically inclined, however, it remained possible to recover the earlier perception of the scene by reading Thomas Starr King's *The White Hills: Their Legends, Landscape, and Poetry* (1859), a guide to the White Mountains for genteel tourists that was popular throughout the second half of the cen-

*Original Willey House*, unknown photographer, late nineteenth century. (Courtesy of New Hampshire Historical Society)

tury. King's book contains a long account of the Willey story and includes all the associations evoked by earlier writers and artists. Even here something has been lost. The sublime moral lesson of the Willey Disaster has faded into Ruskinian aestheticism: "Standing over the Notch," King writes, "we are struck with the grace that curbed the rage of the murderous avalanche. . . . 'Strength and beauty are in his sanctuary,' and it is beauty which the savage forces serve at last."[36] God no longer voices his ominous reminder of human mortality through the avalanche. King focuses instead on the way even nature's most destructive outbursts serve aesthetic ends. But, as King's language indicates, the Notch remained for some, at least, a sacred place where nature continued to teach lessons even if the moral power of the Willey story itself no longer exerted its original strength.

# &~ *Five*

## Prisons, Asylums, Cemeteries, Parks

ALTHOUGH THE dramatic natural settings of sights like the Willey House and the Catskill Mountain House exercised the strongest pull on travelers during the second quarter of the nineteenth century, American cities also attracted the interest of tourists. Tourists were fascinated by the rawness and rapid growth of the new nation's urban areas. "It is an absorbing thing to watch the process of world-making;—both the formation of the natural and the conventional world," wrote the English writer Harriet Martineau in 1837.[1] This was particularly true of the cities of the midwest like Cincinnati, Chicago, and Milwaukee. Milwaukee "seems to grow before you," observed Margaret Fuller, "and has indeed but just emerged from the thickets of oak and wild-roses."[2] The steamboats, canals, and railroads—the very means of transportation which made tourism on a large scale possible—were themselves exciting to watch and contributed to the sense of a mighty transforming power at work.

But the growth of American cities and the immigration and industrialization that accompanied that growth also caused anxiety. Some tourists appear to have found reassurance in the institutions which sprang up in and around urban areas and displayed new methods of coping with social problems. The American city first became an important tourist attraction in an age of reform. Americans who were active in the cause of benevolence were constructing new institutions to accommodate the dead and to care for the insane, the disabled, and the criminal. The American Asylum for the Deaf and Dumb in Hartford opened in 1817, Ossining state prison in 1825, the Connecticut State Penitentiary at Wethersfield in 1827, Mount Auburn Cemetery in 1831, the Perkins Institution

and Massachusetts Asylum for the Blind in 1832, and the Worcester State Lunatic Hospital in 1833, to name a few of the institutions founded at this time. Rather than merely correcting the imperfections of their predecessors, these institutions represented radically new solutions to the problems they addressed. There has been no comparable revolution in the structure of such institutions since that time.[3] The novelty of these institutions and the tremendous hopes they aroused for the banishment of darkness, ignorance, and sin attracted the curiosity of American and foreign visitors.

They suggested that progress was taking place on the moral as well as the material plane and therefore may have softened the ambivalence that some people felt about the rapid physical and social changes taking place in the country. The English writer and actress Fanny Kemble, for example, an admirer of the American prison system, was excited, but also disturbed by the development of America's cities. At Rochester she was upset by the way the Genesee Falls had been reduced to a trickle in order to turn the wheels of "a thousand dingy looking mills and manufactories": "Truly, mills and steam-engines are wonderful things, and I know that men must live; but I wish it were not expedient to destroy what God has made so very beautiful in order to make it useful."[4] The new institutions presented visions of order and methods of control in a world which seemed at times destructive or chaotic.

Although the new institutions were influenced by European ideas and models, the American versions were often considered superior to those in Europe, and Americans took pride in showing them off to foreign visitors who came to see them. America might not have beautiful cathedrals and ancient ruins, but it had the best prison system in the world. "The idea of travelling in America," wrote Martineau,

> was first suggested to me by a philanthropist's saying to me, "whatever else may be true about the Americans, it is certain that they have got at principles of justice and mercy in the treatment of the least happy classes of society which we may be glad to learn from them. I wish you would go and see what they are."[5]

Martineau visited Niagara Falls, the White Mountains, the Catskills, and Lake George, but she also visited prisons, cemeteries, and asylums for the deaf, dumb, and blind. Alexis de Tocqueville, of course, came primarily to study the American prison system. Charles Dickens wrote a much quoted tribute to Niagara Falls, but his greatest interest lay in the landscapes of human suffering and the means of relieving that suffering displayed at the new in-

stitutions. He found the public and charitable institutions of Boston "as nearly perfect, as the most considerate wisdom, benevolence, and humanity, can make them. I never in my life was more affected by the contemplation of happiness, under circumstances of privation and bereavement, than in my visits to these establishments."[6]

Guidebooks published in the 1830s, 40s, and 50s described the new prisons, insane asylums, and institutions for the deaf, dumb, and blind, and urged tourists to see these sights for themselves. Accounts of visits to these institutions, often written by foreign visitors like Dickens and Harriet Martineau or by American women writers like Lydia Sigourney and Caroline Gilman, appeared in magazines and travel books. In *Scenes from My Native Land* (1845) Sigourney interspersed descriptions of her tour of Niagara Falls and other places of scenic interest with accounts of her visits to prisons and asylums and several poems, including "Prayers of the Deaf and Dumb," were inspired by these institutions. "In noticing some of the objects that beautify our city," she writes in introducing a description of the Retreat for the Insane at New Haven, "we trust to be forgiven for introducing the beauty of that benevolence which is the glory of any people."[7] Relatives were discouraged from visiting the insane because their caretakers thought contact with family would interfere with their patients' cure; prisoners were in many cases not allowed to see their families at all. Strangers, however, were often welcome. The Utica asylum, for example, averaged as many as twenty-seven hundred visitors a year, easily outstripping Mammoth Cave in attendance, if not in fame.[8]

Some people objected to the provisions made by prisons and insane asylums to accommodate tourists. Martineau, for example, objected to "staring and amused strangers" at the penitentiary at Auburn, New York, who were permitted to look "down smiling from the portico" as the prisoners marched past the kitchen to pick up their supper cans. When she objected to this practice, the warden agreed, but said "that the free Americans would not be debarred from witnessing the operation of any thing which they have decreed."[9]

Why did so many people wish to visit these institutions? Some no doubt went merely out of curiosity as sightseers, happy to have "done" the lunatic asylum, the prison, or the deaf and dumb asylum. But most accounts written during the period of reform reveal more serious motives. Nothing like these institutions had existed before. The buildings which housed them were themselves monumental and asserted their directors' confidence in the effi-

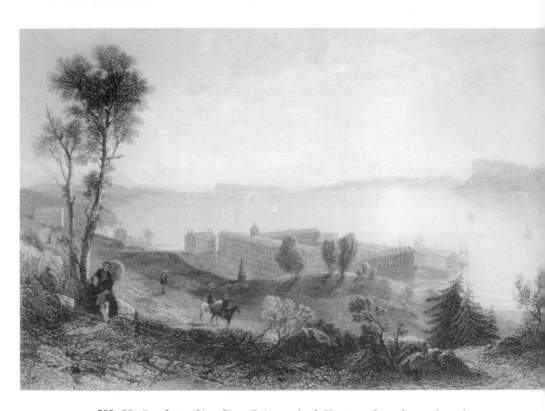

W. H. Bartlett, *Sing-Sing Prison, And Tappan Sea,* from *American Scenery,* 1840. (Courtesy of Adriance Memorial Library)

cacy of the new institutions. They were not tucked away out of sight, but located in highly visible places, often on hilltops, as symbols of the accomplishments and benevolent intentions of their founders. Before the second decade of the nineteenth century, no institutions for the care of the blind and the deaf and dumb existed at all; prisons and insane asylums were small and their inmates were crowded into common spaces. The new institutions were large, highly ordered, clean, well-ventilated, and often equipped with modern heating and plumbing systems. They often consisted of a central administrative building with columns lining the front and other architectural features indicating the importance of the institution. The wings of the building housed the inmates in separate rooms or cells. Some visitors found the designs of the prisons stark and chilling, although the monumentality of these structures and the long rows of cells piqued their interest. The new insane asylums, on the other hand, were more appealing. They "bear no resemblance to a prison," wrote the author of "Insanity, and Treatment of the Insane." "Their graceful architecture and im-

posing appearance give them rather the semblance of some palace."[10] The design of these institutions and the grounds surrounding them were themselves thought to promote the recovery of the patients.

The innovative methods of treatment which represented a sharp break with the past also attracted interest. American social reformer Dorothea Dix shocked her contemporaries into action in the 1840s by describing the conditions under which many prisoners and insane patients were being held. In Illinois, for example, she found a man kept in a rude pen where he was exposed to sun, wind, rain, and frost. In the winter he was thrown into a covered pit in the center of the pen where he was confined without heat, light, or adequate ventilation. Those unruly patients who were institutionalized were placed in "strong rooms" and their behavior brought under control by the use of strait jackets, handcuffs, and whips. In the new institutions the insane were no longer to be restrained or physically abused but kindly and rationally spoken to; the blind and the deaf and dumb were for the first time to be patiently and skillfully taught to read and communicate through braille and sign language; and criminals were to be adequately fed and introduced to orderly routines designed to bring about their reformation. Initially both founders and visitors expressed tremendous optimism about the capacity of these new methods to liberate the blind, deaf, and dumb from the limits imposed by their disabilities, and to cure the insane and reform prisoners through "moral influence." Visitors marveled at their apparent success. *The National Magazine* reported that if an insane patient were brought to the asylum within a year of contracting the disease, the patient had a better than eighty percent chance of recovering.[11] It gratified those who shared the romantic, idealistic, reformist impulses of the age to think that "moral influence" rather than force could not only control criminals and mental patients but cure them of their compulsion to commit crime or of their insanity, and that the blind, deaf, and dumb could be taught to perform useful work and to become Christians. All of these institutions were monuments to enlightened reason and Christian benevolence and seemed to indicate that the nineteenth-century "progress" was moral as well as material. "Beneficent institutions, especially for the *education* of the unfortunate, are among the highest indications of an advancing civilization," *The National Magazine* proudly stated.[12]

Some Americans probably visited the new institutions because European visitors praised them as the most advanced of their kind in the world. The attention that Europeans bestowed on them assuaged the American sensitivity to European charges that Ameri-

cans cared only for money and things. To both Europeans and Americans the new institutions and their initial success seemed to demonstrate that American democracy was best equipped to deal with the welfare of its criminal, mentally ill, and handicapped citizens. "The fundamental democratic principles on which American society is organized," wrote Martineau in a passage which must have gratified American reformers, "are those 'principles of justice and mercy' by which the guilty, the ignorant, the needy, and the infirm, are saved and blessed."[13]

Tourists also visited the new institutions because they were encouraged to do so. The promoters and superintendents of the institutions welcomed visitors because they wanted to raise funds from private sources, gain the approval of legislators who might then vote to support them, allay suspicion about the new, controversial methods of treatment, and demonstrate that the harsh methods previously applied to prisoners and mental patients had been replaced by humane ones. The inmates of the asylums for the blind and the deaf and dumb regularly performed at the institutions where they lived or went on tour to exhibit the skills which they had acquired. These exhibitions were frequently well attended. So many people wished to attend the exhibitions at the Blind Asylum in Philadelphia that the asylum began charging an admission fee to reduce the demand.[14]

The attraction of America's prisons and asylums for many tourists appears to have been their orderliness. Visitors frequently praised the neatness of the facilities, the regularity of the inmates' daily routines, and the decorum which prevailed. At the penitentiary in Philadelphia, Caroline Gilman admired the way dinner "was wheeled in, carefully covered to keep it warm, and delivered in bright tin pans, at each door, slightly ajar, and which was carefully shut as we passed." She found the insane patients at the Pennsylvania Hospital in "every way more comfortable than when subjected to the irregular habits of home." The patients, of course, may have had a different opinion. Gilman was shocked after congratulating one of the patients at the Hospital for the Insane at Worcester on the comfort of her accommodations, when the patient suddenly gave her "a knowing wink" and whispered in her ear, "Suppose you come and try how comfortable it is!"[15]

The historian David Rothman attributes this admiration for the regularity and decorum in the lives of the inmates of the new institutions to worries about the increasing disorder of America's rapidly growing urban society, an anxiety evident in the question Gilman asks shortly after describing her visit to the New-York Lunatic Asylum: "Is the advantage of emigration to compensate us for the

vices and insubordination it is introducing?" Gilman admired the Philadelphia penitentiary for the way it imposed a Christian peace on those who had been most disruptive in society: "For in the precincts of each narrow cell, / Hands, busiest once amid licentious crowds, / Voices that shouted loudest in the throng, / Were now as calm, as erst the winds and waves, / When Jesus said, *be still*."[16]

Visitors also admired the way prisoners were employed in "useful" trades, the way the deaf and dumb were taught to make shoes, the blind to make brushes or mattresses. Gilman admired the "accuracy" with which the inmates at the Pennsylvania Deaf and Dumb Asylum had learned to spell, the way the girls were engaged in sewing and the boys in "industriously" making shoes. These "practical efforts" at educating the deaf and dumb, she argued, "are seen and felt throughout the constitution of society."

The location of the new institutions also satisfied the visitors' desire for quiet and order. Most of them, particularly in the case of the asylums, were constructed in suburban locations. *The National Magazine* recommended that insane asylums should be "in the country, not less than two miles from a large town, and easily accessible," and that they should be surrounded by at least fifty acres of land.[17] The founders believed that such a location ensured the most cheerful and healthy environment for the patients. The "charming retreat" of Blackwells Island in New York City's East River was an ideal location for the reformation of both prisoners and lunatics, wrote the novelist and abolitionist Lydia Maria Child, for it would return them to "the quiet language" of nature which they had forgotten while "tossed on the roaring, stunning surge of society."[18]

The new institutions were meant to be soothing retreats from the turmoil of the unruly city. R. A. Smith in his guidebook, *Philadelphia As It Is* (1852) described the "pleasure-ground" surrounding the Pennsylvania Hospital for the Insane as "beautifully undulating, and interspersed with clumps and groves of forest trees." In this environment the "horrors of the madhouse" were replaced by "kindness and by love," and by activities meant to restore reason: "The mind is not allowed to brood over the past in a gloomy cell, but is kept in constant exercise, by labour or amusement in the garden, on the farm, or in mechanical employments;—riding in the circular railway, ten-pins; carriage riding, or long walks; the use of musical instruments; attendance at parties, lectures, concerts; all the usual varieties of games, and the use of a library and choice collection of papers and periodicals." The model for such an institution appears to have been the home

*American Asylum For Deaf and Dumb, Hartford,* from *The National Magazine,* November 1856. (Courtesy of Vassar College Library)

of a refined middle-class family that valued education and the arts, the kind of home defined by the "cult of domesticity." Smith praised the establishment of similar institutions throughout the United States in a manner which echoes the imagery applied to the idealized home of the Willey family: "They are like green spots of verdure amid the desert, where the mind impaired in its journey, can find peace and repose."[19] Although, as Rothman points out, the calm atmosphere of the asylums was frequently enforced by a factory-like system of discipline, these institutions appeared, like the Willey home, to offer a retreat in an increasingly competitive society.

There were also religious motives for admiring the new institutions. The romantic view of nature and the idea that knowledge came primarily through the senses, a theory that was prevalent among reformist educators of the day, sharpened the idea that those without sight or hearing were deprived of access to God through His creation. "Vague and imperfect indeed are the views which the untaught deaf mute entertains of the Supreme Being," wrote L. P. Brockett in *The National Magazine* in 1856. "The thousand evidences of his goodness and love which the Christian mother points out to her child, are lost upon him." Particularly

devastating, from the point of view of the tourist, was the blind or deaf person's loss of access to the sublime manifestations of God's power—"the deep bass of the mighty cataract, the roar of the ocean surf, the pealing of the thunder, Heaven's artillery."[20] Thus Harriet Martineau was thrilled to see a blind boy accurately trace the route of her journey through the United States with his finger on a raised map as she described her trip to him. Martineau, who herself suffered from deafness, also enthusiastically quotes a deaf-mute's account of her impressions of a trip to Niagara Falls: "The Rapids appeared to us beautiful and violent and quarrelsome. . . . The Falls seemed to us angry and beautiful. We stayed in the part near the Falls for a long time, and felt amazement."[21] Such examples demonstrated that the deaf, dumb, and blind could be taught to apprehend some of the beauties of God's creation that ordinary tourists themselves enjoyed. Such achievements appeared, as Smith put it, to fulfill "the words of the Prophet, that 'the blind would see, the dumb speak, and the ears of the deaf be unstopped.' "[22] Those who seemed forever cut off from the word of God or the sight of his creation, from the paths of salvation open to people who had no handicaps, might in the asylums be led to a knowledge of Scripture.

The most celebrated example of the successful instruction of the deaf, dumb, and blind was Laura Bridgman, a precursor of Helen Keller and the prize pupil of Samuel Gridley Howe, first director of the Perkins Institution in Boston. Howe, a romantic hero of the reform movement, was called Cadmus of the Blind and celebrated in a poem by John Greenleaf Whittier, for he not only pioneered the teaching of the blind and led other reform efforts, but fought in the Greek Revolution against the Turks and was imprisoned by the Prussians for aiding Polish refugees. Byron's cavalry helmet, which had been presented to Howe by the Greek government, hung in his home in Boston. His work with Laura Bridgman and other blind children, however, was considered his greatest achievement and many visited the asylum to see it. When Howe began his work there was no school for the blind or even a person with experience to teach the blind in the United States and he had to go to Europe to study the methods only just beginning to be used there.[23] Deprived not only of sight and hearing, but also of smell and almost entirely of taste, Laura Bridgman possessed only her sense of touch with which to apprehend her surroundings. Thus she was cut off from the moral influence of both nature and family. At the age of four, wrote Howe in an account of Laura's life from which Dickens quotes extensively in his *American Notes*, "The darkness and the silence of the tomb were around her: no

95

mother's smile called forth her answering smile, no father's voice taught her to imitate his sounds." Without the enlightening power of reason, wrote Howe, it would soon have become necessary to restrain her by force. Howe describes how he taught her language first by attaching the names of objects in raised letters to the objects themselves, then by showing Bridgman how the names of the objects could be spelled with the individual letters, then by providing her with a set of metal letters with which she could make words and sentences by fitting them into a board, and finally by teaching her how to communicate through signs made with her fingers. Her ability to communicate by this means, which was frequently demonstrated to visitors to the institution, seemed a miracle. At the time of Dickens's visit, Howe was seeking to convey to Bridgman "some adequate idea of the Great Creator of that universe in which, dark and silent and scentless though it be to her, she has such deep delight and glad enjoyment." For Dickens she was a symbol of hope, happiness, and peace, a model for the ordinary person in facing the vicissitudes of life: "Learn healthy cheerfulness, and mild contentment, from the deaf, and dumb, and blind!"[24]

The success of the asylums for the deaf, dumb, and blind was easily demonstrable; the effectiveness of the penitentiaries, on the other hand, was questionable and controversial. The new American prison system sparked the interest of tourists not only because it promised real reform of the criminal, but because of the intense debate over two extreme, but different approaches to accomplishing this goal. The Auburn or silent system, developed between 1819 and 1821 and employed at the New York State prison at Auburn, allowed prisoners to eat and work side by side but enforced a code of absolute silence; the Pennsylvania or separate system, introduced in Pittsburgh in 1826, Philadelphia in 1829, Wethersfield, Connecticut in 1827, and favored by de Tocqueville and Dorothea Dix, isolated each prisoner in a separate cell with its own small yard. Each prisoner was brought hooded to his cell and so never saw or was seen by any other prisoner. After an initial period, the prisoner was provided with work to do (e.g., shoemaking) and books to read. Both the silent and separate systems were intended to bring about a transformation in the character of the criminal similar to the religious conversions often experienced by ordinary people during the period.[25]

Harriet Martineau, who visited the penitentiary in Philadelphia in the 1830s, believed that the separate system was the best that had been devised. It protected the prisoner from the corrupting influences of other prisoners, it established a relationship of trust

between the prisoner and the wardens who met each prisoner individually and face-to-face, and protected the prisoner's self-respect. The prisoners she spoke with indicated that they preferred it, despite its "dreary solitude." The silent system, she felt, by permitting prisoners to be together but not allowing them to speak to each other, made a natural, innocent act into a crime and thereby destroyed the prisoner's self-respect. The prisoners learned to talk between their teeth to elude the spies who watched them through peepholes. "They are denied the forgetfulness of themselves and their miseries which they might enjoy in free conversation," she wrote, "and also the repose and the shelter from shame which are the privileges of solitary confinement." As an example of the moral influence that a warden in one of these institutions might have over a prisoner, Martineau tells a story about Captain Pillsbury, the warden of the penitentiary in Wethersfield, Connecticut. On hearing that a prisoner had threatened to kill him, Pillsbury invited the man to shave him while no one else was in the room. "The prisoner's hand trembled; but he went through it very well. When he had done, the Captain said, 'I have been told you meant to murder me; but I thought, I might trust you.' 'God bless you, Sir! you may,' replied the regenerated man. Such is the power of faith in man!"[26]

Other European visitors to American prisons, like Dickens and his fellow Englishman, Alfred Pairpoint, found the separate system extremely cruel. After visiting the Eastern State Penitentiary in Philadelphia, Dickens wrote a passionate attack on its methods in his *American Notes*. Although he admired the "perfect order" of the prison building and recognized the benevolent intentions of the founders, the inmates seemed to him like people "buried alive." He admired the way one prisoner had painted the walls and ceiling of his cell in beautiful colors and had cultivated the small patch of ground in the yard behind, but the patch of garden looked to him like a grave. "The taste and ingenuity he had displayed in everything were most extraordinary; and yet a more dejected, heartbroken, wretched creature, it would be difficult to imagine." Dickens believed that the "slow and daily tampering with the mysteries of the brain" by means of solitary confinement was "immeasurably worse than any torture of the body" and was convinced that the mental state it produced made the inmate "unfit for the rough contact and busy action of the world."[27] The silent system, he believed, was far superior.

Images of the tomb and resurrection occur frequently in the accounts of prisons and asylums and suggest that these institutions symbolized, for some visitors at least, the fear of spiritual death, of

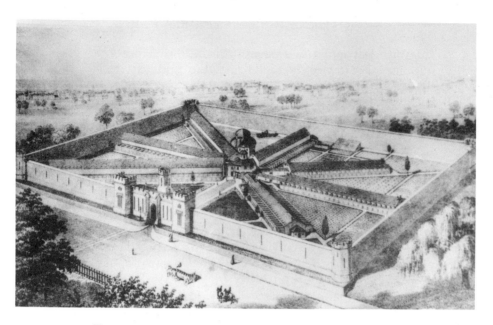

*Eastern State Penitentiary, Philadelphia.* (Courtesy of the Pennsylvania Prison Society)

being cut off from life and God by sin or physical infirmity on the one hand, and the hope of liberation on the other. To visit the penitentiaries was to experience emotions of sadness and fear, but also the Christian promise of salvation. People hoped to find in these institutions dramatic examples of people passing from darkness and silence into light and joyful sound. Miss Foster, the "living, genial, bright form" who served as the superintendent of the female section of the Tombs in New York City—not in most respects one of America's model prisons—presented Fredrika Bremer, the Swedish novelist, with a rosebud from the garden she kept within the prison and from which she cut flowers for prisoners who behaved well or were depressed. Bremer kept it "in memory of her, and hope of the Tombs; for within these Tombs I had beheld the work of resurrection."[28] Gilman, whose idealistic views of the system were not shared by everyone, found the solitary confinement of the separate system frightening but in a romantic, melancholy way. Inspired by the tiny garden kept by a convict released the day of her visit, she regarded his isolated cell as a "chrysalis, from whose dark folds had burst / Th' unfettered wing; or grave, from whence the spirit / Wrapp'd in earth's death-robe long, had sprung in joy."[29]

Tourists visited America's new prisons and asylums until the 1850s because they perceived them as the special contribution of

American society to the moral advancement of humanity. When they visited them, they entered a world complete within itself, which in some respects seemed more perfect than the ordinary world in which they lived, more like the serene world of the pastoral dream. As Rothman and his fellow historian James Leiby both point out, these institutions resembled the utopian communities of the day, like Brook Farm and New Harmony, which were intended to eliminate the disorder and stresses of society at large through the design of ordered environments.[30] As the imagery of burial and rebirth and the story of Laura Bridgman suggest, people expected that miraculous transformations might be brought about by these institutions. They were monuments to the forces of social redemption in which the reformers of the period put their faith: Christian benevolence, enlightened reason, egalitarian democracy, and the influence of Nature.

As sacred places—places which might serve as national monuments or where the divine might appear to enter the world—the asylums and prisons had, at best, a precarious existence. Their sacred aura could only be sustained by the Romantic optimism about nature and human nature which was present at their founding. By the 1850s, as the sense of boundless possibilities and the promise of human perfectibility which characterized the America of the 1820s, 30s, and 40s gave way to a perception of human limitations and a need for tighter control, the asylums and prisons lost their lustre.[31] Within the institutions themselves, the reliance on "moral influence" and useful labor which inspired their founders soon gave way to a bureaucratic approach that emphasized security and discipline. The use of corporeal punishment increased in prisons and insane asylums. People who had once been excited and curious about the new methods of treatment lost interest as the institutions themselves failed to live up to their early promise of curing or reforming their inmates.[32] By 1860 prisons and asylums could no longer be regarded as important tourist attractions, although at least a few tourists continued to visit them after that date.[33]

The rural cemeteries which sprang up in America during the same period as the prisons and asylums were far more popular and successful as tourist attractions. The three most famous—Mount Auburn in Cambridge (1831), Laurel Hill in Philadelphia (1836), and Greenwood in Brooklyn (1837)—were the models for numerous other cemeteries throughout the country. "Already," wrote T. D. Woolsey in 1849,

> not only the larger towns, as Boston, New York, and Philadelphia, but smaller ones, as Springfield and Worcester, and we know not

how many others, have large areas in their neighborhood laid out for the mansions of the dead, where beauty of scenery, taste in landscape gardening, elegance and costliness of monuments awaken wide curiosity, so that the stranger who should not visit them would be regarded as having only half finished his sight-seeing.

One of the directors of Laurel Hill reported that 30,000 people visited that cemetery in 1848 and Andrew Jackson Downing estimated that twice that number visited Greenwood and Mount Auburn.[34] By 1860 the numbers had grown to an estimated 140,000 at Laurel Hill and 400,000 to 500,000 at Greenwood, according to one estimate. No place, of course, could be more obviously sacred ground than a cemetery. The rural cemeteries were, moreover, America's first public parks. They were intended from the beginning to be places of resort, not only for those who had friends or relatives buried there, but for the general public as well. Père-Lachaise, the cemetery built in Paris in 1765 which inspired Mount Auburn and its successors, was well known for attracting both the residents of Paris and foreign tourists. Like "the Elysian Fields of the Egyptians," wrote Henry Dearborn in his 1831 report to the Massachusetts Horticultural Society recommending the establishment of Mount Auburn, the cemetery and the experimental garden attached to it, "will present one of the most instructive, magnificent and pleasant promenades in our country."[35]

The design of the rural cemeteries itself encouraged tourism. The winding avenues and paths invited leisurely carriage rides and walks, a tower on the top of Mount Auburn provided a view of both the cemetery and the surrounding countryside, and a circuit route, called the Tour, guided the visitor to Greenwood past the principal tombs, graves, and views. Père-Lachaise provided the idea of a "city of the dead," but the English landscape tradition dictated the laying out of the grounds. The sites chosen for Mount Auburn, Greenwood, Laurel Hill, and many other rural cemeteries possessed the inequalities of surface and variety of feature that formed the ideal picturesque landscape. "Every mind capable of appreciating the beautiful in nature," wrote the author of an 1844 guide to Laurel Hill, "must admire its gentle declivities, its expansive lawns, its hill beetling over the picturesque stream, its rugged ascents, its flowering dells, its rocky ravines, and its river-washed borders."[36] The way the avenues and paths were adapted to the contours of the land enhanced this variety and helped produce the picturesque effect desired.

The rural cemeteries attracted visitors not only because of their picturesque beauty, but because they represented tangible expressions of "noble sentiments and refined taste."[37] The image of

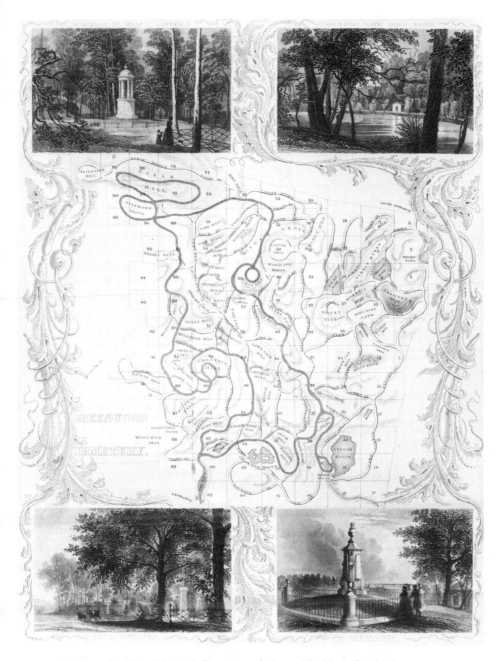

James Smillie, *Map of Greenwood*, from N. Cleaveland, *Green-
wood Illustrated*, 1847. (General Research Division, The New
York Public Library, Astor, Lenox, and Tilden Foundations)

Americans as "a hard, practical people," as the author of one guidebook put it, "intensely absorbed in business," and "surrounded by circumstances which accustom us to the livelier kinds of excitement,"[38] was softened by the beauty and repose of the new rural cemeteries. They became a source of national pride. Americans who cringed at the descriptions of American crudity by Dickens, Frances Trollope, and other foreign visitors, must have been pleased when Lady Emmeline Wortley wrote after her visit to Greenwood: "When will London have any thing even *approaching* to this magnificent cemetery?"[39]

Besides their beauty and the patriotic pride they evoked, the rural cemeteries attracted Americans because they embodied, in an exciting form, some profound changes taking place in American values and ways of living. Like the asylums and prisons, they also helped relieve anxieties about the increasing density and disorder of American cities. Until the establishment of rural cemeteries, most residents of American cities were buried in churchyards or in vaults beneath the churches. Burial places in the city, argued writers praising the establishment of rural cemeteries, had become unhealthy, grim, insecure, and "glutted with inhabitants."[40] They were too close to the noise, hurry, and dirt of business, and were often not well cared for. Headstones leaned or fell to the ground, weeds grew among them. Too often, "the ruthless spirit of money making" allowed new streets and buildings to encroach upon them. Old graves were reused, with or without the removal of the remains of the previous tenant, and doctors testified that the crowding together of bodies in vaults caused "miasmata" which endangered public health.[41] "Why should we deposit the remains of our friends in loathsome vaults," wrote Joseph Story in his address at the consecration of Mount Auburn in 1831, "or beneath the gloomy crypts and cells of our churches, where the human foot is never heard, save when the sickly taper lights some new guest to his appointed apartment . . . ? Why should we expose our burying-grounds to the broad glare of day, to the unfeeling gaze of the idler, to the noisy press of business, to the discordant shouts of merriment, or the baleful visitations of the dissolute?"[42] Rural cemeteries, "sufficiently remote to be beyond the range of city improvements, yet so near as to be of convenient access," as another writer put it,[43] offered a solution to these urban ills. They provided privacy and quiet for the living who came to visit, space and security for the dead. The dead were the first people to move to the suburbs.

The movement of burial grounds to the suburbs reflected not only a concern with urban noise, crowding, disease, and disrup-

James Smillie, *Rev. Dr. Channing's Monument, Mount Auburn*, from *Mount Auburn Illustrated*, 1847. (Courtesy of Adriance Memorial Library)

tion, but a determination to banish Calvinist gloom. The picturesque landscapes of the rural cemeteries took away the terror of death and replaced it with hope. Christianity, Story and others insisted, was above all an optimistic religion. "The house of the dead is to a heathen mind a house of desolation," wrote the author of an article in the *Christian Review* in 1848, "But Christianity dispels its cold and cheerless horrors. It makes it a place of calm and serene repose, a house of expectation, where mortal relics await a promised immortality."[44] City burial grounds were not only unwholesome, crowded, and insecure; they lacked Christian cheer. In the rural cemetery, on the other hand, the trees, flowers, and grass symbolized eternal life. For Harriet Martineau the beauty of nature at Mount Auburn muted all grieving. The cemetery appeared to her to be the sacred source of all life and to assure the resurrection of the body as well as the spirit: "A visitor from a strange planet," she writes, "ignorant of mortality, would

take this place to be the sanctum of creation. Every step teems with the promise of life. Beauty is about to 'spring up out of ashes, and life out of the dust': and Humanity seems to be waiting, with acclamations ready on its lips, for the new birth."[45]

The promoters of rural cemeteries recommended that they be situated within three or four miles of the city so that they could be reached easily by carriage or on foot. Laurel Hill was only three-and-one-half miles from Philadelphia and was situated on a rugged, wooded bluff overlooking the Schuylkill River. Greenwood and Mount Auburn were about the same distance from New York and Boston, and the visitor could obtain from their heights a panoramic view of both city and country. The appeal of such a location for a cemetery as well as for an asylum, was not only its convenience, but the contrast it presented to the nearby city. "A short half-hour ago," wrote Nehemiah Cleaveland, the visitor to Greenwood "was in the midst of a discordant Babel; he was one of the hurrying, jostling crowd; he was encompassed by the whirl and fever of artificial life. Now he stands alone, in Nature's inner court—in her silent, solemn sanctuary."[46] In their repose and security rural cemeteries, like the suburban developments soon to follow, provided retreats from the unceasing change that was more and more characteristic of American cities.

The lots in Mount Auburn and other rural cemeteries were sold as real estate, the purchasers owning their lots in fee simple, although required to abide by the regulations of the cemetery of which they became joint stockholders. In many ways the lots were a property owner's dream. There were no taxes, they could not be sold to cover the debts of the cemetery, and part of the purchase price was placed in a fund for perpetual care of the cemetery grounds, thus insuring that the neighborhood would always be kept up. Each lot was as secure and permanent as a piece of property could be. In a rural cemetery wrote Rev. A. D. Gridley of New York City, in 1863, "a spacious burial-lot can be obtained at a moderate sum by every household, that shall remain an heirloom forever sacred and inviolate, kindred of several generations can repose together."[47]

Moreover, unlike the old burial grounds, the lots provided ample scope for displays of fashion, pride, and social status in the construction of impressive monuments. The description of lots in the guidebooks sometimes read like advertisements for suburban homes: the lot in Mount Auburn belonging to Little and Brown "attracts attention from the peculiar appropriateness of the design of its two freestone Gothic monuments, and the care that is evidently bestowed upon the lot itself. Every thing about it looks

W. H. Bartlett, *Cemetery of Mount Auburn*, from *American Scenery*, 1840. (Courtesy of Adriance Memorial Library)

neat and in good taste and devoid of any attempt at display."[48] Owners of lots could indicate both their taste and their virtue by taking good care of them. Cornelia Walter, writing in *Mount Auburn Illustrated* in 1847, advised that "the flowers planted on or around the spot of internment, whilst as far as possible maintaining their natural appearance, should never be permitted to run together and crowd like weeds, but should be so carefully trained, separated, and arranged, as to impress the passerby with a sure feeling that those interred beneath, have a perpetual memory in the hearts of the survivors."[49]

Lots were usually purchased as family lots and laid out along one of the curving avenues or paths like the lots in one of the suburban developments later designed by Frederick Law Olmsted and his followers. The avenues, paths, hills, dells, and ponds in Mount Auburn, Greenwood, and Laurel Hill were given the sylvan names later popular for suburban streets and developments: Willow Avenue, Cypress Avenue, Cedar Hill, Bay-Grove Hill, Orchard Hill, Magnolia Avenue, Woodland Avenue. The lots

E. Wason/N. Carr Plot, Mount Auburn Cemetery. (Author's photograph)

were often surrounded by stone curbing, sometimes surmounted by a wrought iron fence. Stone steps descended to the avenue or path. The lot number was engraved on one of the steps and the family's name on the front curbing. The whole effect reminds one of an elegant suburban home of the period. And, in fact, the same architects who designed homes for wealthy people frequently designed the enclosures and monuments of their burial lots as well.[50]

The lot usually contained a family monument in the center surrounded by smaller stones for the deceased members of the family. Occasionally even the family dog was buried along with the rest of the household. In the earlier burial grounds, situated beside or beneath the church, people were buried with the congregation they belonged to. Families might be buried together, but their lots were not clearly demarcated as they were in the new rural cemeteries and certainly not laid out as if they were homes. In the rural cemetery your neighbors were not necessarily members of the same congregation. You might not even know them, although relatives and neighbors were sometimes encouraged to buy lots near each other.[51]

This shift in the setting of burials from the church or churchyard to a picturesque park, and in the social unit of burial from the congregation to the family, reflected the emerging bourgeois,

Old Burying Ground, Cambridge, Massachusetts (1635). Burial place of early settlers and leaders of Cambridge and Harvard. (Author's photograph)

consumer culture of nineteenth-century America, a culture which expressed itself in the 1840s in the establishment of America's first commuting suburbs as well, and in the design and furnishing of the homes in those suburbs.[52] The secularization of American culture, however, was disguised in religious rhetoric. The Reverend Henry Ward Beecher, members of whose wealthy, suburban Brooklyn Heights congregation bought lots in Greenwood, argued that the design, furnishing, and landscaping of the home and its grounds was an indirect form of philanthropy. The beauties of domestic architecture and of the grounds surrounding people's homes educated and elevated the taste of the lower classes, he argued. Thus when Christians spent money to improve their homes and enhance the lives of their families they were contributing morally to their community. Such an argument could be applied equally well to the adornment of cemetery plots.[53]

The home, moreover, as is evident in the literature of the Willey Disaster, was consecrated as a sacred institution and the grave, as a replica of the home, not only imitated the home's material form, but partook of its religious significance. It metaphorically bound a family's earthly residence to their eternal "home"

above. In addition, the family plot carried the meaning embedded in the word "cemetery" itself. "Cemetery" came into common usage with the new mode of burial in the 1830s, replacing the earlier "burial ground" or churchyard. It meant "sleeping place" in Greek and, according to nineteenth-century scholars, was the term adopted by early Christians to distinguish their own view of death as a temporary rest, from the Greek and Roman view that it was final. In consecrating the Oak Hill Cemetery in Newbury-port in 1842, Jonathan Stearns wrote, "Let it ever be, what its name indicates, a *cemetery*, a place of rest, a *lodging-chamber*, where the sleep of the grave may be slept undisturbed, till the morning of the Resurrection shall break it."[54]

Since the new rural cemeteries housed their residents by family, they kept the Christian home intact, just as the Willey family had been kept together by their sudden death in a common grave: "This . . . is one of the pleasantest thoughts connected with rural cemeteries," said a writer in the *Christian Review*, "that pro-vision is made that those whom affection and sympathy grouped together in life may sleep in a family group in death. Delightful, yet affecting, is it to look upon the graves of a household, all within the same small enclosure, awaiting together the morning of the resurrection."[55] The inscription on the Magoun Monument in Mount Auburn reads:

> A household tomb, to Faith how dear!
> A part have gone; part linger here;
> United all in love and hope,
>     One household still!
>
> Together we shall sleep,
> Together may we rise,
> And sing our morning hymn,
>     One household still!

To those still living, the family lot provided a second residence to which they would move after death. "We doubt not," wrote Nehemiah Adams in 1834, "that to many there is a spot in these grounds which next to the fireside is more endeared than any spot on earth."[56] The form of the cemetery lot implied that not only the soul, but the home and the domestic life lived in it would continue, somewhat the way the Indian custom of burying a bow and arrows with a dead hunter prepared him to resume his occu-pation in another world. One monument in Greenwood even memorialized the home and mode of life of a commuter. On its facade appears in relief the residence of Mr. Charles Griffith, who

Graves of Willie (d. July 15, 1865; 18 years old) and Abbott Wingate (d. May 23, 1865; 20 years old) with their dog ("Their favorite") in Wingate family plot, Mount Auburn Cemetery. (Author's photograph)

is shown saying goodbye to his wife before leaving for work. The horse-car can be seen waiting in the background.

The promoters of rural cemeteries regarded them as models which might influence the landscaping of both public spaces and private homes. "Indeed," wrote Downing, "our rural cemeteries are doing a great deal to enlarge and educate the popular taste in rural embellishment."[57] Gridley, writing in 1863, connected the landscaped plot in the rural cemetery explicitly to the landscaped grounds of the suburban home: rural cemeteries, he said, "suggest new ideas, they awaken pure tastes, they show the observer how the simplest piece of ground may be embellished by a little skill and labor; how even the stern repulsiveness of the grave can be chastened; and they send him back to his usual sphere of life determined to adorn his own home, and to beautify the spot where he expects ere long to lay his ashes."[58]

Not everyone was happy with the suburban values the rural

cemeteries embodied. Many admired the rural cemeteries for their calming effect: the "trees, the flowers, the still waters, and the green landscape," wrote Wilson Flagg, "soften our grief into a tender melancholy, and quiet the anxieties of faith."[59] But others wondered whether it was such a good thing to quiet the anxieties of faith. Adams worried that the visitor to Mount Auburn might be lulled into thinking that everyone who died was pardoned. One should not assume, he warned, that because God makes the beauty of Mount Auburn available to all that He "makes no distinction in human character."

What most deeply troubled Adams was the way Mount Auburn focused the attention of the visitor on the substance and comforts of this world. People might conclude that they loved God when in fact what they loved were "the avenues and paths and the summit of Mount Auburn." He feared rural cemeteries would "fill the mind with a sentimental materialism, and make dying appear as a repose amidst evergreens."[60] This materialism bothered other writers as well. They detected a dangerous error in making the grave a replica of the home. In the most thorough critique of the movement, T. D. Woolsey wrote that it is very appropriate "to select a place possessing great natural beauties for a dwelling place of the living." Such a location possessed moral as well as aesthetic advantages: "The moral nature may be assisted by raising up for it an efficient helper in the love of simple unadorned scenery,— not to mention the pleasure which good looking houses, picturesquely situated, strike into the traveler's heart, as he passes them by." But, do such reasons apply to the selection of sites for cemeteries, Woolsey asked? He thought they did not. It might be pleasant to visit Laurel Hill Cemetery in the spring, "when the dogwood is in blossom, and the Judas tree . . . is covered with its red robe of flowers," and to walk "along the banks overhanging the Schuylkill, watching perchance the little steamboat as it comes down the stream, or the cars and canal boats, bringing their loads to the great city," but such lovely scenery drew the mind away from the dead. The solemn feelings which cemeteries ought to elicit were "repressed by the very beauties of the spot."

Even worse, Laurel Hill appealed to fashion and the desire to own a choice bit of property: "Perhaps, the thriving merchant, with a young family, as he visits it, thinks it a genteel place, and resolves to go to the directors to enquire the price of a lot." The dead were too well-housed at Laurel Hill, as if, in the grave, they had found a permanent residence. Woolsey preferred the cemeteries for strangers and travelers in Europe with their simple, inexpensive monuments: "In such solitude, one can realize what it is

to be a pilgrim and stranger on earth, and how death isolates its passengers from all that loved and valued them once."[61]

The prominence given to the family lot in rural cemeteries bothered Woolsey for another reason too: it separated people from the Christian communities to which they belonged. Although he recognized the difficulty of maintaining churchyards amid the congestion of cities, he admitted that he liked them better than the new cemeteries. While the promoters of rural cemeteries argued in their favor from precedents among the Hebrews, Greeks, Romans, and early Christians, Woolsey argued that the later Christians had adopted the churchyard and parish burying-ground because of the Christian belief that "Christian brotherhoods" should "rest in one place, that when the trumpet should sound, they might rise together to meet their Lord." It should be clear, he wrote, that a burial ground "belongs to a religious community, and that the mass of those who lie in it are animated by the same Christian faith and hope."[62]

Woolsey's congregational principle did not preclude the burial of family members together, but it raised the issue of whether cemeteries in which lots were bought by individual families at a price not everyone could afford and then adorned in ways that expressed the taste and status of the owners were really democratic in a Christian or political sense. Although "families should ever lie together," Woolsey wrote, "we ought also, to recognize brotherhood in faith, or the brotherhood of the human kind, or both. But at present in our new burial grounds, brotherhood in wealth seems to be the principle of admission. The poor must stand aloof and seek some less genteel place of burial."[63]

The rural cemeteries apparently did make some provision for the poor. Nehemiah Cleaveland, who shared some of Woolsey's concerns, notes that Greenwood contained a public lot "where a single grave at moderate cost can be had." He also mentions that several congregations had bought lots in Greenwood in which all their members, both rich and poor, could be buried, a practice which he hoped would become common.[64] But these exceptions merely dramatized the radical change that had taken place in the social structure of burial grounds. The largest sections of the rural cemeteries consisted of fashionable neighborhoods of private lots. Even Wilson Flagg, a rural cemetery enthusiast, lamented that they "exhibit too many sad attempts to carry the arbitrary distinctions of social life down to the grave, where all the slumbering inhabitants should be united in one common brotherhood."[65]

This obsession with social distinction was particularly evident in the style of monuments. From the beginning of the movement

writers urged that monuments be kept simple. William Peabody wrote in the *North American Review* in 1831 that "The ornaments of the sepulchre should be trees and flowers. Let the monuments be found in the noble forests of our land."[66] Like Isaac McLellan who believed that the White Mountains surrounding the Notch provided a noble and sufficient monument to the Willey family, writers like Peabody felt that natural, God-created monuments were all that a virtuous, egalitarian people should need. But it quickly became fashionable to erect substantial, sometimes showy monuments in the rural cemeteries and to adorn them with a variety of symbols. Cornelia Walter insisted that "*taste*, whether exhibited in flower-crowned mounds, or in the chaste and classic monument, may exist in a rural cemetery, in close connection with *morals*."[67] A rural cemetery *could* conform to the principles of Christian virtue and remain artful and pleasing in its design, but as Walter's statement implies, they often did not.

A variety of monumental styles became available to the consumer: obelisks, tiny pyramids and Gothic steeples, miniature Greek and Egyptian temples, broken columns, draped columns, Roman funeral urns on pedestals, veiled urns, sarcophagi, as well as statues and slabs mounted on foundations. The classical styles were the fashion. The monuments could be adorned with inverted torches, hourglasses, butterflies, scythes, harps, snakes tasting from a bowl, snakes with their tails in their mouths, sheaves of wheat, and so on.

Some questioned the appropriateness of classical monuments and symbols in a Christian culture. Cleaveland complained that the broken column and the upside down torch suggested the pagan belief that death was final and seemed to deny the Christian promise of resurrection. It would be far better, he argued to erect symbols of hope, reminding us that "the broken pillar will be more than restored, and the extinguished blaze shall be relumined, never to fade again."[68] The costliness of many of the monuments also caused concern. Too much marble in a memorial, wrote Flagg, "implies some doubt of the immortality of its subject." It also struck him as antirepublican. The "members of a republic . . . where all are politically equal," should not be imitating the lavish monuments of the Old World. He was disturbed that money seemed to be replacing virtue in character and deed as a sign of a successful life, and he found the attempts of wealthy, but undistinguished people to memorialize themselves grotesque. You "cannot force immortality upon one who lived a private life, or who was conspicuous only in a circle of fashion," Flagg wrote. In the long run such attempts would prove embarrassing: "Who

Samuel Appleton (d. 1853), Mount Auburn Cemetery. (Author's photograph)

is this man, posterity will inquire, with a tower of stone erected over his remains, whose works and deeds are not recorded even in the local history of his own neighborhood?"[69]

The fact that taste in monuments was a lively topic of discussion among those who wrote about rural cemeteries underlines the fact that these places were important arenas in which rivalries in consumption and displays of wealth were played out. Those who promoted the rural cemeteries hoped that people would be attracted to them because, as Flagg put it, the "emblems of grief and of the relations of time and eternity are picturesque and affecting," but they recognized that many of those who flocked to them went to gape at the "gewgaws and expensive follies."[70] Although intended to be places of meditation and schools of virtue, the rural cemeteries were for many people, places of recreation and consumption. Nathaniel Willis saw in Mount Auburn and other rural cemeteries "delightful indications of a purer growth in our national character than politics and money-getting,"[71] and there is no doubt that they represented an important achievement

Monument to Frederick Harnden (d. 1845), founder of express business in America, Mount Auburn Cemetery. (Author's photograph)

in landscape architecture. But they were also monuments to the materialism of American society and one of the earliest bazaars of consumer culture. There the rich could display their wealth and taste while ostensibly contributing to the civic good and the advance of Christianity. Tourists could go there for the same reasons they moved to the suburbs: to escape the unpleasant effects of industrialization and urbanization. At the same time, they could

consume the landscaped grounds and the various monuments as cultural products which reflected the fads of their society. The rural cemeteries were places where nature and art, the city and the country, the classical and the Christian, the secular and the religious, European and American culture met. Their great popularity can be attributed to the way they intensified and reflected back the emerging fashion-conscious, status-oriented, property-owning culture of the time. The well-to-do wished to display their wealth, the less well off to observe that display. Moreover, the American upper middle class was eager to associate itself with the classical past and with an optimistic Christianity that corresponded to its own economic optimism and expansiveness. The rural cemetery embodied at once the Christian hope of the resurrection and the new American dream: a fine suburban home in the best neighborhood.

The debate over the nature of the rural cemetery was an argument about the role of sacred space in a democratic and commercial

Monument to Frederick Harnden, side panel showing a package being delivered. (Author's photograph)

society. Would the popular desire for entertainment control the use of such places? Would private interests, represented in the case of the rural cemeteries by the monuments erected by individuals on their own plots, or commercial interests be allowed to determine the nature of such landscapes? Or, could the educated citizens of a democratic society shape them according to their genteel taste? Although Nehemiah Adams expressed some concern even in 1834, the sharpest criticism of the displays of personal wealth in the rural cemeteries appeared after 1848, when, as the historian John Higham has pointed out, Americans became more critical of individualism, more concerned with institutional planning and with organizing and conserving public spaces. The questions about who should control such spaces would be asked not only about the rural cemeteries but about the other public spaces of America's emerging national culture as well: the urban parks, national parks, and expositions that appeared soon after the rural cemeteries, and Niagara Falls which remained under private control until the 1880s. As these places achieved popularity, the desire on the part of many people for novelty and show came into conflict with the genteel ideal of contemplation and order.

The creation of Central Park and the other urban parks beginning in the 1850s was in part a response to the problem raised by the rural cemetery. Even some of the most ardent admirers of the rural cemeteries felt that their use as pleasure grounds was inappropriate. Caroline Gilman found the holiday mood offensive. The festive atmosphere, characteristic of the fairs surrounding the pilgrim churches of the Middle Ages, had here invaded the sacred place itself. There is "too much life," at Mount Auburn, she wrote, "too much of the world collected there. Idle questions of childhood, flippant jests of the gay who have none to mourn for, criticisms over the model of monuments where affection longs to come and lie down and weep alone, press on the ear with painful dissonance to the still harmonies of nature."[72] Andrew Jackson Downing also found the "gala-day air of recreation" in the cemeteries offensive. To him their popularity as gathering places clearly indicated the need for large public parks: "Judging from the crowds of people in carriages, and on foot, which I find constantly thronging Greenwood and Mount Auburn, I think it is plain enough how much of our citizens, of all classes, would enjoy public parks on a similar scale."[73]

Partly through the influence of Downing, who advocated the construction of a public park in New York City in an article in 1848, and also of William Cullen Bryant, editor of the *New York Evening Post*, the park idea gained support in the 1850s from a

group of leading citizens in New York City who persuaded the Common Council to acquire a large tract of land in the center of Manhattan. Frederick Law Olmsted was hired to design what became Central Park. Olmsted had been strongly influenced by Downing and was also familiar with the urban parks of Europe. The conditions he and Downing identified as creating the need for urban parks were the same as those motivating the construction of rural cemeteries: the overcrowding, dirt, disorder, and unhealthiness of the modern city and the stress caused by these conditions. As an antidote to the ills of the city, the large public park would provide fresh air, open space, and tranquility, and since the park would be in the very center of the city rather than in the suburbs, it had the advantage over the rural cemetery of being readily accessible. It would be possible to step out of the busy street directly into the soothing atmosphere of the park.

Olmsted conceived of Central Park and the many other urban parks he designed throughout the country in strongly touristic terms. They were meant to promote receptive rather than active experience. He wished to exclude competitive sports, parades, and other activities which only mirrored the busy life of the city itself, and to encourage instead the contemplative enjoyment of scenery. He ordered the planting of trees and shrubs, the construction of lakes, and the creation of open meadow to give the illusion of rural scenery. Whenever possible he preferred an open, pastoral landscape, since this provided the greatest contrast to the confining spaces of the city, but when the natural terrain made this impossible, as at the lower end of Central Park, he settled for more rugged picturesque effects. Roads for carriages and paths for walking and horseback riding were laid out to take advantage of the best views. As in the case of the rural cemeteries, roads and paths looped through the park allowing the visitor to make a leisurely tour, taking in each scene successively, but Olmsted also provided for large meadowlike areas in his parks, undivided by road or path, and creating for the park-goer the illusion of being in the open country. Furthermore, although he didn't entirely have his way in the end, he wished to exclude all architectural monuments, statues, and formal gardens. Unlike the rural cemetery there would be no reminders of the status-seeking society without.

A similar concept developed among the builders of cemeteries at about the time that Olmsted was constructing Central Park. First introduced in 1855 by Adolph Strauch, superintendent of the Spring Grove Cemetery in Cincinnati, the park or lawn cemetery featured open, uncluttered expanses of lawn rather than the uneven, wooded, picturesque scenery of the rural cemetery. Bronze

*Central Park*, 1863, John Bachmann, lithographer. (Courtesy of The
New-York Historical Society, New York City)

tablets set even with the surface of the ground replaced the rural
cemetery's distinct family plots and large monuments. There were
few roads and paths. By the final decades of the nineteenth cen-
tury the park cemetery would become the dominant form of
American burial ground. Like the parks designed by Olmsted, its
success owed something to the disenchantment with the individ-

ualism so ostentatiously expressed in the rural cemeteries. In the park cemetery the corporation which owned it and the cemetery superintendent determined how the graves were to be laid out and marked.[74]

Olmsted's desire for large open meadows within his urban parks expressed his intention of drawing as sharp a contrast with the city as possible. He also sought to achieve this by planting a row of trees completely surrounding the park which would effectively conceal the presence of the city from those within. The border of trees was also intended by Olmsted to mark a change in the nature of time. Within the sacred space of the park time would no longer be experienced as pressing. The hurry of the city would be replaced by a leisured, meditative state of mind. Olmsted's concept of the urban park in both its spatial and temporal dimensions suggests a nostalgia for paradise or a golden age in which the problems of the city and of a commercial, capitalist society did not exist.

But the urban park, as Olmsted conceived it, was intended to provide more than escape from the city, it would reform it. Although in one sense it would provide release from the restraints of city life, its calming effect would encourage order and security. It would, according to Olmsted, not only refine the taste and promote "courtesy, self-control, and temperance" among all classes but tame the unruly passions of the "dangerous classes." Olmsted feared the small groups of men loitering on the streets of the immigrant districts of the city, "rudely obstructing the sidewalks," commenting on the passersby, and descending into basement drinking establishments. A pastoral park, he believed, would draw these restless men into "family and neighborly parties" picnicking on the grass and refined by the influence of nature.

Like the asylums, prisons, and rural cemeteries built before them, the construction of the urban parks designed by Olmsted was motivated by an impulse toward reform and an effort to reduce the stress of an increasingly industrial and urban society. The urban park, however, did not aim at the redemption of the individual or romanticize the home in a suburban haven. It tried to bring order to the urban landscape itself and, by doing so, stability to society as a whole. Central Park was readily accessible and served the needs of all. Although it was enormous, it was simple and unpretentious. By choosing to draw as sharp a contrast as possible with the city around, Olmsted succeeded in avoiding the disturbing contradictions of the rural cemetery which functioned both as a retreat from the city and as a display of fashion, pride, and social status. Despite the invasion of statues, athletic fields,

J. O. Woodward, *Prospect Park, Brooklyn*, designed by Frederick
Law Olmsted, from *Picturesque America*, II, 1874. (Courtesy of
Vassar College Library)

museums, and zoos which Olmsted had wished to exclude, Central Park solved the problem of public space in a democratic society better than any other institution at the time.

Olmsted applied the principles he had established at Central Park to projects in Brooklyn, Buffalo, Boston, Louisville, and other cities throughout the country and his impact on the landscapes of those cities was enormous. It is possible, too, that the precedent established at Central Park influenced the creation of the first National Parks at Yosemite and Yellowstone in 1864 and 1872. Certainly the establishment of those parks expressed the same impulse to set aside large natural areas for the use of everyone. But Yosemite and Yellowstone not only met the needs of a democratic nation for public parks, they also satisfied the desire for monuments on a sublime scale, a desire which Olmsted did not share with many of his fellow Americans.

# ह्ल *Six*

## Scenery as Art: Yosemite
## and the Big Trees

LIKE THE Willey Disaster in the White Mountains in 1829, the discovery of the Yosemite Valley in the 1850s was a cultural event. Yosemite lay only 180 miles from San Francisco, yet it had remained virtually unknown to European Americans until the middle of the nineteenth century. A deep, enclosed valley, cut into the Sierra Nevada, with sheer granite walls rising 3,000 feet from the valley floor, Yosemite matched the beauty of the great monuments of European architecture yet possessed the freshness and wildness of unspoiled American nature. The nearly flat valley floor, on which the clear Merced River meanders through meadows and groves, made a natural park and the valley's granite walls displayed a variety of immense sculptured forms. For America's cultural nationalists it was as if both a slice of paradise and a natural cathedral had been found hidden among the mountains.

Early visitors raved about Yosemite's beauty. Albert D. Richardson wrote that looking down from Inspiration Point, where most of the visitors got their first impression of the valley, was like viewing "the interior of some stupendous roofless cathedral, from the top of one of its towering walls."[1] And when Samuel Bowles, the influential editor of the *Springfield Republican*, caught sight of Yosemite for the first time, it moved him to religious ecstasy:

> The overpowering sense of the sublime, of awful desolation, of transcending marvelousness and unexpectedness, that swept over us, as we reined our horses sharply out of green forest, and stood upon high jutting rock that overlooked this rolling, upheaving sea of granite mountains, holding far down [in] its rough lap this vale of beauty of meadow and grove and river,—such tide of feeling, such stoppage of ordinary emotions comes at rare intervals

122

in any life. It was the confrontal of God face to face, as in great danger, in solemn, sudden death. It was Niagara, magnified. All that was mortal shrank back, all that was immortal swept to the front and bent down in awe.[2]

Such rhetoric suggests a strong continuity between the response of tourists to Yosemite and to earlier attractions, but the almost immediate establishment of Yosemite as a major tourist attraction and, more important, its preservation in the form of a park represent not just continuity but a turning point in the history of American tourism and in the search for an adequate national cultural monument. By the 1850s tourism in the United States was well-established both as a cultural activity and as an industry. Although the age of the travel agent and the package tour had not yet dawned (that was to occur in the 1870s and 1880s),[3] entrepreneurs of various sorts from hotel keepers and agents for railroad lines to artists and writers recognized the profit to be made from catering to the rising tide of travelers and to the armchair tourists who consumed accounts and images of Niagara Falls, the White Mountains, and other places of interest at home. By the time Yosemite was developed as a tourist attraction in the late 1850s and early 1860s, the means of cultural production had become highly sophisticated and were tailored to a growing audience in the increasingly urban and industrial East. Yosemite, and Yellowstone later, were appropriated and produced for an audience hungry for national icons and for places which symbolized the exotic wonder of a region just beginning to be known and accessible to it. The raw material of nature was rapidly transformed into a cultural commodity by reproducing and marketing verbal descriptions and pictorial representations of these places, by building roads and railroads so that tourists could reach them, by constructing facilities to accommodate the tourists, even by the act of naming their features (a process which defined in important ways their cultural meaning). Photography, particularly in the form of the stereograph, played an important role for the first time in the production of tourist attractions and made it possible to manufacture and distribute hundreds of images showing the various points of interest. The magic of the new technology was enhanced by the way the stereograph created the three-dimensional illusion of being transported into the scene.

Yosemite, and Yellowstone as well, are remarkable for the self-conscious and efficient manner in which an alliance of scientists, businessmen, writers, photographers, and artists accomplished their cultural production. The way in which Yosemite, early in its

123

history, was granted to the state of California by the United States Senate for use as a public park indicates how aware educated people had become of the economic and symbolic importance of America's major tourist attractions. It also expresses, as in the cases of the rural cemeteries and Central Park, how sensitive Americans were becoming to the tension between commercial development and the need for places which could serve both as symbols of a national culture and as recreational areas open to everyone. Although Yosemite evoked images of the infinite and the cosmic, and thus seemed to symbolize the boundlessness of America as a nation, the way it was measured, commodified, and preserved suggests the increasing urge for consolidation, which as John Higham suggests, is characteristic of this period. Yosemite would not be controlled by individual desires, but by corporate needs and ideals.

Yosemite was discovered during an expedition against a band of Miwok-Paiute Indians, called the Ahwahneechees. Although the Joseph R. Walker party glimpsed Yosemite from the rim of the valley in 1833 and prospectors visited it during the gold rush, its existence did not become publicly known to the white world until the Mariposa Battalion pursued this group of Indians into the valley in 1851. White perceptions of the Indian occupants of the valley became an important part of Yosemite lore (a subject I will return to later), but the Indians themselves were soon dispersed and the entrepreneurs who followed in the tracks of the Mariposa Battalion recognized Yosemite immediately as a tourist attraction. They saw it not merely as sublime scenery, as the early visitors to the White Mountains or Niagara Falls had done, but imagined its future development. They had a clear sense of what kinds of places made successful tourist attractions, how they were made known, and how they were likely to develop.

The person who most swiftly and clearly recognized Yosemite's potential was James Mason Hutchings, a writer and publisher. Publicity from the Mariposa Battalion's 1851 expedition and a second one in 1852 aroused his interest and as a result he led the first group of tourists into the valley in 1855. Hutchings's glowing description of Yosemite's "wild and sublime grandeur," first published in the *Mariposa Gazette*, was reprinted in many other journals. In it he quotes the enthusiastic responses of his companions who, somewhat confusedly, saw in Yosemite the transformation of the earth predicted in Revelations: " 'What!' exclaimed one at length, 'have we come to the end of all things?' 'Can this be the opening of the Seventh Seal?' cries another."[4]

Hutchings's 1855 expedition resulted in the following year in

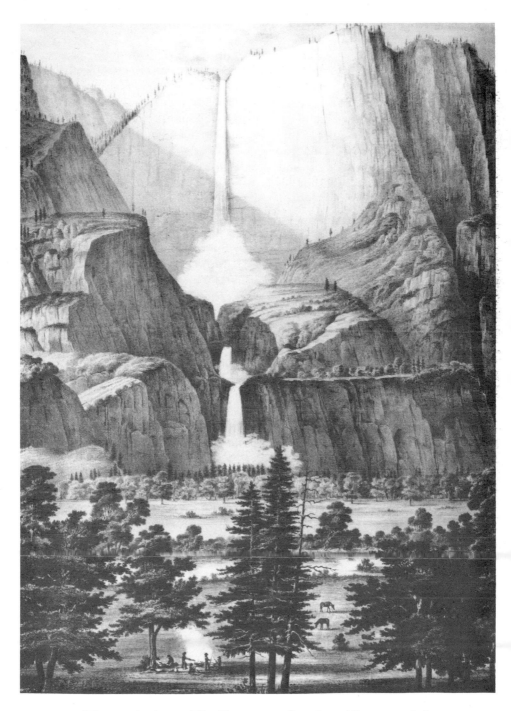

Thomas A. Ayres, *The Yosemite Falls*, 1855. (Courtesy of the California Historical Society, San Francisco)

the construction of a trail from Mariposa to Yosemite and the building of the first hotel. Although Yosemite remained difficult to get to for many years and accommodations were primitive, tourist parties visited the valley regularly from 1856 onward. When organizing the first group of tourists, Hutchings asked the artist Thomas A. Ayres to accompany them. In October 1855 he published a lithograph made from one of Ayres's drawings, thus making a visual image of Yosemite available to the public for the first time. When he published his account of Yosemite in the first issue of his *California Magazine* in July 1856, he used four engravings made from Ayres's drawings to illustrate it. Later he published another lithograph based on Ayres's work. Ayres returned to Yosemite on his own in 1856, made more drawings, and wrote an account of his journey for the *Daily Alta California*. Some of Ayres's drawings were exhibited in New York and at the time of his death in 1858 he was employed by *Harper's* to produce a series of illustrations for several articles they were planning on Yosemite. Ayres's drawings are simple and geometric. By eliminating detail, flattening surfaces, and sharpening cliff edges his drawings of *The Yosemite Falls* (1855) and the *Cascade of the Rainbow* (1855) dramatize the height and perpendicularity of Yosemite's walls. In their unworldly, even ghostly quality they supported Hutchings's suggestion that Yosemite represented a new heaven and earth.

In 1859 Hutchings brought the first photographer to Yosemite to make illustrations for his *California Magazine*. Charles Leander Weed took about twenty 11″ × 14″ photographs of the valley on glass plate negatives. He also made at least 40 stereographs, the double-image photographs which created a three-dimensional effect when viewed through a stereoscope. The stereograph was becoming popular just at this time and Yosemite benefited from the new form of armchair tourism which stereography made possible. Weed's large views and his stereos were displayed at Vance's gallery in San Francisco and helped to fuel the growing fame of Yosemite. To Ayres's unearthly depiction of Yosemite, Weed added a more realistic version that reveals the varied texture of its rocks and trees and the variety of its granite forms.

Together, the work of Hutchings, Ayres, and Weed established Yosemite as the major tourist attraction for visitors to San Francisco. No earlier tourist attraction had been promoted in such a systematic, thorough and rapid manner. The way Hutchings drew on his own literary skills, the artistic talent of Ayres, and the new technology of photography indicates a remarkable instinct for how to employ the means of cultural production. Other tourist attractions had been established by similar methods, but no one had di-

rected them so consciously and effectively. By the time he bought the Upper Hotel in Yosemite Valley in 1864, Hutchings was ready to reap the benefits of his promotional efforts.

But Yosemite's rapid ascent to the status of a national monument depended not so much on Hutchings's direct efforts to promote it as on the attention it received from other writers, painters, and photographers partly as a result of his campaign. Their celebration of Yosemite ultimately prevented Hutchings from receiving the full commercial reward he expected from his efforts. The well-known newspaper editor, Horace Greeley, made a quick trip to Yosemite in 1859 and published his account in the *New York Tribune* and in *An Overland Journey* (1860). The *New York Tribune* had a circulation of nearly 300,000 and was one of the most influential newspapers in the nation.

One of the people who read Greeley's account was Thomas Starr King who was about to go to San Francisco to become the minister of the First Unitarian Church. In Boston he was well-known as the pastor of the Hollis Street Church, a polished lyceum lecturer, and a travel writer. He had just published *The White Hills* (1859), his popular book about the White Mountains in which he recounted the story of the Willey Disaster. *The White Hills* was composed from a series of letters he had written to the *Boston Evening Transcript*, and when he arrived in California he continued to contribute to the same newspaper. He made the trip to Yosemite almost immediately and published an ebullient account in the *Transcript* between December 1, 1860 and February 9, 1861. The immense mass of El Capitan seemed to him to be "pushed up from below to give us a sample of the cellar-pavement of our California counties, and to show us what it is that our earthquakes joggle. . . . A more majestic object than this rock I expect never to see on this planet. Great is granite, and the Yo-Semite is its prophet!"[5] His description reached a large audience including Oliver Wendell Holmes and John Greenleaf Whittier who wrote to him in praise of his work.

King's account of Yosemite had a major impact in establishing Yosemite's reputation as a national treasure, not only because he had a gift for nature description, but because his fame as a minister, lecturer, and travel writer gave him authority with his readership. His book about the White Mountains was no ordinary guidebook. *The White Hills*, which is full of quotations from the Romantic poets and descriptions of nature as scripture, treated scenery as art and sightseeing as a cultural activity equivalent to a concert or visit to an art museum. King treated Yosemite with the same cultural seriousness. He was someone readers listened to and

when Hutchings and others wrote guidebooks to Yosemite in the years after King's visit, they quoted him and used his name to support their own assertions.

Several other painters, in addition to Thomas Ayres, also contributed to the public's awareness of the beauties of Yosemite in the 1850s and early 1860s, including Frederick Butman, Antoine Claveau, and the watercolorist James Madison Alden. But the photographers who came to Yosemite in the early years were as important as the painters in spreading its fame and, since the images they made could be reproduced, their work came into the hands of many more people. The most important of these photographers was Carleton Watkins who made his first trip to Yosemite in 1861 equipped with both a mammoth-plate and a stereographic camera. His photographs and stereographs beautifully captured the greatness of Yosemite granite—its form and texture—and made Yosemite's scenery dramatically accessible to the Eastern audience. It was no wonder that Fitz-Hugh Ludlow, who accompanied the painter Albert Bierstadt to Yosemite in 1863, wrote in *The Atlantic Monthly:* "We were going into the vale whose giant domes and battlements had months before thrown their photographic shadow through Watkins's camera across the mysterious wide continent, causing exclamations of awe at Goupil's window, and ecstasy in Dr. Holmes's study."[6]

As these writers, artists, and photographers made Yosemite nationally famous, and as Hutchings and others worked to develop it as a tourist attraction, a group of California gentlemen became concerned with its preservation. It is not known who composed this group or how the idea of setting Yosemite aside as a park for the free use of everyone originated. It is possible that King had an influence on the effort and was even personally involved in it himself. In addition to writing the series of articles for the *Boston Evening Transcript*, he preached a sermon on Yosemite soon after his return to San Francisco where he was an important intellectual leader. His text—"lead me to the rock that is higher than I"—and his belief that mountains "were created as an overflow of God's goodness"[7] indicate how clearly he regarded Yosemite as a sacred place, a view which could have encouraged its preservation. But the only person known to have had a direct role in the establishment of Yosemite Park was Israel Ward Raymond, the California representative of the Central American Steamship Transit Company who wrote to Senator John Conness of California on February 20, 1864, urging that Yosemite be permanently set aside as a public park. Senator Conness responded immediately by asking the commissioner of the General Land office to draw up a bill.[8] This

Full page advertisement from the *San Francisco Business
Directory*, 1873. (Courtesy of the California Historical
Society, San Francisco)

bill, which was introduced in the United States Senate on March 28, 1864, granted the Yosemite Valley and the Mariposa grove of *sequoia gigantea* or Big Trees nearby, to the State of California "for public use, resort and recreation . . . inalienable for all time." It passed on June 30, 1864, and the first national park was, in effect, established.[9]

As Alfred Runte has demonstrated in his history of America's National Parks, Yosemite and the Mariposa Big Trees were not set aside for environmental reasons. The idea of wilderness preservation did not become prominent until the end of the century and did not play an important role in the establishment of the national parks until the 1930s. Yosemite and the Big Trees were preserved because they were regarded as wonders, curiosities, and works of art. In a state which was otherwise rough and raw, and which had a reputation for greed and violence, Yosemite represented beauty. In an age when scenery and art were closely identified, Yosemite constituted an unparalleled cultural resource, not only for California but for the entire nation.[10]

The cultural motives of those who supported the bill were closely tied to economic ones. Senator Conness, anticipating the concerns of his practical-minded colleagues, emphasized in his argument in favor of the bill that Yosemite was "for all public purposes worthless." It was not, in other words, fit for mining, agriculture, or similar pursuits. It could therefore be set aside without interfering with the economic development of the country. He did not mention another economic consideration, however, which clearly influenced the supporters of the bill: making Yosemite free and open to the public would benefit the railroads and other commercial interests in California who wished to attract tourists to the state and encourage people to settle there. In suggesting the idea of Yosemite Park to Senator Conness, Raymond must have recognized that a major tourist attraction would increase travel to California on the steamship line which he represented.[11] Frederick Law Olmsted, writing in the year following the passage of the bill, assumed that one of the considerations motivating Congress must have been the "pecuniary advantage" that the nation would gain from possessing beautiful scenery which was free for anyone to enjoy. The natural scenery of Switzerland, he noted, had generated a major tourist industry that provided a market for Swiss farm products and stimulated the development of inns, railroads, and carriage roads. Yosemite, he predicted, would "prove an attraction of a similar character and a similar source of wealth to the whole community."[12]

Probably the most important factor in the preservation of Yosemite as a park was the example of Niagara Falls. The rapidity

with which Yosemite was described, painted, promoted, and preserved after its discovery reflected an awareness of the powerful role which Niagara had played in the cultural and economic life of the nation. Niagara shaped everyone's concept of what a tourist attraction was and what it might become. Thousands of people, including famous foreign travelers, had visited it; scores of writers had written about it; and many painters had painted it. Panoramas of Niagara had toured the country and thousands paid to see Church's famous painting of the Falls. Americans, in fact, had demonstrated an almost insatiable craving for images of the Falls in the form of paintings, engravings, lithographs, and, most recently, stereographs. By 1864 Yosemite was well on its way to attracting similar attention and Niagara was the standard by which it was measured. Its waterfalls were compared to Niagara's in terms of their height, volume, and beauty, and were found superior in the grandeur of their setting. The example of Niagara encouraged painters and photographers to deliver images of Yosemite to a hungry public, magazine editors to publish accounts of its wonders, and entrepreneurs to build hotels and plan the development of Yosemite as a tourist attraction. More important, Niagara served to warn people that a national treasure could be spoiled by the uncontrolled commercialization of private interests. The very forces which made tourism possible—rapidly improving transportation technology and increased commercial development—threatened tourist attractions themselves with overdevelopment. The men who acted to set aside Yosemite as a park were well aware of how unpleasant Yosemite could become if commercial interests were allowed to develop it, as they had done at the Falls, and were determined not to let that happen to this still unspoiled Western wonder.[13]

It seems likely that Central Park may also have influenced these men. Central Park had just established the principle of creating large parks for the use of all the people and although Yosemite was located far from the city, it could function, like Central Park, as a retreat from the stresses of urban life.[14] The fact that Olmsted was chosen as one of the first commissioners of Yosemite and aked to draw up the first plan for its development, suggests that Central Park may, in fact, have been on the minds of the men behind the Yosemite reservation. Although Olmsted's plan never reached the California state legislature and has only been rediscovered recently, his concept of Yosemite is an important one that calls attention to the competing versions of what Yosemite might mean to the nation.

The floor of Yosemite Valley was already a natural park con-

Eadweard Muybridge, *Loya* (*The Sentinel*), 1872. (Yosemite Research Library, National Park Service)

taining open meadow, groups of trees, and large bodies of water (Mirror Lake and the Merced River). The valley walls shut out the rest of the world, achieving the effect created at Central Park by planting trees entirely around its border. In both Central Park and Yosemite, the enclosed space constituted a retreat from the world, a place suited for the peaceful enjoyment of scenery. What appealed to Olmsted about Yosemite was not the beauty or grandeur of any particular scene, but the effect of completeness which he had striven to create by artificial means in Central Park. Every part harmonized and contributed to the whole. At Yosemite "the union of the deepest sublimity with the deepest beauty of nature" was "all around and wherever the visitor goes." Olmsted was not so much interested in its sublime aspects as in its parklike vegetation: "Cliffs of awful height and rocks of vast magnitude . . . are

banked and fringed and draped and shadowed by the tender foliage of noble and lovely trees and bushes, reflected from the most placid pools, and associated with the most tranquil meadows, the most playful streams, and every variety of soft and peaceful pastoral beauty." The Merced reminded him of a stream such as "Shakespeare delighted in."[15]

Olmsted's plan for Yosemite resembles in important respects his design for Central Park. He proposed that there be as few "artificial constructions" erected in Yosemite as possible and that those which had to be constructed for the convenience of visitors harmonize as much as possible with the scenery. He also proposed a circular carriageway which would take in all the best views in the valley, feature frequent turnouts, and like the circuit roads in Central Park (or the rural cemeteries, for that matter) allow for leisurely contemplation of the scenery.

Olmsted's pastoral vision of Yosemite and his proposal for treating it as a domesticated park did not represent the dominant attitude toward Yosemite's scenery. Most writers, painters, and photographers emphasized its grand and monumental qualities rather than its gentler beauties. But his view that Yosemite should be developed as a public park, that roads and railroads be built to it and facilities constructed for the accommodation of tourists, and that it would prove of enormous economic benefit to the nation was shared by other supporters of the park idea whether they possessed his pastoral attitude or not.

Whatever influence Central Park actually had on the establishment of Yosemite as a park, Yosemite combined the functions of Central Park and Niagara Falls as symbols of America's cultural achievement. As a park it represented the commitment of a republican government to providing, in Olmsted's words, "reinvigorating recreation" among "the choicest natural scenes in the country," not just for the wealthy, but for all its citizens. As a natural wonder it rivaled the monuments and mountain scenery of the Old World.

In many ways Yosemite met the requirements of a national cultural shrine better than Niagara Falls. Nineteenth-century visitors to the Yosemite Valley felt they were returning to the origin of things, to the central point at which creation began. "If report was true, we were going to the original site of the Garden of Eden— into a region which . . . out-valleyed the valley of Rasselas," wrote Ludlow in 1864.[16] As the early visitors descended into the valley from Inspiration Point, they descended deep into the earth, into a secret place embedded in the vastness of the surrounding mountains, whose walls soared toward heaven. Yosemite was complete

to itself and seemed, like Mammoth Cave, to reproduce the cosmos.

Just what kind of cosmos Yosemite reproduced, however, depended on the interpreter. Carleton Watkins's photographs, for example, capture Yosemite's geological muscles—the swelling, rounded, rolling forms of its domes and half-domes. In positioning his camera Watkins emphasized the way the Yosemite landscape curves away from the top of a dome, drops away to immense depths from the rim of the valley, and rises to great heights from the valley floor. His black and white prints are more effective than paint in recording the light and dark of granite and evergreen, the texture of rock scoured by glaciers and eroded by wind and water, the luxuriant trees on the parklike valley floor, and the files of pines following the routes of gorges, crevices, and terraces. Surprisingly, they are often better than the large canvases of painters at encompassing the great volume of space contained by Yosemite's walls.

But black and white photography could not register Yosemite's magical atmosphere. The geologist Clarence King, whose *Mountaineering in the Sierra Nevada* (1872), helped define Eastern perceptions of Yosemite and the surrounding Sierra Nevada region, described it as "a soft aerial depth of purple tone." Looking down from the lip of Yosemite Falls to the valley floor twenty-six hundred feet below, King saw that "over it all, even through the dark sky overhead, there seemed to be poured some absolute color, some purple air, hiding details, and veiling with its soft amethystine obscurity all that hard, broken roughness of the Sentinel cliffs."[17]

It was Yosemite's atmospheric effects, rather than its geological forms, that most inspired the paintings of Albert Bierstadt. He bathed the valley in a religious light and color and did much to reinforce the image of it as a paradisiacal place. Already famous for his painting, *The Rocky Mountains* (1863), Bierstadt's paintings of Yosemite made after his first visit and on three subsequent trips made an enormous impression in the East. His large canvases, including *Valley of the Yosemite* (1864), *Sunset in Yosemite Valley* (1868), and *Domes of the Yosemite* (1867) helped establish Yosemite as a national icon on a par with Niagara Falls and Bierstadt himself as a rival to Frederic Church. Bierstadt's interpretation of Yosemite received criticism in some quarters, however. In reviewing *Domes of the Yosemite* Mark Twain wrote: "Some of Mr. Bierstadt's mountains swim in a lustrous, pearly mist, which is so enchantingly beautiful that I am sorry the Creator hadn't made it instead of him, so that it would always remain there."[18] And Clarence King recounts an amusing encounter on one of his

Carleton Watkins, *North and Half Domes from Sentinel Dome*, 1863.
(Courtesy of the Boston Public Library, Print Department)

rambles in the Sierras with a painter who complains: "It's all Bier-
stadt and Bierstadt and Bierstadt nowadays! What has he done
but twist and skew and distort and discolor and belittle and be-
pretty this whole doggonned country? Why, his mountains are too
high and too slim; they'd blow over in one of our fall winds." Bier-
stadt, he concludes "hasn't what old Ruskin calls for."[19]

Whether it was depicted in gorgeous, glowing color or, in the
photographs of Watkins, in bare, sculptured forms, Yosemite's
very scale set it apart from other places and suggested a break with
ordinary reality. Yosemite Falls is 2,425 feet high compared to Ni-
agara's 167 feet and the cliffs rise to 3,000 feet above the valley
floor. It is difficult even when you are there to comprehend such
dimensions. Caroline Churchill wrote that one could only compre-
hend the height of Yosemite's walls after they had been "care-

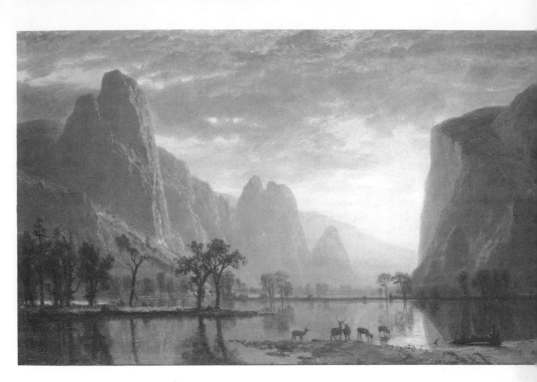

Albert Bierstadt, *Valley of the Yosemite*, 1864. (Gift of Mrs. Maxim Karolik for the Karolik Collection of American Paintings, 1815–1865. Courtesy, Museum of Fine Arts, Boston)

fully, studiously compared with all the pinnacles and elevations one has ever climbed." But even this was difficult: "I remember to have thought a hundred and seven feet pretty well up from the ground, when climbing to the tower of a village water tank; but to compare this height with three or four thousand feet perpendicular is rather more than one can comprehend with the eye when it comes to altitude." She found, furthermore, that it was impossible to determine how far away an object was because the height of the surrounding walls distorted one's sense of distance. El Capitan loomed so cosmically huge that it appeared impossible to pass it as you moved up the valley. "Some of these large rocks are like the moon or stars—one may travel half the length of the vale, still they will be ever present."[20]

Like the strange qualities of Mammoth Cave, such features served to establish Yosemite as a place where ordinary laws did not apply. Both the mammoth-plate camera employed by Watkins and the large canvases used by Bierstadt, and particularly by Thomas Hill, attempted to encompass these cosmic dimensions.

Watkins's camera took glass plate negatives measuring 17″ × 21″, Bierstadt's *Domes of the Yosemite* (1867) measured 9½′ × 15′, and Hill's *Yosemite Valley* (1876) 6′ × 10′.

Writers sometimes employed the rhetoric of the sublime to communicate Yosemite's scale, but they seemed to recognize the inadequacy of the clichéd terms that had been so frequently applied to Niagara and to many sights of lesser size back in the East. More frequently, and with an eye to a skeptical Eastern audience, writers attempted to capture Yosemite's scale by citing its measurements and by comparing it to more familiar objects. "Think of a cataract as high as St. Peter's at Rome," wrote one early visitor, "and multiply it by six—and you have an approximation" of the height of Yosemite Falls.[21] Hutchings—always with an eye to his tourist clientele—used the Palace Hotel in San Francisco, "one of the most imposing structures of any city" as his benchmark. It would take thirty Palace Hotels stacked together, he wrote, to match the height of El Capitan.[22]

The emphasis on assessing the size of objects at Yosemite appears closely tied to the mapping and measuring activities which were being carried out throughout the world in the second half of the nineteenth century, and very intensively in the American West where the various government surveys prepared the way for settlement and exploitation of the region's natural resources. The presentation of measurements and the comparison of objects according to their size are the common matter of guidebooks. In one sense such statistics are tourist trivia, similar in their appeal to the weight of the fat lady at the circus. More significantly, they function, paradoxically, both as a means of bringing extraordinary phenomena within a rational framework and of certifying that tourists are in the presence of something which transcends their familiar world. Measurement is the point where science and tourism meet and wed. For scientists measurement is an essential step in the accurate description of an object and a basis for determining its nature and origin. For tourists measurement is the means of validating an object's uniqueness. Measurement is their passport to wonder and to a sense of specialness for having been present at a one-of-a-kind place. Partly because of their common need for measurement, tourism and science serve each other. The tourist, eager for wonders and curiosities, provides the scientist with a popular audience for his work; science helps to satisfy the tourist's thirst for some sort of apprehension of the cosmic dimensions and forces of the world. In the case of Yosemite, the alliance between tourism and science was symbolized by the fact that the popular and influential *Yosemite Guide-Book* was written by Josiah D. Whit-

ney, the director of the California geological survey. After its publication in 1868 other writers referred to Whitney's measurements as scientific authority for their assertions about the dimensions of the valley.

But it was not merely Yosemite's tremendous scale which contributed to the nineteenth-century tourist's sense of being at an opening into the cosmos, it was also the solidity, smoothness, and perpendicularity of the valley's walls. They appeared "rentless, jointless, unsplintered," as if they belonged to the unfallen perfection of the original creation.[23] "The immense escarpment has no crack or mark of stratification," wrote Thomas Starr King of El Capitan. "There is no vegetation growing anywhere on it, for there is no patch of soil on either front, and no break where soil can lodge and a shrub can grow. It is one block of naked granite." Since there was almost no talus at the foot of Yosemite's cliffs, their vertical line remained uninterrupted all the way to the valley floor. "A plummet could be dropped straight from its pediment to its base."[24]

For John Burroughs, writing in 1910, Yosemite was "like the sides and the four corners of the globe itself" and El Capitan "like one of the veritable pillars of the firmament." For him Yosemite possessed the sacredness of Nature independent of man. It was "not architectural, or like something builded."[25] But to the nineteenth-century visitor the enormous volume of space enclosed by Yosemite's walls, their soaring height, their solidity, and the spires and domes formed by their summits often suggested the architectural forms of the great Gothic cathedrals of Europe. The walls of Yosemite, wrote Starr King, "support all sorts of crowning figures and ornaments. Cones are set on them; domes swell from them; turrets and towers overhang them; aiguilles and spires shoot above them."[26] Thus Yosemite's sacredness derived not only from its natural features but from its resemblance to the great sacred monuments of Europe.

The cathedrals of Europe—and the temples of Egypt, Greece and Rome, as well—were the archetypal sacred places for which Americans sought equivalents. Whatever visual resemblance actually existed between Yosemite and European architecture, the frequent comparisons of Yosemite to Gothic cathedrals and the measuring of its walls against the height of Cheops pyramid or the spires of Strasbourg, were a means of validating its status as a cultural monument and asserting its superiority. But the tendency of Americans to detect resemblances to European architectural monuments in Yosemite was not entirely a reflection of American cultural insecurity about the absence of such monuments in the

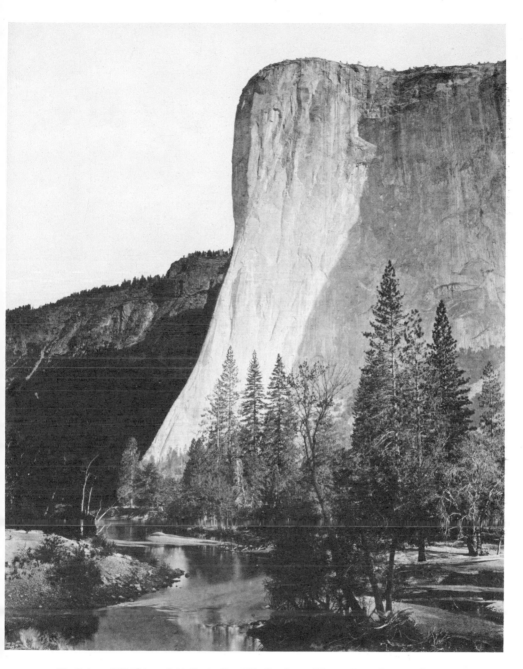

Carleton Watkins (attributed), *El Capitan, Yosemite*, about 1870.
(The Metropolitan Museum of Art, Whittelsey Fund, 1972)

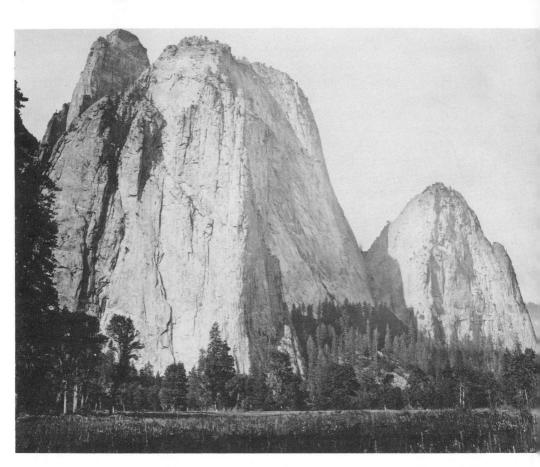

Carleton Watkins, *Cathedral Rock, 2,600 ft., Yosemite*, No. 21, Published by I. Taber, ca. 1866. (The Metropolitan Museum of Art, The Elisha Whittelsey Collection, The Elisha Whittelsey Fund, 1922)

United States. Cultural nationalism was no doubt an important part of the motivation for seeing such forms, as it was in the case of Mammoth Cave, but Americans were not the only ones to see architectural features in mountains. Europeans saw such resemblances too. John Ruskin, whose *Modern Painters* had a powerful influence in shaping the attitude of American writers like Thomas Starr King, Clarence King, and John Muir toward mountain scenery, saw the Alps in architectural terms, finding in their rocky formations the forms of the gothic towers, battlements, and Egyptian temples in the world built by men. Mountains, he wrote, are earth's "natural cathedrals." In the cliffs of the Matterhorn Ruskin finds "an unaltered monument, seemingly sculptured long ago, the huge walls retaining yet the forms into which they were first engraven, and standing like an Egyptian temple."[27]

From the end of the eighteenth century onward, America's cultural nationalists had pined for a scenery that matched the Alps in scale and magnificence. Thomas Jefferson had boasted in his *Notes on the State of Virginia* that the passage of the Potomac through the Blue Ridge was worth a journey across the Atlantic, but reality hardly justified such a claim. Certainly no mountains in the East came anywhere near matching the height and drama of the Alps. Niagara Falls did much to satisfy the needs of cultural nationalism because it had no parallel at all in Europe, but even in that case some critics complained of the absence of Alpine scenery around the cataract.[28] Thus the discovery of Yosemite met a lack that had been felt for a long time. In Yosemite, wrote Whitney proudly in the *Yosemite Guide-Book*, the traveler can find "as grand panoramic views of mountain and valley, as he can find in Switzerland itself."[29]

Were it not for a change in the status of mountains brought about by Ruskin, however, Yosemite would not have met America's cultural needs as well. Ruskin conferred a cultural status on mountains they had not had before. For him mountains did not require the associations with human history provided by the presence of ruined castles, picturesque villages, cultivated fields, or reminders of historical events. The associations a place possessed with human events could no doubt give pleasure, said Ruskin, but they were not the basis of landscape beauty. His dismissal of the position "that in uninhabited countries the vegetation has no grace, the rock no dignity, the cloud no color, and that the snowy summits of the Alps receive no loveliness from the sunset light, because they have not been polluted by the wrath, ravage, and misery of men" relieved America's cultural nationalists from the need they had felt so acutely at the time of the Willey Disaster for a storied landscape. Yosemite needed no Willey Disaster to sanctify it. No one bemoaned its lack of historical associations. From the point of view of Ruskin's followers, Yosemite's scenery *was* art. Its forms were to be interpreted as Ruskin had interpreted the Alps. "Mountains," Ruskin wrote, "are, to the rest of the body of the earth, what violent muscular action is to the body of man. The muscles and tendons of its anatomy are, in the mountain, brought out with fierce and convulsive energy, full of expression, passion, and strength." The form of mountains was best seen without the clothing of vegetation, in its "naked purity."[30] The Yosemite Valley, as Starr King recognized in his appreciation for Yosemite's "clean, naked granite," fit this requirement perfectly. And in Ruskin's terms, Watkins created the truest work of any of the nineteenth-century photographers and artists who depicted Yosemite

because he succeeded so well in revealing the anatomy of its bare granite forms.

In addition to its cosmic stature both as a natural work of art and as the subject of widely admired paintings and photographs, three other factors contributed substantially to Yosemite's success as a national shrine: the presence nearby of the Mariposa grove of Big Trees, whose own stupendous scale linked them closely to Yosemite; the attention given to Yosemite's geological origins by Josiah Whitney and John Muir; and Yosemite's sentimental association with the American Indian tribe which the tourists had so rapidly displaced.

The Mariposa grove of *sequoia gigantea* known as the Big Trees, which was discovered about the same time as Yosemite and included in the 1864 grant to California, satisfied the needs of America's cultural nationalists in ways very similar to the Yosemite Valley itself. The destruction of America's abundant and virgin forests had begun to disturb a few people as early as the 1830s. The "ravages of the axe are daily increasing," complained Thomas Cole in his "Essay on American Scenery" in 1835, "the most noble scenes are made desolate." But Cole's protest was hardly a call for wilderness preservation. What disturbed him was the total disregard for aesthetic principles in the cutting of trees. Nature's beauty was being destroyed "without substituting that of Art."[31] Other genteel writers encouraged Americans to regard trees as important adornments of the Christian home, the cemetery, and the urban park. A magnificent tree, wrote Lydia Sigourney is "a monument of the goodness of the Almighty." A settler who thoughtlessly cut all the trees on his property would find that he had none to adorn his mansion when he came to build it and therefore his home would lack an important symbol of refinement. Sigourney reminded her countrymen of the way the English set aside groves of trees and marked them to indicate who had planted them.[32] The rural cemetery, in which the planting of trees to create a natural parklike landscape played such an important role, and the work of Andrew Jackson Downing, particularly his widely read *Treatise on the Theory and Practice of Landscape Gardening*, popularized the idea that trees were emblems of civilization. Finally, Olmsted, in the construction of Central Park, made the planting of trees vital to the work of civilizing the American city. It was this attitude that trees were an essential part of an artistically designed landscape, rather than an environmental concern, that led to the preservation of the Mariposa Big Trees in 1864. America's possession of the Big Trees was a mark of cultural distinction.

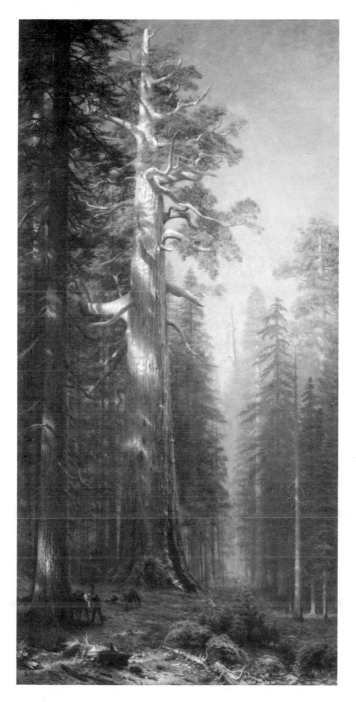

Albert Bierstadt, *The Great Trees, Mariposa Grove, California*, 1876. (Private collection)

As cultural monuments the Big Trees were not only unique to America, but like the walls of Yosemite reminded the nineteenth-century visitor of the architectural monuments of the Old World. "They would associate themselves in the mind more with the Napoleonic column of the Place Vendome, or the London Monument, than with any tree we have ever seen," wrote Therese Yelverton.[33] More important, they were very old and thus compensated for America's lack of venerable buildings and ruins. America's trees, wrote Bayard Taylor, "are our truest antiquities. . . . As well think of going to Egypt without seeing the Pyramids, as of visiting California, without making a pilgrimage to her immemorial Trees!"[34]

The Big Trees, Americans could boast, were not only as old or older than the relics of the Old World, they were alive. They had heroically outlived the entire history of Western civilization. "They were of very substantial size when David danced before the ark" and "when Aeneas fled from the burning wreck of vanquished Troy," exulted Horace Greeley.[35] Later estimates reduced this es-

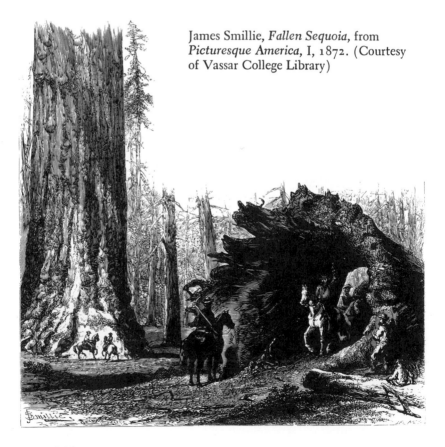

James Smillie, *Fallen Sequoia*, from *Picturesque America*, I, 1872. (Courtesy of Vassar College Library)

timate considerably, but Americans could still assert that the life of the trees spanned a good part of Western history. The botanist John Torrey, after examining the rings of a tree that had been cut down estimated that it was eleven hundred years old. "If this calculation be trustworthy," wrote Starr King, "the column at whose root I sat took its first draught of sunshine in the time of Charlemagne. It is three hundred years older than the Norman Conquest and the great Hildebrand. It was a giant in the time of the first Crusade. And it antedates the foundation stone of the oldest Gothic spire of Europe."[36]

Measurement, which features so prominently in descriptions of Yosemite Valley, plays an even more important role in accounts of the Big Trees. The trees were commonly compared to tall structures in the East, especially the spire of Trinity Church in New York and the Bunker Hill Monument, which both confirmed their status as monuments and—since the tallest of the trees surpassed those architectural monuments in height—conveyed a sense of how they transcended ordinary reality. In the most vivid and imaginative of these comparisons, Starr King playfully projects one of the Big Trees into the urban and domestic world of his genteel Eastern audience. He suggests first of all that his readers measure off a piece of string one hundred feet long to represent the size of the trunk of one of the largest of the trees and then to stretch it into a circle in their parlor—if they have a parlor large enough to do that in.

> Now conceive this tree rooted on the Common near the Park street entrance. What do you say to the idea of looking up its smooth trunk to a point higher than the topmost leaf of any elm on the Tremont street mall, and of seeing there a bough thicker than the largest of those elms shooting out from it? What do you say to the fact that its plume would nod a hundred feet above the vane of Park street spire? What do you say to the possibility, if it lay hollowed on the ground, of driving a barouche and four through it, without their being able to touch the highest point of its curved ceiling "with a ten foot pole?"[37]

King's fantasy domesticates the Big Trees—associates them with home, and parks, and the pleasure driving which park planners, like Olmsted, wished to promote—while at the same time communicating how far they outstrip that familiar world.

Such comparing and measuring while it confirmed the monumental and transcendent qualities of the Big Trees, also encouraged people to regard them as curiosities. "No other plant ever attracted so much attention or attained such a celebrity within

145

# THE GREAT CALIFORNIA TREE.

**Over 3000 years old—Ninety Feet in Circumference.**

NOW EXHIBITING
## AT No. 596 BROADWAY, NEAR NIBLO'S.

ADMISSION . . . . . . . . . . . . . . . .25 CENTS | CHILDREN . . . . . . . . . . . . .HALF-PRICE
Hours of Exhibition from 9 A. M., till 10 P. M.

*The Great California Tree*, broadside, 1854. (Yosemite Research Library, National Park Service)

so short a period," wrote Whitney in 1868. He estimated that there had already been one to two hundred references to it in scientific and popular articles and books. The attention came from both naturalists and showmen. Although the Mariposa Big Trees were to a large degree protected after 1864 by being included in the park, the Calaveras Big Trees were not. To the disgust of people like Starr King, they became a source of entertainment. One tree was cut down and its floor made into a dancing floor, twenty-five feet in diameter. Other trees were cut down and sections of their bark taken off and displayed at the Crystal Palaces of

New York and London in the 1850s, at the Centennial Exhibition in Philadelphia in 1876, and at the World's Columbian Exhibition in Chicago in 1893.[38]

Many writers objected to the treatment of the Big Trees as objects in a zoo, not because they cared about wilderness preservation, but because it reduced the dignity and majesty of the trees as natural works of art. They particularly expressed disgust at the custom of naming the trees after heroic and not-so-heroic citizens of the modern world and of attaching these names to the trees on marble or metal plates. Like the stories of accidents and deeds at Niagara Falls these activities elevated the ordinary to the heroic plane. But the more genteel tourists were disturbed by the discordance between the grand and the trivial, just as they were bothered by the ostentatious monuments erected in memory of ordinary people in the rural cemeteries. "Even Senator Gwin, as I was informed," wrote Bayard Taylor, "had his name cast on an iron plate, and sent to the Mariposa Grove, to be placed on one of the largest trees. Oh! the pitiful vanity of our race!"[39]

If the mythic appeal of the Big Trees derived in large part from their great age, which seemed to put their origin at the beginning of Western history, part of the mythic appeal of Yosemite sprang from the tremendous forces that people imagined must have been responsible for its existence. As in the case of Mammoth Cave, Yosemite appeared to be a special creation, requiring a marvelous explanation, and scientific theories about its origin functioned as creation myths. The great nineteenth-century argument among geologists about whether the mountains and valleys of the earth were formed by sudden, catastrophic events or by the slow operation over time of the same geological forces at work in the contemporary world—the same argument which shaped the competing theories about the origin of Mammoth Cave—was played out at Yosemite in a debate between the geologist Josiah Whitney and the naturalist John Muir.

In his *Yosemite Guide-Book* Whitney concluded that the valley had been formed by subsidence during the creation of the Sierra Nevada Mountains: "The bottom of the Valley sank down to an unknown depth, owing to its support being withdrawn from underneath during some of those convulsive movements which must have attended the upheaval of so extensive and elevated a chain."[40] Although Whitney admitted that Yosemite was "a peculiar case," since a very small area had sunk a very long way, he was insistent that no other explanation was possible. Whitney's *Yosemite Guide-Book* was first published in 1868 and by 1874 had gone through

147

five editions.[41] His views were also repeated in many of the other accounts and guidebooks written during that period.[42] Although Whitney indicated that the process of subsidence may have taken a very long time, his theory was sometimes translated into the idea that the mountains had been torn asunder and the bottom of the valley had fallen out. Like the 1826 avalanches in the White Mountains, this popular version corresponded nicely with biblical accounts of sudden, cataclysmic events.

Whitney's theory had a persistent and painstaking opponent, however, in John Muir, who later was a founder and first president of the Sierra Club. Muir had first come to the Yosemite Valley in 1868 and worked as a shepherd and sawmill operator. Although not a professional geologist, he undertook a careful study of the valley's geological history as recorded in its rocks. Believing, like Ruskin, that the "footmark" of a glacier is as "recognizable as the trail of any well-known animal,"[43] he concluded that the valley had been formed by the slow, grinding force of glacial action. In the early 1870s he began publishing a series of articles in the *Overland Monthly* and the New York *Tribune* refuting Whitney and developing his theory. He also expounded his views to the people he guided through the valley, including the geologist Joseph Le Conte. Both Le Conte and the well-known scientist Louis Agassiz, to whom Muir reported his discoveries, became convinced that Muir was right. His theory was soon repeated in many of the popular accounts of Yosemite in place of Whitney's.[44] Muir's interpretation of the origin of Yosemite was both more empirical in its basis and more religious in its language than Whitney's. Because of the importance of time to his thesis and the manner in which he expressed it, it was both scientifically correct and mythic. Yosemite was not, he wrote, " 'an exceptional creation,' or rather *exceptional destruction* accomplished by violent and mysterious forces," but rather an expression of the operation of "Divine harmonious law."[45]

Muir adopted Ruskin's mountain worship like no one before or since. Mountains, Ruskin had written, "seem to have been built for the human race, as at once their schools and cathedrals; full of treasures of illuminated manuscript for the scholar, kindly in simple lessons to the worker, quiet in pale cloisters for the thinker, glorious in holiness for the worshipper."[46] So for Muir, Yosemite and the surrounding mountains were a divine text. Although the glaciers were gone, he wrote, "their history is indelibly recorded in characters of rock, mountain, canon, and forest," and these hieroglyphics, this "ice manuscript" could be read by anyone who would take the time. Muir loved to "walk the pathways of Yosem-

ite glaciers and contemplate their separate works—the mountains they have shaped, the canons they have furrowed, the rocks they have worn, and broken, and scattered in moraines," and to guide others along these historic trails.[47] When Ralph Waldo Emerson visited Yosemite in 1871, it was Muir who gave him a tour. Like Thoreau, who had tested and shaped Emersonian principles with a kind of visionary empiricism, Muir pursued Ruskin's ideas in a close and careful reading of Yosemite's mountain text.

Muir detested the ordinary tourists who made a quick tour of Yosemite's "points of interest" and then left. Unlike Olmsted, he glorified in the sublime qualities of the region, but his version of the sublime was different from that of most tourists. It was rooted in his admiration for nature's dynamic forces rather than in the thrill of stupendous heights. In "Yosemite in Flood" he describes a wave of water from the spring thaw "sweeping logs and ice before it" and "plunging over the tremendous verge" of upper Yosemite Fall. Such events did more than provide sublime pictures or souvenirs of the mind for future contemplation: "Visions like these do not remain with us as mere maps and pictures—flat shadows cast upon our minds, to brighten, at times, when touched by association or will, and fade again from our view, like landscape in the gloaming. They saturate every fibre of the body and soul, dwelling in us and with us, like holy spirits, through all of our after-deaths and after-lives."[48] Muir was much sought out as a guide by visitors like Emerson and for those who would listen to him he provided an experience of Yosemite that took them behind the looming scenery in a Ruskinian investigation of nature's text. Although most tourists continued to experience the valley superficially, Muir encouraged a different approach and eventually helped establish an alternative view of Yosemite as wilderness rather than monument.

Perhaps Muir's view could only be arrived at and shared by others after the frontier was almost fully subdued. In looking back at the history of Yosemite's early years, it is important to remember that it was developed as a tourist attraction during the rush to subjugate the Indian and exploit the resources of the American West. Its character was shaped by these larger events. This not only meant that there was little admiration for the wilderness *per se* in the beginning, but that the actual Indians of Yosemite disappeared into myth. The history of Yosemite's discovery, which was recounted in the major guidebooks and in its richest and most complex form in Lafayette Bunnell's *Discovery of the Yosemite, and the Indian War of 1851* (1880), is a story of the sudden dis-

placement of a native American culture by the culture of the genteel tourist. Inevitably this process meant misunderstanding and rejection of native American concepts of the sacred in nature and of the relationship of nature to society, as well as the imposition of white ideas about beauty, sublimity, and property on the landscape. The Indians were sometimes romanticized and their legends recounted to tourists, but such gestures merely relegated them to the status of historical figures.

The goal of the expedition which led to the discovery of Yosemite in 1851 was to capture a band of Ahwahneechees and remove them to a reservation on the Fresno River, but the impact of the expedition on Yosemite's future as a tourist attraction went well beyond that.[49] The members of the battalion conferred the name "Yosemite" on the valley and named many of its features, thereby appropriating them for the tourists who followed. This act of naming, like the descriptions, paintings, and photographs which followed, was a means of exercising cultural power, a way of taking imaginative possession of a place.

Lafayette Bunnell's account of the expedition, written in 1880 both from the perspective of someone who had been a member of the Mariposa Battalion and someone who had witnessed 25 years of tourism in Yosemite, expresses an attitude toward the Ahwahneechees that is at once realistic and sentimental, contemptuous and sympathetic. According to his own account, Bunnell was the person most responsible for the choice of names for the various features of the Yosemite Valley. He portrays himself as a worshipful lover of scenery, a tourist among practical, coarse joking men who made fun of his scenic enthusiasm and obsession with nomenclature. Captain Boling, the leader of the party which captured the Ahwahneechees, teasingly suggested that Bunnell should have studied divinity rather than medicine so that he could have "fully gratified" his "passion for christening," a remark that correctly indicates the sacred nature of the naming act. Bunnell, with some help from his comrades, was the Adam of Yosemite.

Although the name "Yo Semite" derived from the Miwok-Paiute word for grizzly bear, most of the names Bunnell and his comrades selected for the features of the valley were English: "The Three Brothers," "Cathedral Rocks," "Royal Arches," and so on. Later writers, who followed in the footsteps of the Mariposa Battalion, regretted that few of the original Indian names had been retained and cited these names and their meanings as well as the English names in their accounts. The Miwok-Paiute names seemed more melodious to them and poetically appropriate. "In the dialect of the Indians," wrote Samuel Kneeland, Bridal

Veil Falls "is 'Pohono'—a blast of wind, or the night wind, from the chilliness of the air experienced by coming under the cliff, and perhaps from the swaying of the sheet in the wind like a veil; others think Pohono was an evil spirit, whose breath was a dangerous and deadly wind. Whatever its derivation, the poetical name of the Indian is, here as in other places in the valley, much superior to the English one."[50] In addition, they found many of the English names foolish, particularly those names which diminished the grandeur of Yosemite by associating it with the romantic preoccupations of the tourists themselves. "A worse name might be given to it," wrote Starr King of Bridal Veil Falls,

> In fact a worse name was given to it; for I find that in 1856 it was christened "Falls of Louise" by some explorers, in honor of "the first lady of our party that entered the valley." Thank Heaven, the cataract wouldn't stand this nonsense; and it seemed to me to be pleading with us to have the "Bridal Veil" folly thrown aside, that it might be known forever by its Indian baptism, "Pohono."[51]

Bunnell, however, defended the appropriateness of the English names he and his comrades conferred on Yosemite and argued that the Indian names were too long, their pronunciations too varied, or their meanings too unclear to be of practical use. Throughout his account, he tries to disassociate himself from his rough, frontier comrades and presents himself to his genteel audience as a man of taste and sentiment. Bunnell made an effort, he reports, to find appropriate English names to replace the Indian ones and also to substitute for the "fantastic and absurd" ones thought up by some of his comrades: "It is so customary for frontiersmen to give distinctive names of their coinage, that we had great difficulty in getting any of the Indian names adopted; and considerable judgment had to be exercised in selecting such English names as would 'stick'—as would displace such names as the 'Giant's Pillar,' 'Sam Patch's Falls,' 'The Devil's Night-Cap,' etc."[52] He also claimed that he had recorded and preserved the Indian names even though he helped replace them in common usage.

Although Bunnell recommended the study of the Indian cultures and the preservation of their language, he despised the Indians themselves. He also felt contempt for "those credulous admirers of the NOBLE RED MAN" who supposed that the Indians were naturally poetical: "There is really no more sentiment or refined imagery of expression among Indians than will be found among ignorant people of any kind," he wrote. To Bunnell the Indians

were a superstitious race, "graded low down in the scale of humanity." They looked on Tote-ack-ah-noo-lah (the Miwok-Paiute name for El Capitan, the great prow of rock which is one of Yosemite's grandest features) "as an emblem of some mysterious power, beyond their comprehension." For Bunnell the attribution of sacred meaning to nature by the Ahwahneechees was mere demonism. Most important, in justifying their removal from Yosemite and their replacement by white tourists, Bunnell believed the Indians lacked a sense of beauty: "In none of their objections made to the abandonment of their home, was there anything said to indicate any appreciation of the scenery." Bunnell contrasts the Indians' indifference with the enthusiasm he and the leaders of the battalion felt for landscape beauty. When the battalion encountered a sublime panorama of the Sierra Nevada illuminated by the sun on returning to the valley after the final capture of the Indians above the Yosemite rim, Bunnell quotes Addison's observation in the *Spectator* on the spiritual effect of such scenery: "We are flung into a pleasing astonishment at such unbounded views, and feel a delightful stillness and amazement in the soul."[53]

It is in the naming of Lake Ten-ie-ya, however, that Bunnell's insensitivity to the Ahwahneechees' relationship to the land is most apparent. Looking back at the lake where they had captured the Yosemite band, and seeing Ten-ie-ya, the Yosemite chief, approaching, he suggests to Captain Boling that the lake be named after the chief. Boling agrees, remarking that "it is rendering a kind of justice to perpetuate the name of the old chief." Ten-ie-ya, however, fails to appreciate the gesture:

> At first, he seemed unable to comprehend our purpose, and pointing to the group of glistening peaks, near the head of the lake, said: "It already has a name; we call it Py-we-ack." Upon my telling him that we had named it Ten-ie-ya, because it was upon the shores of the lake that we had found his people, who would never return to it to live, his countenance fell and he at once left our group and joined his own family circle.[54]

As Ten-ie-ya may have recognized, naming is claiming, an act of asserting cultural hegemony. The use of Ten-ie-ya's name does not diminish this fact since the substitution of his name for the orginal Indian name represents the relegation of his culture to the past, the reduction of his home to the status of a landmark.

Bunnell's cultural imperialism is apparent throughout his account. He disdains to view the Indian as "noble" and treats Ten-ie-ya condescendingly ("I never at any time had real personal dislike for the old sachem. He had always been an object of study,

James Smillie, *Tenaya Canon, From Glacier Point*, from *Picturesque America*, I, 1872. (Courtesy of Vassar College Library)

and I sometimes found in him profitable entertainment."), and he never for a moment wavers from his conviction that the expedition against the Ahwahneechees and their removal from the valley is fully justified. He does cast his story in tragic terms. As Ten-ie-ya sorrowfully moves away from him, he pities him: "From this lake we were leading the last remnant of his once dreaded tribe, to a territory from which is was designed they should never return as a people."[55] But the romantic pathos with which Bunnell imbues this scene only makes him swell with self-satisfaction at the "justness" of "perpetuating the name of Ten-ie-ya" in the lake.

The day following this event, as the Mariposa Battalion escorts the captive Indians out of the Yosemite Valley on the way to the reservation, Bunnell looks back at Yosemite from the top of the steep trail out of the valley and again feels sympathy for the Indians. But what he records, from his perspective in 1880, is the strange, imperialistic act of transforming the home of the Indians into a temple of Romantic, Christian culture:

> As I looked back upon El Capitan, his bald forehead was cooling in the breeze that swept by me from the *"Summer land"* below, and his cheerful countenance reflected back the glory of the rising sun. Feeling my own inferiority while acknowledging the majesty of the scene, I looked back from Mt. Beatitude, and quoting from Byron, exclaimed:
>
> > Yosemite!
> > Thy vale(s) of evergreen, thy hills of snow
> > Proclaim thee Nature's varied favorite now.
>
> We reached the Fresno without the loss of a captive, and as we turned them over to the agent, we were formally commended for the success of the expedition.[56]

What Bunnell regards as the culture of an ignorant, superstitious, and treacherous people has been in his mind justly displaced by the genteel culture of a people capable of being moved to reverence and awe in the presence of God's creation. The valley no longer belongs to the Indians but to "Nature," and to all the Byron-quoting tourists who followed in Bunnell's footsteps. The fact that some of these tourists preferred the Indian names to the English ones conferred on Yosemite by Bunnell and the other members of the Mariposa Battalion didn't change matters. The tourists were not holding onto the original names as a protest against the treatment of the Indians themselves. For them the names, and the legends associated with them, were merely the relics of a vanished culture, similar to the artifacts found at Pompeii. Like the poetry

the tourists quoted, the Indian names cast a veil of history, poetry, and romance over the Yosemite landscape while the English names seemed plain and obvious.

But the situation at Yosemite in the latter half of the nineteenth century was not really comparable to the case of Pompeii or to other historic sites in the Old World. The Ahwahneechees had only very recently been driven from the valley, as Bunnell's account indicated, and Indian tribes all over the West were being forced into reservations or coming under attack throughout the period. Small groups of Indians still lived in the region of Yosemite well after it had been developed as a tourist attraction. The romanticization of the Indians as historic figures known only through the names and other relics they had left behind was in fact a denial of Indians as they actually were and of their subjugation and extermination. Just as in the Yosemite Valley the tourist displaced the Indian; in the imagination of the tourist, the Indian of fantasy displaced the actual Indian. To the well-to-do, genteel tourist it was no doubt comforting for the Indian to vanish into history and poetry.

It is remarkable how rapidly Yosemite was transformed from the home of the Indian to a national park for which Olmsted drew up a plan and in which Muir could complain that it was being overrun by tourists. The urge to identify and set aside the monuments of a national culture impelled Yosemite quickly from wilderness to park and tourist attraction. Its example helped inspire similar efforts. When Samuel Bowles visited the valley just after it had been ceded to California as a park, he saw it as a model for what should be taking place in the East. New York, he wrote, should preserve Niagara Falls and its surroundings and portions of the Adirondacks; Maine should preserve one of its lakes and the neighboring forest.[57] Successful efforts at preservation were, in fact, made in the Adirondacks and at Niagara Falls in the two and one-half decades following the establishment of Yosemite. But the most immediate effect of the Yosemite model was the creation of the first official national park at Yellowstone, and there again, even more than at Yosemite, the early years of the park were characterized by the juxtaposition of wilderness with the trappings of genteel tourist culture.

# Seven

## Yellowstone and "The Wild West"

WHEN "BUFFALO BILL" CODY arrived in England with his "Wild West" show in 1887, he was struck by the symbolism of the ship on which he sailed. The *State of Nebraska* was not only named for the territory where he had spent his youth, but it carried the living representatives of his adventures during those years. Its cargo, he wrote in his autobiography,

> consisted of early pioneers and rude, rough riders from that section, and of the wild horses of the same district, buffalo, deer, elk and antelope—the king game of the prairie,—together with over one hundred representatives of that savage foe that had been compelled to submit to a conquering civilization and were now accompanying me in friendship, loyalty and peace, . . . all of us combined in an exhibition intended to prove to the center of old world civilization that the vast region of the United States was finally and effectively settled by the English-speaking race.[1]

As Buffalo Bill clearly intended, his show represented both the wildness of the West and the triumph of civilization over that wildness. Its effectiveness in embodying both the wild and the civilized depended on the rapidity with which Cody transformed himself and some of the other participants in the settling of the West into actors and turned the contemporary events of Western history into theater. In the early years of his theatrical career, Cody returned each summer to his life as a scout. In the year after Custer's defeat at Little Big Horn he joined a party seeking revenge and, dressed in his stage costume, killed and scalped an Indian named Yellow Hand. This incident and Custer's "Last Stand" itself were then reenacted on stage employing some of the

SHOOTING GLASS BALLS

FROM PRAIRIE

1857
BILLY CODY, THE BOY MESSENGER
AT THE AGE OF 12.

Col. W.F. CODY,
BUFFALO B...

TO PALACE

HUNTING BUFFALO

*From Prairie to Palace*, poster, ca. 1887, Russell-Morgan Printing Company, Cincinnati, Ohio, printer. (Courtesy, Buffalo Bill Historical Center, Cody, Wyoming)

Indians who had actually participated in the original battle at Little Big Horn.

The American West that emerged in the latter third of the nineteenth century was a place of wonders and curiosities in which fact and fiction, history and theater, actual and staged events were blurred together. It was a tourist's West, performing and reenacting itself for the entertainment of Easterners and Europeans and the profit of entrepreneurs like Buffalo Bill Cody. It expressed itself in Wild West shows and dime novels; in the popular paintings of Albert Bierstadt, Thomas Moran, and Thomas Hill; and in the fiction of Mark Twain and Bret Harte.

No place came to embody the vast, strange, exotic, wild, and even grotesquely comic qualities of the West better than Yellowstone. Not even Yosemite was as deliberately produced for Eastern audiences. Leading citizens of the Montana Territory interested in the economic development of their region, capitalists interested in the building of the Northern Pacific Railroad, explorers, geolo-

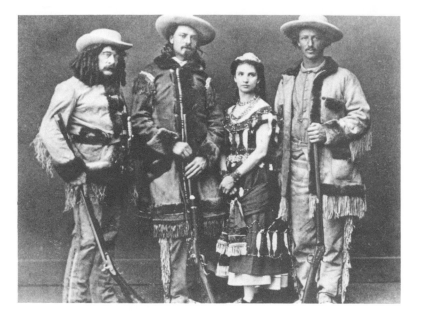

Ned Buntline, Buffalo Bill, Giuseppina Morlacchi, and Texas Jack Omohundro as they appeared in the 1872 melodrama *The Scouts of the Prairie; or Red Deviltry, As It Is.* (Courtesy, Buffalo Bill Historical Center, Cody, Wyoming)

gists, painters, writers, and photographers acted together, mutually supporting each other's interests, in order to publicize the area and establish it as an important tourist attraction.

Yellowstone, like Yosemite, remained unknown until relatively late in the nineteenth century. The discovery of its landscape of geysers, mud volcanoes, boiling sulphur springs, castellated cliffs, and other strange phenomena evoked wonder among Eastern and European travelers, restless within the increasing confines of urban life and eager for fresh sights to explore. "Four years ago the white world knew absolutely nothing of the country we were leaving," wrote the Earl of Dunraven, the Irish nobleman who visited Yellowstone in 1874. "And even now scarcely anything is known about it."[2] It offered the opportunity for tourists to be pioneers without having to face the hardships of actual settlement, to pass by the agricultural settlements of the frontier and to follow right in the footsteps of the hunter and the trapper, to step into the half-fictional world of the Wild West.

The trapper John Colter may have visited the Yellowstone region as early as 1806 and another trapper, James Bridger, told

stories in the 1830s of steaming pools, hot cauldrons of mud, and spouting water. But the reports of trappers were dismissed as tall tales, since they were laced, as Ferdinand Hayden noted, with accounts of "petrified forests, of animals turned to stone, and of streams flowing so rapidly that their waters became heated."[3] Prospectors visited the area in the early 1860s, but they were not believed either. It was not until the expeditions of the late 1860s and early 70s that the existence of the strange phenomena of the Yellowstone region was verified and made known to the public. An expedition led by David E. Folsom penetrated the Yellowstone area in 1869 and the reports of its members stimulated others to follow.[4] In 1870 a party headed by Henry Dana Washburn, which included several of the leading citizens of the Montana Territory, many of them Eastern educated and active in politics, banking, mining, and the law, toured the major points of interest in the region. Accounts of that expedition appeared in the *Helena Daily Herald*, the *New York Times* and other newspapers. Nathaniel Pitt Langford, a leading member of the expedition published an account in *Scribner's Monthly*. These articles publicized Yellowstone's wonders for the first time. Langford's article was illustrated by Thomas Moran who had never been to Yellowstone but based his work on Langford's descriptions and on some rough drawings made by a soldier in the Washburn party. Moran's illustrations were not very accurate but they communicated the fact that Yellowstone was a place of strange, fascinating phenomena. More important, Moran's work excited in him a desire to visit Yellowstone and led eventually to large, popular paintings which did much to promote the region.

Langford, upon his return from Yellowstone, lectured on his experiences both in Montana and back East. His lecture in Washington, D.C. was heard by Ferdinand V. Hayden, director of the Geological and Geographical Survey of the Territories, and it inspired him to seek funds from Congress to undertake an exploration of the area. As a result, Congress passed a bill in 1871 extending Hayden's geological survey and making it possible for Hayden to include Yellowstone in his 1871 expedition.[5] The Hayden expedition established the existence of the strange features of the Yellowstone region on a scientific basis, documented them in the photographs of William H. Jackson and the paintings of Moran, and led almost immediately to the establishment of Yellowstone National Park.

Although a number of people appear to have suggested the idea of preserving Yellowstone for public use somewhat earlier, the first proposal of any consequence came in the form of a letter from

Thomas Moran, *The Grotto Geyser*, from *Scribner's Monthly*, May, 1871. (Courtesy of Vassar College Library)

A. B. Nettleton to Hayden in October 1871. "Dear Doctor," he wrote, "Judge Kelley has made a suggestion which strikes me as being an excellent one, viz.: let Congress pass a bill reserving the Great Geyser Basin as a public park forever—just as it has reserved that far inferior wonder the Yosemite valley and big trees. If you approve this would such a recommendation be appropriate in your official report."[6]

Hayden responded enthusiastically and undertook to make the idea a reality. In view of the backgrounds, connections, and statements of Hayden and the other men who worked for the passage of the bill, it is apparent that they were primarily motivated by patriotism and an interest in economic development. Hayden and Langford were moved, awed, and immensely curious about what they had seen and they knew that such wonders would bring tourists. Langford predicted as soon as he saw Yellowstone that it would become a fashionable resort.[7] As in the case of Yosemite, the question was not whether it would be developed but how it would be developed and by whom. Those who supported the Yellowstone bill were willing, indeed eager, to see Yellowstone developed as a tourist attraction, but they were concerned, like the supporters of the Yosemite bill, that it not become another Niagara Falls.

Some of the leading citizens of Montana saw the creation of Yellowstone Park as a means of attracting attention to the territory and encouraging development. The park would lie just across the Wyoming border and not far from the main line of the Northern Pacific Railroad which, when completed, would pass through Montana on its way to the West Coast. In an article published on February 28, 1872, the *Helena Daily Herald* praised the creation of Yellowstone National Park as "the means of centering upon Montana the attention of thousands heretofore comparatively uninformed of a territory abounding in such resources of mines and agriculture and of wonderland as we can boast." Langford himself had an interest in the economic development of the area. He had been involved in an abortive scheme to build a wagon road from Bozeman City to Laramie, Wyoming and, more important, maintained ties with Jay Cooke & Co., agents for the Northern Pacific Railroad. The lectures on Yellowstone he undertook to deliver during the winter of 1870–71 were sponsored by the Northern Pacific Railroad and he supported the park proposal as an agent for the railroad. The Northern Pacific would clearly benefit from the establishment of a national park at Yellowstone free and open to the public since the railroad would provide the only practical access to it. Congressman James G. Blaine, another ally of the Northern Pacific, strongly supported the bill financing the Hayden survey of Yellowstone. Even William H. Jackson and Thomas Moran participated in the Hayden expedition, according to the *Helena Daily Herald*, "directly in the interest of the N.P.R.R. Company."[8] In fact, Moran's participation was subsidized by Jay Cooke,[9] and Nettleton's letter to Hayden, containing Judge William D. Kelley's proposal for reserving Yellowstone as a public park, was written on the stationery of Jay Cooke & Co. Hayden too was concerned with the region's economic development; he was, of course, interested in the region from a scientific point of view, but his surveys had a practical purpose. They were intended to assist farmers, miners, railroad surveyors, and others engaged in the settlement of the Western territories by supplying them with useful information.

The bill to establish Yellowstone National Park, which was introduced to Congress in 1871, reads very much like the Yosemite bill and appears to have been modeled on it. The arguments in favor of it, set forth in the report of the House Committee on the Public Lands, are well calculated to appeal to a practical, economy-minded Congress concerned with economic development but also susceptible to appeals to its patriotism. The bill, the report

said, would set aside the Yellowstone region as "a great national park or pleasure ground for the benefit and enjoyment of the people." The report pointed out first that as far as agriculture and mining were concerned, the Yellowstone region was a wasteland. The nature of the soil and severity of the winters made cultivation and stockraising impossible and the volcanic origin of its rocks made successful mining unlikely. Having assured Congress that the region was of no value for anything else, the report urged on patriotic grounds the value of a Yellowstone National Park as a tourist attraction. The reservation of Yellowstone as a park for all the people, the report asserted, "will be regarded by the entire civilized world as a step of progress and an honor to Congress and the nation." Moreover, no matter what Congress did Yellowstone was inevitably going to become a tourist resort:

> In a few years this region will be a place of resort for all classes of people from all portions of the world. The geysers of Iceland, which have been objects of interest for the scientific men and travelers of the entire world, sink into insignificance in comparison with the hot springs of the Yellowstone and Fire-Hole Basins. As a place of resort for invalids it will not be excelled by any portion of the world.

The report warned that unless Congress acted immediately, Yellowstone would be ruined by commercial development: "Persons are now waiting for the spring to open to enter in and take possession of these remarkable curiosities, to make merchandise of these beautiful specimens, to fence in these rare wonders so as to charge visitors a fee, as is now done at Niagara Falls, for the sight of that which ought to be free as the air or water!"[10]

Those who argued for the creation of Yellowstone National Park on the grounds of national pride were justified by the enthusiastic approval it received from visiting Europeans. Lord Dunraven, who visited Yellowstone soon after it had been established and whose *Great Divide* made Yellowstone known to Europeans, expressed his disgust at the practice of charging fifty cents or a dollar for the privilege of viewing Niagara Falls from a particular spot:

> Nothing is more revolting to our instincts, more disgraceful to our civilisation, than the system of trafficking in the charms with which Nature is so bountifully endowed. All honour then to the United States for having bequeathed as a free gift to man the beauties and curiosities of "Wonderland." It was an act worthy of a great nation, and she will have her reward in the praise of the present army of tourists, no less than in the thanks of the generations of them yet to come.[11]

Hayden campaigned for the bill by organizing an exhibition of geological specimens, Jackson photographs, and Moran sketches and watercolors from the expedition of 1871 in the rotunda of the capitol. Every senator and congressman received copies of Langford's *Scribner's* article, "The Wonders of the Yellowstone," and Gustavus C. Doane's official report of the Washburn expedition. Representative William H. Clagett of Montana, Hayden, and Langford spoke personally to each senator and congressman in support of the bill.[12] Hayden wrote a sequel to Langford's article for *Scribner's Monthly* which, in calling for the creation of a national park at Yellowstone on the grounds of patriotism, echoed Judge Kelley's letter to Hayden in 1871: "The intelligent American will one day point on the map to this remarkable district with the conscious pride that it has not its parallel on the face of the globe. Why will not Congress at once pass a law setting it apart as a great public park for all time to come, as has been done with that not more remarkable wonder, the Yosemite Valley?"[13]

The bill creating Yellowstone National Park was signed by President Grant on March 1, 1872. In the long run it would turn out to be an important precedent in the history of conservation, but in 1872 it was a milestone in the history of tourism. Educated Americans had increasingly recognized the cultural and economic importance of the nation's tourist attractions. They were not only objects of national pride in themselves, which matched the natural and architectural monuments of the Old World, but the subject of paintings which also became objects of admiration. Moran's painting, *The Grand Canyon of the Yellowstone*, which measured 7′ × 12′ and rivaled Bierstadt's Yosemite canvases, was purchased by Congress in 1872 and hung in the capitol in Washington. The creation of Yellowstone National Park recognized what was already a fact—that the nation's greatest natural wonders were its sacred places and should be treated as such.

But if Yellowstone was sacred, it was certainly no temple. It was the strangest of natural places and, as a result, nineteenth-century visitors responded very differently to it than they did to Yosemite. If Yosemite was the masterpiece of the Divine Architect, Yellowstone was a collection of nature's weirdest productions. If Yosemite's beauty was in its seamless cliffs, enormous trees, and magnificent waterfalls, Yellowstone's was in its strange colors and the grotesque architecture of its springs, mud pots, and geyser cones. If Yosemite was a natural, pastoral park, Yellowstone was a desolate wasteland. If Yosemite was Eden or the Happy Valley of Rasselas, Yellowstone was hell.

Despite its size—it is larger than Rhode Island and Delaware

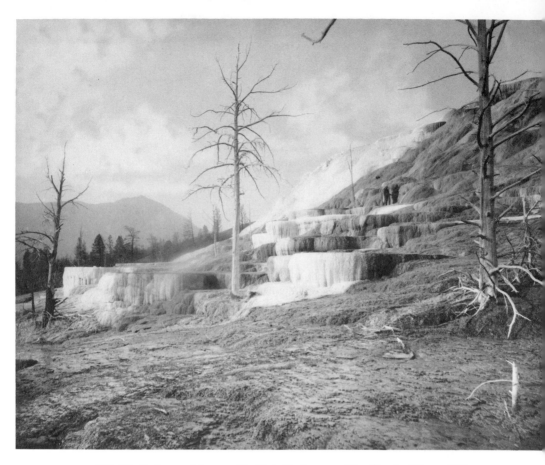

W. H. Jackson, *Mammoth Hot Springs on Gardiner's River* (*Wyoming*), No. 1091. After 1880. (The Metropolitan Museum of Art, Rogers Fund, 1974)

combined and two-thirds as large as Connecticut—part of Yellowstone's attraction, like that of Niagara Falls and Mammoth Cave, was the way it exhibited so many features, so much power and variety in a concentrated area: "Should the whole surface of the earth be gleaned," boasted the *Helena Daily Herald*, "not another spot of equal dimensions could be found that contains on such a magnificent scale one-half the attractions here grouped together."[14] Yellowstone was an enormous "cabinet of curiosities," a Barnum's Museum of the natural world.

Yellowstone inverted the structure of sacred places like Niagara Falls at which the entertaining side shows surrounded the sublime object of worship at the center. At Yellowstone the sideshows were the primary attraction, but the sideshows were not entertainments

arranged by people. They were productions of nature. Like Mammoth Cave, Yellowstone was a natural theater, but in this case no human stage manager was required. Nature performed on her own. Yellowstone's popular nineteenth-century name, "Wonderland," first given to it by the *Helena Daily Herald* in 1872 and inspired by *Alice's Adventures in Wonderland* published in 1865, suggests an unpredictable place in which events occur illogically and sometimes alarmingly and it relates Yellowstone to later, man-made amusement parks, like Luna Park at Coney Island, Disneyland, and Disneyworld. Initially, Yellowstone was regarded as "a colossal sort of junketing-place!" as the editor of *Scribner's Monthly* put it, rather than a wildlife refuge or even a scenic preserve.[15]

Yellowstone's landscape was strange and exotic rather than pastoral or even picturesque. Its most conventionally scenic feature was the Grand Canyon of the Yellowstone River, but even there the most striking features were the "lurid" colors of the canyon walls and its "grotesque" rock formations. As Rudyard Kipling wrote after a visit to the park in 1889, "the sides of that gulf were one wild welter of colour—crimson, emerald, cobalt, ochre, amber, honey splashed with port-wine, snow-white, vermilion, le non, and silver-grey, in wide washes."[16] To some the Grand Canyon seemed templelike and evoked the traditional sublime response: "A sense of reverence creeps over us,—a reverence for that Almighty hand whose power is here recorded in such unequaled splendor."[17] But to others its main interest lay in its more grotesque features. Lord Dunraven found the Grand Canyon lacking in the "stupendous and soul-subduing" qualities of Niagara. Its attraction lay instead in the "solitary" and "utterly desolate" nature of the scene, the "startling and novel" coloring of the canyon walls, and the "weird" shapes of the rocks.[18] To John Muir the canyon seemed unearthly. He was disturbed that he could not recognize "Mother Earth" there: "The very ground is changed, as if belonging to some other world. . . . All the earth hereabouts seems to be paint."[19] Only "the rich and gentle beauty of the vegetation" reassured him. Moran's enormous painting of the Yellowstone which captured the grandeur of the Yellowstone gorge, caused some scepticism, as well as great excitement, when it was first exhibited in 1872 because of the brightness and strangeness of the colors. Langford in his 1872 report as the first Superintendent of Yellowstone Park noted that "By some who have seen this picture its coloring has been criticized, because they could not realize that such a remarkable natural combination of colors was possible. But in this respect the painter's tints cannot equal the original."[20]

165

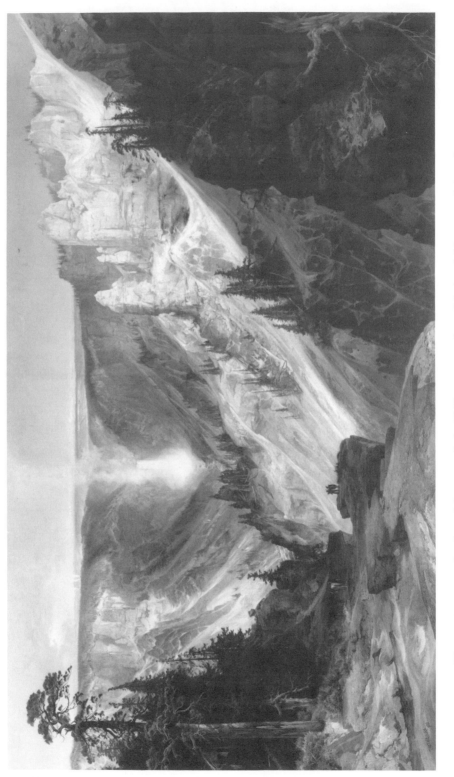

Thomas Moran, *The Grand Canyon of the Yellowstone*, 1872. (National Museum of American Art, Smithsonian Institution. Lent by the U.S. Department of the Interior, National Park Service)

The Grand Canyon of the Yellowstone, strange as it was, could still be composed into an appealing picture; on the other hand, Yellowstone's landscape of geysers, hot springs, and mud volcanoes could not be. Its beauties lay in the structural details and the color of particular objects. Although writers occasionally compared Mammoth Hot Springs to the Taj-Mahal or the Castle Geyser to a ruined castle, such comparisons to the architectural monuments of the Orient or Europe are much less frequent in the Yellowstone literature than they are in the literature of Yosemite and Mammoth Cave. Writers focused instead on the details of the various phenomena: "The frost-work of a winter's window," wrote Almon Gunnison in 1884,

> has not more dazzling wonders, delicate fretted work, flowers with rarest petals, curious lace-work fashionings, and finer weavings, as though a spider's web had stiffened into rock; with coralline traceries and quaint arabesques, as though this were the fairy's workshop, and we had surprised them at their toil. The color, too, is marvellous, the prevailing tint is salmon, but shading into every hue with such invisible transitions as the colors of a rare sea-shell.[21]

They admired the "scalloped" edges of the pools, "the lace-work and bead-work ornamentation . . . almost microscopically minute," the intermingling of colors—emerald, sapphire, beryl, topaz, orange, green, yellow, and blue.[22] Margaret Cruikshank, who left a long unpublished account of her visit to the park in 1883, was fascinated by the "great pure sparkling sapphire rippling" pool of an inactive geyser: "Here we stood entranced gazing into its funnel throat for perhaps twenty feet. Far down in its indigo depths there would form a phantom—a faint white cloud—growing whiter and more defined as it floated up to the surface and discharged itself in ebullition."[23]

But if Yellowstone's thermal landscape contained elements of delicate beauty, they were intermingled with features that were unpleasant, even ugly, and whose only attraction was that they were curiosities like the freaks in a circus sideshow. The activity of the geysers and hot springs created a desolate landscape of whitened, barren soil and dead trees encrusted with deposits from the geysers. Gunnison found that despite the "emerald pools" of pure water and the "sulphur crystals yellow as beaten gold" this landscape of strange phenomena, of desolated grass and trees, was "fearful in its vast unrelieved malignant weirdness":

> [In] these steaming cauldrons, the spouting geysers, the dark venomous-looking mud-pots with their seething mass of variegated

167

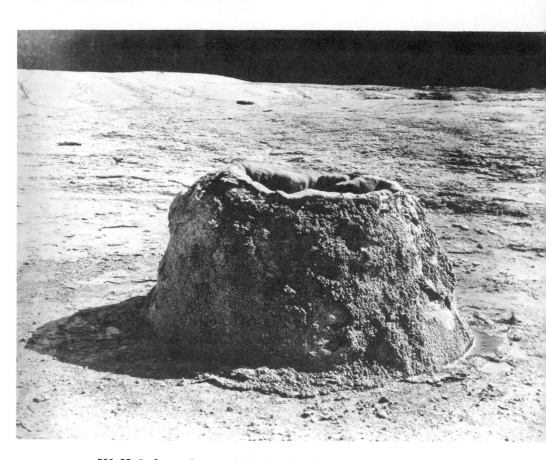

W. H. Jackson, *Crater of the Beehive Geyser, The Great Hot Springs on Gardiner's River (Wyoming)*, 1872. (Library, Academy of Natural Sciences of Philadelphia)

clay, there is active hate. The very soil beneath our feet is but a shell,—a frozen scum above a cauldron's waters; and fissures yawn at us, and the thin crust bends, and from crack and seam come scream and hiss, as though in subterranean caverns vipers scented the coming of human prey.[24]

If there was a "Prismatic Spring," there was also a "Valley of Death" and a "Dental Cup."

The hot springs in the geyser basins bubbled and growled, gurgled and gasped, grunted and roared, hissed and rumbled. The mud pots sputtered, thudded, and popped. Owen Wister employed this sinister Yellowstone landscape as the setting for "Hank's Woman," the story of a mismatched marriage between a prospector and an Austrian maid, fired and abandoned by her

wealthy employers at the park hotel in Gardiner, Montana. The story ends with the maid murdering the prospector and falling to her own death in Pitchstone Canyon. "The Virginian," who appears for the first time in this story describes a "queer steam" rising from the green water at the bottom of the canyon accompanied by a weird sound: "Not that it's a big noise, even when a man is close up. It's a fluffy kind of a sigh. But it sounds as if some awful thing was a-makin' it deep down in the guts of the world."[25]

The air around the springs in Yellowstone was full of the sickening smell of sulphur, "the volcanic whiff," the Virginian calls it.[26] Charles Dudley Warner compared it to the smell of steam coming from "a dirty laundry" and referred to it as "the Park smell." Warner was particularly revolted by the mud volcano "which perpetually vomits a compound of mud, putty, nastiness." "The most disgusting part of it," he wrote, "is that this awful mixture cannot get out, and the creature has to swallow it again, and is perpetually sick to nausea. It is the most fascinatingly loathsome thing in the world."[27]

Yellowstone was in many ways uninviting. It lacked the comforting, human qualities of the picturesque landscape that had been so dear to people like Timothy Dwight: "These vapor columns that we see are not the smoke of farmers' cottages," wrote Gunnison, "but the steamings of the springs, . . . there is no trace of village, nor human soul, perhaps for miles beneath us."[28] No one summed up the "horrors" of Yellowstone better than Kipling:

A mud volcano spat filth to Heaven, streams of hot water rumbled under foot, plunged through the dead pines in steaming cataracts and died on a waste of white where green-grey, black, yellow, and pink pools roared, shouted, bubbled, or hissed as their wicked fancies prompted. . . . There was a potent stench of stale eggs everywhere, and crystals of sulphur crumbled under the foot, and the glare of the sun on the white stuff was blinding.

The mouth of a geyser looked to him like "a horrible slippery, slimy funnel."[29] Given that sort of description, it was amazing that anyone would travel thousands of miles to see such a place. But writers seemed as much fascinated as repelled by the ugliness of the landscape and the ugliness was often strangely mixed with beauty. "Horrible mud volcanoes, and pools of black, boiling mud," wrote Constance Gordon-Cumming, "alternate with fairy-like terraces."[30]

Because of the strange, underworld features of its landscape, Yellowstone appeared to the nineteenth-century visitor to provide

access to the infernal rather than the heavenly regions. A member of the Washburn party compared a "hideous glen filled with the sulphurous vapor, emitted from six or eight boiling springs" to "the entrance to the infernal regions."[31] The park contained among other features: the Devil's Well, the Devil's Kitchen, the Devil's Soup Bowl, and Hell's Half Acre. Although few accidents were reported, visitors had the impression that they were "separated from the raging fires below by only the thinnest crust of earth." "The soil in many parts is burning hot, and echoes to the tread as though liable to open at any moment and swallow the venturesome stranger."[32] The tourist's habit of comparing the geyser landscapes to hell sometimes evoked amusing comments: "Seems a pity that they should ha' come so far just to liken Norris Basin to Hell," remarks the driver of the buggy carrying Kipling and his party through the park. " 'Guess Chicago would ha' served 'em, speaking in comparison, jest as good."[33]

If the geysers, hot springs, and mud pots seemed threatening, ugly, and infernal they also seemed to some visitors humorous. "There is something very ludicrous" about the mud springs and cauldrons, wrote Lord Dunraven, "They fuss and fume and splutter and spit in such a rage about nothing, and with such small results, and are withal so dirty and undignified, that one feels quite inclined to laugh at them."[34] The droll nature of these phenomena helped create a carnival atmosphere. This sense of play seems less light-hearted than it does at Mammoth Cave— perhaps because Mammoth Cave brought people into intimate association in a dark, silent place where laughter was particularly welcome—but the tourists who visited Yellowstone also dropped the usual proprieties and let themselves go. They experienced a sense of freedom which they could not find in their daily routine, the formal life of Victorian society, or among the pressures and restraints of urban living. Often, however, they let go in ways very destructive to the park's distinctive features. They carved their names into the silicate deposits around the geysers, attempting as tourists had done elsewhere, to record their individual part in "the Yellowstone story": "Nature fixes the insult indelibly," wrote Kipling, "and the after-years will learn that 'Hattie,' 'Sadie,' 'Mamie,' 'Sophie,' and so forth, have taken out their hairpins and scrawled in the face of Old Faithful."[35] They hooked fish in Yellowstone Lake, swung the pole over a boiling spring on its shore, and dropped the fish in the spring to cook. They took hot sulphur baths. They tried to encourage the growth of new geysers by poking sticks through the crust where water bubbled to the sur-

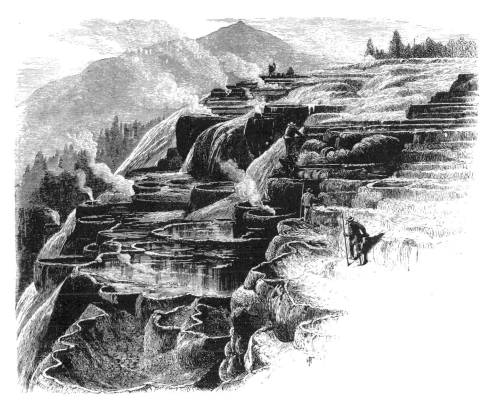

Harry Fenn, *Hot Springs*, from *Picturesque America*, I, 1872. (Courtesy of Vassar College Library)

face.[36] They threw pieces of clothing into the geysers to be washed. After a time the clothing reappeared: "We picked up a piece of a silk handkerchief, the size of a finger nail and some similar pieces of flannel shirts," wrote George Wingate. "They were very clean, but their usefulness as clothing was greatly impaired. One geyser known as the 'Laundress' is quite celebrated as a washer woman."[37] Tourists also placed pine cones, ferns, acorns, pieces of wood, shoes, hats, thimbles, knives, forks, scissors, horseshoes, bottles, and picture frames in the hot springs. When they removed them a day or two later, they were encrusted with a hard, white deposit of silica. Such objects soon became a staple of the Yellowstone souvenir sellers. A few tourists tried making tea from the boiling water of a geyser, although William Owen reported that an hour after drinking three cups of the stuff, he experienced an attack of "violent retching and blinding headache, accompanied with vertigo."[38] Both Wister and Kipling were told that if you "soaped" a geyser, it would make it sick. "If you take of soft-

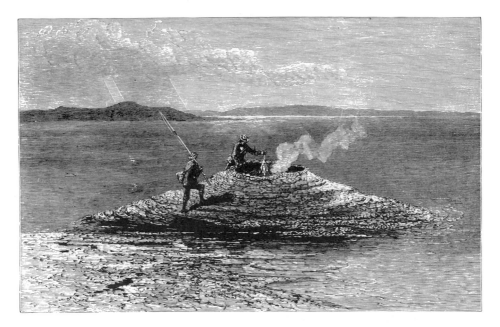

Harry Fenn, *Hot-Spring Cone*, from *Picturesque America*, I, 1872.
(Courtesy of Vassar College Library)

soap a small barrelful and drop it down a geyser's mouth, that geyser will presently be forced to lay all before you and for days afterwards will be of an irritated and inconsistent stomach."[39]

The amusement that tourists sought at Yellowstone depended in part on whether nature performed at the right moment. Tourist attractions often seem less impressive than the descriptions in guidebooks and tourists must also contend with the flatness of their own responses. They must always struggle with the inflated expectations that made some of them describe their visit to Niagara Falls as the greatest thrill of their lives (whether it was or not), while others experienced it as the greatest disappointment. Most of the tourists who visited Yellowstone spent only four or five days in the park. For them the principal frustration was "the very capricious conduct" of most of the geysers. The geysers refused to go off. "What would we not have given to see the display of the Grotto, the Castle, the Grand and above all, the Giantess!" wrote Cruikshank, "that, as I have said, goes off only once a fortnight and we were just seven days too late and too early."[40] The hotel at the Upper Geyser Basin, wrote Owen Wister who visited the Park in 1887, employed a boy, whose voice was changing, to alert tourists when a geyser started to go off. He stood outside the door, "motionless as a steel trap": "Suddenly the trap would

172

spring, the boy would catapult into the door, and in his piping treble scream out: 'Beehive's a-goin' off!' at which every tourist instantly started from his chair, and a leaping crowd gushed out of the hotel and sprinted down over the formation to catch the Beehive at it."[41] Old Faithful became Yellowstone's principal symbol because only it behaved to suit the tourist's schedule. Old Faithful, wrote Cruikshank, was the "perfect geyser" partly because it rose "so straight and clean, uninterfered with by side spurts and splashings," but principally because "He is so entirely all that we had anticipated and was so reliable, playing for us every hour." "Why if it weren't for him there'd be no Park," one of the drivers told her, "the whole thing would be a fraud."[42]

Perhaps because of its ugly features and infernal associations, geology played a very small role in stimulating the imagination of visitors to Yellowstone. Whitney and Muir played important roles in informing visitors of Yosemite's geological history and the debate between them stimulated interest in Yosemite's origins, but Yellowstone had no such spokesman. Hayden, who might have played such a role, did not write effectively for tourists. His guidebook, *The Great West*, was a compendium of useful information on mining, agriculture, and similar topics drawn from his surveys and was aimed mainly at prospective settlers and prospectors. Its description of the geology of the Yellowstone region was matter-of-fact. His article in *Scribner's Monthly*, on the other hand, emphasized the "wonders" of Yellowstone, but said little about its geology. Hayden was not alone. Some of the guidebooks and visitors' accounts contained explanations of the way geysers function, including the temperatures, steam pressure, and so on, but the geysers were treated mainly as curiosities.[43] The Yellowstone landscape did not evoke myths of creation. Furthermore, since Yellowstone lacked the sculptured mountain forms which were the principal scenic feature of the Alps and Yosemite, there was no scope for Ruskinian geological aestheticism. Lord Dunraven notes the erosive effects of water and ice on the landscape of Yellowstone and the abundant evidence of volcanic activity, but although he takes satisfaction in observing these signs, they do not greatly excite his imagination.

The one exception to this want of imaginative response to Yellowstone's geological history was John Muir's "The Yellowstone National Park" which he wrote after a visit to the Park in 1885. Muir regarded the landscape of Yellowstone as a "grand geological library" where we can "see how God writes history." Unlike other writers, who merely fancied that they had reached the entrance to the infernal regions or described the way geysers func-

tion, Muir regards Yellowstone as a window through which to look at its long history of volcanic and glacial activity: "We see Nature working with enthusiasm like a man, blowing her volcanic forges like a blacksmith blowing his smithy fires, shoving glaciers over the landscape like a carpenter shoving his planes." Even for Muir, Yellowstone is an exhibition, but he succeeds in incorporating the carnival atmosphere of the geysers, mud pots, and hot springs into a myth of creation. He combines an appreciation for the grotesque qualities of the phenomena to be found in the park with a vision of the divine geological forces that have been at work in their creation over a long period of time. The inanimate features of Yellowstone become living things which perform with joy and energy. The geysers play in "bright, triumphant bands," "dancing and singing." The large columns appear to him like sequoias, "standing rigid and erect, hissing, throbbing, booming, as if thunderstorms were raging beneath their roots, their sides roughened or fluted like the furrowed boles of trees, their tops dissolving in feathery branches." Others appear like flowers "tossing their pearly branches in the wind, bursting into bloom."[44]

Muir's metaphors embrace the grotesque and ludicrous qualities of the geysers, hot springs, and mud pots while at the same time fitting them into a vision of potency and life. At Yellowstone the forces of creation themselves seem to be on holiday, carrying on not with the solemn dignity of glaciers, but with joyful whimsy. Here Nature is not the Great Artist of Yosemite, but a scientific wizard or mad chef:

> These valleys at the heads of the great rivers may be regarded as laboratories and kitchens, in which, amid a thousand retorts and pots, we may see Nature at work as chemist or cook, cunningly compounding an infinite variety of mineral messes; cooking whole mountains; boiling and steaming flinty rocks to smooth paste and mush,—yellow, brown, red, pink, lavender, gray, and creamy white,—making the most beautiful mud in the world; and distilling the most ethereal essences. Many of these pots and caldrons have been boiling thousands of years. Pots of sulphurous mush, stringy and lumpy, and pots of broth as black as ink, are tossed and stirred with constant care, and thin transparent essences, too pure and fine to be called water, are kept simmering gently in beautiful sinter cups and bowls that grow ever more beautiful the longer they are used.

The liveliness and intensity of Muir's response appears, at least in part, to be an attempt to compensate for the disturbing, destructive, and infernal aspects of Yellowstone's landscape. "The ground

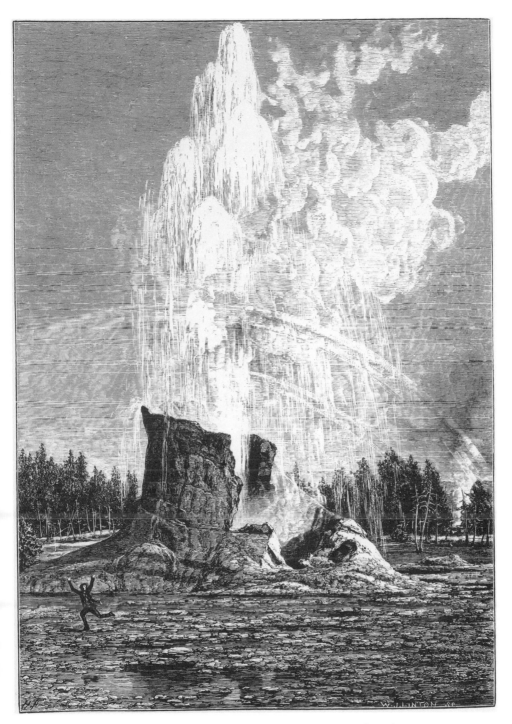

Harry Fenn, *The Giant Geyser*, from *Picturesque America*, I,
1872. (Courtesy of Vassar College Library)

sounds hollow underfoot," he writes, "and the awful subterranean thunder shakes one's mind as the ground is shaken." In stormy weather, the "wild songs" of the geysers and "the earthquake thunder replying to the storms overhead seem doubly terrible, as if divine government were at an end." It is only with the return of sunlight, the sight of living things—flies, squirrels, birds—the song of the ouzel, "most faithful evangel, calming every fear, reducing everything to love," that faith is restored. The destructiveness of geological forces, he reminds us are "creation, progress in the march of beauty through death."[45] Like Emerson at Mammoth Cave, Muir discovers in the Yellowstone show images of heaven and hell, life and death, the end and the renewed beginning of things. The genius of Muir's account is not so much in the addition of new material to the description of Yellowstone, but in his creative use of the images of power, beauty, and ugliness present in other accounts. His imaginative letting go is a more sophisticated form of the release which Yellowstone encouraged among its other visitors.

As in the case of Mammoth Cave Yellowstone promised not only an exhibition of curiosities, a symbolic access to heavenly or infernal regions, and a sense of release, but a restoration of health. Part of the "sacredness" of places like Yellowstone is rooted in the belief that they are a source of special health-giving powers. A small group of invalids was already camped near Mammoth Hot Springs in 1871 when the Hayden expedition arrived. Wingate noted in 1886 that a well-known German doctor had predicted that Yellowstone Park would become "the great International Nervous Sanatorium" because the arsenical content of its spring water was especially effective for nervous disorders. The "predominating smell (some would say stench) of sulphur and sulphurated hydrogen" may have been more easily tolerated by nineteenth-century travelers because they believed it was "unmistakably healthy."[46] Gordon-Cumming predicted that every hotel in Yellowstone would become not only a stopping place for tourists, but "a center of medicinal baths, among which even the revolting mud-pools shall do their part for the healing of mankind."[47]

The search for health-restoring waters of mineral springs was, of course, older than sightseeing. In America the wealthy had gone to take the cure at places like White Sulfur Springs in Virginia beginning in the second half of the eighteenth century. But the idea that camping and "roughing it" might also be a means to better health was a new idea that grew steadily in popularity after the Civil War, particularly in the American West. The early published accounts of Yellowstone which made the region known to

the public associated it with exploration and wilderness adventure. In his article in *Scribner's Monthly*, Langford described the rigors of the Washburn expedition as they struggled through dense forests and over fallen trees, and added at times a touch of mock-romantic adventure. One of his comrades cheers the party on by quoting "in theatrical tone" from Childe Harold: "There is a pleasure in the pathless woods, / There is a rapture on the lonely shore."[48] Truman Everts, a member of the expedition, experienced near death when he became separated from the party and spent thirty-seven days wandering in the wilderness before being rescued. His account of his experiences appeared in *Scribner's Monthly* shortly after Langford's article on the "wonders" of Yellowstone and helped to establish a suitably wild image of the region. Only a few years later, Lord Dunraven rhapsodized about the joys of lying

> flat on your back in your shirt sleeves without any collar. . . . You are not trespassing and nobody can warn you off. There is plenty of fish in the river, some whisky left in the bottle, lots of bread in the buggy; and you run no risk of being disturbed, for there is not another human being within miles. . . . You can go when you like, or stay as long as you choose. You can stretch your arms and kick out your legs without any danger of treading on a sensitive corn, or of poking out somebody's eye; and you can throw back your shoulders, expand your chest, and inhale a full draught of fresh pure air; with a sense of glorious independence only to be enjoyed in a large country.

He appealed to the fashionable men of London—you who "spend perspiring nights struggling on a staircase, inhaling your fellow-creatures, absorbing fat dowagers, breathing men and women!" to come and enjoy the wild, free life of the American West.[49]

Partly because of mismanagement, Congress's unwillingness to appropriate money for roads and other improvements, and delays in the completion of the Northern Pacific Railroad, the facilities for tourists at Yellowstone remained primitive during the first two decades of the park's existence. Travelers often had no alternative but to rough it since there were so few accommodations. But camping was becoming popular in the White Mountains, the Adirondacks, and Yosemite during the same period. What began in part out of necessity, and grew partly because it was less expensive than staying in the luxury hotels that were later built, soon became a popular form of recreation. Camping was regarded as a means of restoring both physical and mental health and of offering a vitalizing change from urban routines. George Wingate took his

*Camping in the Yellowstone*, from George W. Wingate, *Through the Yellowstone Park on Horseback*, 1886. (Courtesy of Vassar College Library)

family through Yellowstone on horseback in 1886 to improve the health of his daughter who suffered from lung disease. In twenty-six days, he exulted, they rode more than four hundred and sixty miles "over prairies and mountains, through rocky canons and along frowning precipices, enjoying the most magnificent scenery that the world affords, until we were all as brown as Indians and able to spend eight hours a day in the saddle without excessive fatigue." They all came back "better and stronger than we have been for years" and Wingate highly recommended to his Eastern readers that they forgo another vacation at a "fashionable watering place" and instead "mount a spirited horse and gallop at full speed over a rolling prairie, in the high altitudes of the Rocky Mountains, where the pure air and rapid motion stirs the blood like a trumpet."[50]

Tourists complained that the tent hotels which were established at a number of sites around the park in the early years lacked chairs, mirrors, and even soap and that the beds sometimes had to be shared.[51] Many women visited the park in the 1880s and although they found the experience rough, they also enjoyed the outdoor life. Margaret Cruikshank, who was accompanied on her 1883 journey to Yellowstone by a Miss Abbott, reported on the problem of accommodations and amenities, particularly for ladies, in the delightful, unpublished account of her adventures already

cited. After two days of roughing it, "It was a luxury to comb out one's hair," she wrote. But she also loved the "simple experiences" of boiling coffee and cooking eggs over an open fire. She and her companion traveled sometimes by carriage, sometime by horseback. Distances were long in the park and a day's carriage ride might be as much as forty miles or more. Yellowstone Park, she wrote, "is no place for the delicate": "Wherever you go there are streams to ford, corduroy to fall over, sagebrush plains to crawl along and mountains to cross." She thought often of Everts and his ordeal in the wilderness and she "longed for railroads." She was exhausted by the time she returned home and two of her companions went to bed sick.[52] Other women were more positive about the camping experience. Mary Richards worried that the "Hotel Fiend" would introduce "regulations and high prices" to the park and bring an end to camping. "How great has been our privilege to follow so closely the trail of the Indian and the pioneer."[53]

By the 1880s tourists often traveled in luxury as far as Bozeman, Montana on well-appointed Pullman cars, a mode of travel which, like the comforts of the Catskill Mountain House, set them at strange odds with the wilderness around them. The Pullman cars, wrote Almon Gunnison in 1884, made it unnecessary to "make our pilgrimage a penance." But at Bozeman his party hired a wagon and purchased camping equipment for "half a month of roughing it" in Yellowstone. Roughing it was a form of playacting and reflected a desire to participate in the Wild West show, not just watch it. Gunnison's party put up with darkness, fatigue, fear of snakes, bogs, inadequate cooking gear, and poor food. Fifty miles of his journey was by foot on a diet mainly of Boston baked beans.[54] Some groups numbered as many as forty people on horseback and carried tents in the baggage wagons which accompanied them; others stayed in the "canvas towns" that were set up for tourists along the route of the tour through the park.[55]

Yellowstone's reputation as a place to rough it also benefited from the interest that sportsmen began to take in it. Although the preservation of wildlife was not among the original motives for establishing Yellowstone National Park, it soon became important as a preserve for buffalo, bear, elk, antelope, and other animals which were fast disappearing elsewhere. In 1893 the artist Frederic Remington praised it as "a great game-preserve and breeding-ground" which would supply wild animals for big game hunting to Montana, Wyoming, and Idaho. One of the early defenders of the wildlife in the park was *Forest and Stream*, founded in 1873 and edited by George Bird Grinnell who, along with Theodore Roose-

velt, founded the Boone and Crockett Club, a group of sportsmen concerned about conservation. The efforts of Grinnell and Emerson Hough, whom Grinnell sent to Yellowstone to report on the wildlife there, helped bring about the passage of the National Park Protective Act which protected the park against poachers. *Forest and Stream* reflected the new passion for hunting, fishing, and camping, and its championing of the park with the support of Theodore Roosevelt helped associate Yellowstone closely with the new fashion of rugged, outdoor living.

Yellowstone's vastness, its wild game, the strange phenomena found within its borders, its reputation as a place to rough it all contributed to its success as a show, which, like "Buffalo Bill's Wild West," combined in strange fashion the wild and the tame. Gunnison wrote in 1884 that "A round trip across the continent in these prosaic days is not prolific in adventures. The wild Indian, in harmless fashion, eats his rations on the reservation, and Jesse James has gone where the wicked cease from troubling, and even the stage robber is at rest. . . . [I]n most aggravating security we make our journey, and return home in a state of mortifying safety."[56] But, as Gunnison's statement itself attests, the tourists eagerly took with them an image of a violent West. This image was kept alive not only by Buffalo Bill's show and by dime novels featuring the adventures of Buffalo Bill and other Western heroes, but by the outbreaks of actual violence which still occurred or were fresh in people's minds. The development of the West as a place of recreation overlapped with its settlement as a frontier and, in places like Yellowstone, followed so quickly its existence as a wilderness that genteel tourism and frontier life sometimes came into vivid, even violent confrontation.

In 1877 a group of Nez Perce Indians, who were being pursued by the U.S. cavalry because they refused to be placed on a reservation, passed through the park and attacked groups of tourists they encountered, wounding or killing several of them. George Cowan, a member of one of these groups was badly wounded and almost died. Cowan's group was well equipped for pleasure camping with a double-seated carriage, baggage wagon, four saddle horses, a cook, and musical instruments with which to entertain themselves. Mrs. Cowan, who later wrote an account of the trip, had arrived in the Montana Territory when she was ten and remembered the tales told to her as a girl in Virginia City about the wonders of Yellowstone. Looking back on her trip from the perspective of 1904, when the park was populated by tourists, she remembered the pleasure of being in a land "fresh from the maker's hand."[57]

At the end of a week in the Lower and Upper Geyser Basins,

however, just as the Cowan party was about to turn toward home, their enthusiasm was suddenly chilled by the news that Indians were in the area. That night, her brother Frank and another member of the party tried to cheer them up by singing and telling jokes, dressing themselves as outlaws, and arming themselves with pistols, knives, and guns. But the "Western" staged by her brother was suddenly overrun by the actual West. The Nez Perce, they discovered later, had watched the show from the woods. In the morning they appeared, took the party captive, and shot and abandoned her husband. She and the rest of the party eventually were released or escaped and her husband was rescued, but what had begun as a tourist jaunt to see "wonders" and "curiosities" had ended in a real frontier experience.

Less violent incidents in which fantasy and reality blurred also occurred. Owen Wister, who made eight visits to Yellowstone, was amused in 1887 by the response of the stagecoach tourists to his party: "We were merely five white men and one Indian, on six horses, with eight packs, in single file, riding at a walk, perfectly harmless, and as new to the Park as were the tourists who leaped from the stagecoaches to snapshot us."[58] Both the actual and the imagined wild West were oddly juxtaposed with the trappings of tourist culture which by the late 1880s had been imposed on the Yellowstone landscape. Kipling was struck by the strangeness of "a howling wilderness of three thousand square miles, full of all imaginable freaks of a fiery nature" where there were "hotels at all the points of interest, guidebooks, stalls for the sale of minerals, and so forth, after the model of Swiss summer places."[59]

Despite the vast natural areas of the park that remained unvisited by the average tourist, Yellowstone was curiously artificial. It combined "the grandest, most wonderful, and most unique elements of nature," wrote Langford, "to produce upon the most stupendous scale an exhibition unlike any other upon the globe."[60] Its natural wonders were theatrical and the impact of these curiosities as elements in a show was reinforced by the trappings of tourist culture which sprang up around them. The preservation of the region as a national park insured that as a national symbol of the vastness and exotic character of the American West the show belonged to everyone.

# ᢒᢏ *Eight*

## Tourism and the Industrial Age: Niagara Falls and Mauch Chunk

DESPITE THE IDENTIFICATION of Yellowstone with the special characteristics of the American West, its geyser basins and mud pots reminded many visitors of a landscape increasingly familiar to them back in Europe and the eastern United States. Near the Upper Geyser Basin, wrote Lord Dunraven, the Firehole River "appeared somewhat like a steaming canal cut through a country entirely composed of limekilns, slagheaps, and the refuse of old smelting works."[1] One party dubbed a group of mud springs "The Chemical Works."[2] No one considered this landscape picturesque. If it had been man-made, few would have cared to visit it. At times the vast and restless power stored just beneath the surface of the earth seemed sublime,[3] but it was not a sublimity which raised the heart toward God.

Visitors to Yellowstone were fascinated, nevertheless, by the way the natural imitated the industrial. The park's natural phenomena resembled the great productive machines that were transforming the modern world. The Fan Geyser is "a massive natural engine twenty-five by one hundred feet," wrote Harry J. Norton, "with two small valves, two large escape pipes, and the extreme upper end a huge smoke stack."[4] Visitors heard "the clank of machinery" in the depths of geyser cones[5] and steam vents roaring like "blast-furnaces."[6] The landscape of the Yellowstone geyser basins both looked and sounded like a factory. The Upper Geyser Basin "suggested to my modern mind a manufacturing center in full swing," wrote Owen Wister. "It might have been Lowell."[7]

The industrial analogies were sometimes mixed with the even more frequent comparisons of the Yellowstone landscape to hell. In the Upper Geyser Basin, wrote Lord Dunraven, "You fancy you

W. H. Jackson, *Mud Geyser in Action, The Great Hot Springs on Gardiner's River* (*Wyoming*), 1871. (Library, Academy of Natural Sciences of Philadelphia)

can hear the rattle of the loom, the whirl of wheels, the clang and clatter of machinery; and the impression is borne upon the mind that you are in the manufacturing department of Inferno, where the skilled hands and artisans doomed to hard larbour are employed."[8]

With the exception of a few people like John Muir, however, those who wrote about Yellowstone in the nineteenth century were not anti-industrial. They saw no contradiction between their enjoyment of a bit of wilderness adventure and their faith in progress and economic development. Nor were most of them bothered by the way Yellowstone's natural phenomena mirrored the machinery of the industrial age. In the first place, the geysers, hot springs, and mud pots were not actually factories, they only resembled them. The resemblance was novel and fascinating, and did

not require them to deal with the actual effect industry has on the landscape or the conditions of workers. In the second place, as John Kasson has demonstrated in *Civilizing the Machine*, most Americans loved technology. In 1876, for example, just as Yellowstone was being developed as a tourist attraction, Americans were flocking to the Philadelphia Centennial Exposition to admire the enormous Corliss steam engine, the centerpiece of the exhibition.[9] The new machines excited people and the geysers at Yellowstone which imitated those machines captured that excitement in a comic, caricatured form.

This did not mean, however, that everyone ignored the negative effects of industrialization on the landscape. At Niagara Falls, where industry intruded on a grand natural phenomenon, many observers became upset. Factories were built on the banks of the river above and below the Falls along with commercial establishments including hotels, laundries, stables, and shops. Sewage flowed directly into the river. There was nothing novel or exciting about this landscape. By the 1860s the increasing industrialization, as well as the commercialization of the Falls had become obnoxious to many visitors. Niagara "resembles a superb diamond set in lead," complained *Picturesque America* in 1872. "The stone is perfect, but the setting lamentably vile and destitute of beauty."[10] Moreover, the pressures to harness more of Niagara's power for industrial purposes were growing.

For the genteel traveler part of the problem was that the class of person who visited the Falls was changing. Before the Civil War Niagara Falls was a resort, and well-to-do tourists frequently came to stay for a week or more in one of its grand hotels. But the excursionists who arrived after railroad fares declined usually visited Niagara Falls only for a day. The genteel tourist regarded them as less cultivated. They appeared more eager for exciting diversions than the better-off tourist, less inclined to the quieter pleasures of a sylvan walk. "Like locusts," wrote the journalist Henry Norman in 1881, "they sweep everything before them."[11] Part of the appeal of Yosemite and Yellowstone was that these "excursionists" could not follow the well-to-do travelers to such far Western destinations.

In response to the threats posed by the commercialization and industrialization of Niagara, Frederic Church, Frederick Law Olmsted, and other prominent individuals proposed that the state of New York establish a park at the Falls that would allow the public free access and protect the Falls from the incursions of souvenir shops, sideshows, mills, and other desecrations. Their proposal was finally enacted into legislation in 1883 after a long campaign of pe-

*Disfigured Banks, Repulsive Scenery Around Visitor Approaching Goat Island Bridge for First View of Rapids*, ca. 1879, from James T. Gard-ner, *Special Report of the New York State Survey on the Preservation of the Scenery of Niagara Falls.* (Courtesy of the Local History De-partment, Niagara Falls Public Library)

titions, editorials, and newspaper articles, and in 1887 Olmsted and his fellow landscape architect Calvert Vaux submitted their final plan for the park.

For Olmsted the enemy was the sort of commercial structuring that had turned Niagara Falls into a series of commodities to be consumed by the tourist. Niagara Falls increasingly served the popular need for entertainment which, at a later time, would be met by places like Coney Island, and Olmsted intended to put a stop to it.[12] "The aim to make money by the showman's meth-ods," Olmsted wrote in the *Special Report of the Commissioners of the New York State Survey of 1879*,

> the idea that Niagara is a spectacular and sensational exhibition, of which rope-walking, diving, brass bands, fireworks and various "side-shows" are appropriate accompaniments, is so presented to the visitor that he is forced to yield to it, and see and feel little else than that prescribed to him.

He felt the problem arose from the way the proprietors of the Falls had come to exercise more and more control over the move-

ments of visitors by means of guides, gates, walkways, and toll booths:

> Visitors are so much more constrained to be guided and instructed, to be led and stopped, to be "put through," and so little left to natural and healthy individual intuitions.[13]

But it was not merely the means by which the proprietors marketed the sensational aspects of Niagara to which Olmsted objected. He rejected all forms of "astonishment," including the sublime, out of which he clearly felt the sensationalizing of the Falls had sprung. His approach to Niagara depended on the categories of the picturesque and the beautiful, which were not applied to grand natural phenomena as frequently as the sublime, but were just as well established and derived from the same body of eighteenth-century English aesthetic theory. For Olmsted the true enjoyment of the Falls required a quiet and pensive contemplation of their beauty.[14] His firm rejection of the sublime represented an important turning point in the history of the Falls, although his response to the quieter attractions of Niagara had many precedents. Earlier writers, like Harriet Beecher Stowe and Charles Dickens, had emphasized the calmness and the beauty of Niagara rather than its thrilling qualities, and artists, like Jasper Cropsey, had depicted groups of tourists gazing serenely at the Falls amid pastoral surroundings. But the commercialization and industrialization of the Falls and the changing character of the tourists who frequented them had made it difficult to sustain these visions of Niagara's beauty and picturesque tranquility.

Olmsted concluded that most of the tourists who visited Niagara had poor taste, were in a hurry, and were easily led by the arrangements made for them. No improvements, he felt, were likely to "increase the astonishing qualities" that drew many of them there.[15] But improvements could encourage the excursionist to take a more leisurely approach to the experience of the Falls. In his plan for the reservation, Olmsted set out to redesign the landscape in order to expand what he had called "the influence of the scenery" and allow the tourist to follow his "natural and healthy individual intuitions" rather than the dictates of guides, markers, gates, and so forth.[16]

The landscape that Olmsted proposed was, like Central Park and his proposed plan for Yosemite Valley, essentially domestic and genteel: a natural park with carriage roads set back from the edges of the island, giving precedence to winding walks closer to the water; places for sitting and standing, paths for strolling through

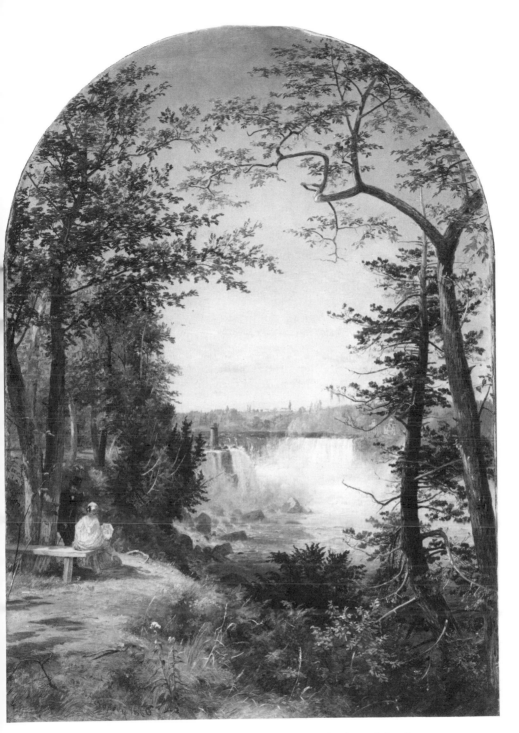

Jasper F. Cropsey, *Niagara Falls*, 1860. (Collection of Jo Ann
and Julian Ganz, Jr.)

secluded woodland and viewing the rapids or falls through breaks in the trees. It was a middle-class version of the nobleman's estate and was in harmony with the rural cemeteries of the period; the grounds of the scenic hotels, like the Catskill Mountain House; and the picturesque landscape architecture of Andrew Jackson Downing, all of which appealed to a taste for cultivated naturalness. It would be necessary to construct "walks, roads, bridges, stairways, seats and standing places," in order for visitors to enjoy the scenery, wrote Olmsted in his final plan for the Niagara Falls Reservation in 1887, but such "artificial appliances" should be as unobtrusive as possible and not interfere with the visitor's freedom of movement.[17] All man-made structures still intruding on the natural landscape were to be hidden by screens of trees. When Olmsted's plan was fully realized, Goat Island and the smaller islands above the Falls became covered with vegetation, and a band of trees, grass, and walks was created on the American shore from the head of the rapids down to the brink of the Falls. A more formal park, not designed by Olmsted, was constructed on the Canadian side. What William Howard Russell, a *London Times* correspondent, called in 1863 the "fixed fair" of Niagara did not entirely disappear, but was pushed back, and made, just barely, to keep its distance.[18]

By the 1860s and 1870s the commercial version of Niagara as a spectacle had threatened to swallow every other experience of the Falls. Olmsted's plan for the reservation made room for the genteel tourist again but defined the proper experience of the Falls as picturesque contemplation rather than sublime excitement. Within the reservation Olmsted succeeded in transforming the environment from one in which tourists were processed through the sight to one in which they could direct themselves. Thus, Olmsted provided an alternative mode in which tourists could consume the Falls as a cultural product. But he didn't defeat the sensational version of the Falls that continued to operate from the periphery of the Niagara Reservation. The two versions of the Falls settled down side by side to vie for the attention of visitors. Although it had as its centerpiece a picturesque park rather than the highly formalized and monumental "White City" which anchored Chicago's Columbian Exposition of 1893, Niagara resembled the Chicago exposition in the way very different cultural experiences were juxtaposed to each other. The White City, whose landscape Olmsted helped design and which was intended to embody the refined values of genteel civilization, competed with the exposition's Midway, where popular entertainments and sideshows abounded.[19]

J. B. Harrison, who had warned in *Certain Dangerous Tenden-*

*cies in American Life* (1880) of the threat to the property-owning class from rampant democracy and labor unrest, wrote a series of newspaper articles in 1882 in support of Olmsted's efforts to preserve Niagara Falls. In it he argued that the proposed reservation would help civilize, and thus control, the lower classes. It would offer a vital change for those who wished to escape from "the wearing, exhausting quality which is so marked in modern life," and provide a "quickening and uplifting of the higher powers of the mind."[20] The effort to save the Falls was an attempt to assert the values of upper middle-class society in the name of raising the moral tone of democratic life. Niagara Falls, however, lent itself as much to being a thrilling spectacle, an act in a circus, as it did to being nature's masterpiece in a picturesque park, and it remained both.

If some nineteenth-century tourists found the intrusion of ugly industrial structures into the Niagara landscape offensive and were revolted by the resemblance of parts of Yellowstone to a chemical works, these were exceptions. Most Americans, as the discussion of the machinelike phenomena at Yellowstone suggested, perceived no conflict between nature and industrial civilization. One measure of their acceptance of industrialization is the way machines, mills, and other products of the new age are represented in popular depictions of American scenery. Steamboats and railroads, for example, appear entirely at home in the scenes represented in the engravings of Nathaniel P. Willis's *American Scenery* (1840). A train crosses a graceful aquaductlike bridge, a canal boat is towed along a peaceful, moonlit canal. No clearly identifiable mills are present in that early book, but cotton mills, flour mills, and powder mills appear as prominent objects in *Picturesque America* (1872–74). "Too often," writes O. B. Bunce in the chapter "Scenes on the Brandywine," "labor mars the landscape it enters, but the mill seems to partake of the spirit of its surroundings, to gain a charm from woods and waters, and to give one." *Picturesque America*, in fact, depicts a highly industrialized American landscape. Its repertory of the picturesque includes foundries illuminating the night in Poughkeepsie and a forest of grain elevators at Buffalo as well as wooded cliffs, gnarled trees, and moonlit streams. The frequent views of cities in *Picturesque America*—Chicago, Richmond, Savannah—show tall factory smokestacks streaming black smoke. Constance Woolson writes in the chapter on Pittsburgh that the city "has the picturesque aspect of a volcano, owing to its numerous manufactories." It "seems satanic" and reminds visitors of Dante's Inferno. But Pittsburgh's iron mills, "resting not day or

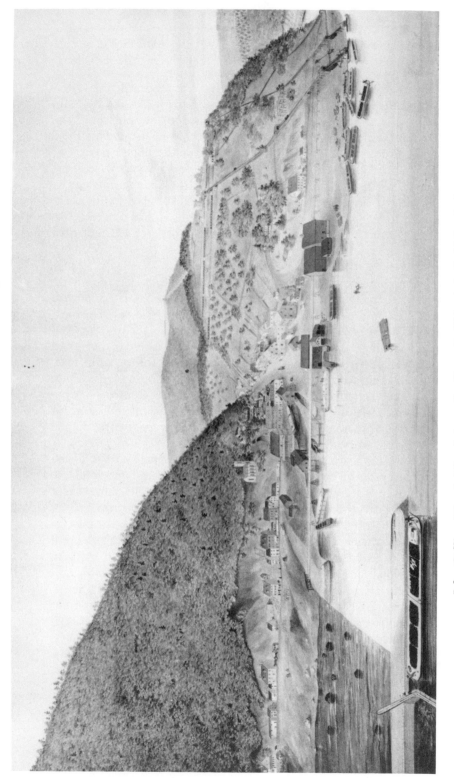

John Collins, *Mauch Chunk, from the Opposite Side of the Lehigh*, 1846. (Courtesy of the Museum of Art, Pennsylvania State University)

night, but ever ceaselessly gleaming, smoking, and roaring" excite rather than dismay her and she composes the scene into a sublime painting: "What a grand, lurid picture Turner, Ruskin's art-god, would have made of Pittsburgh by night!"[21] If the inferno of Pittsburgh could be thus imaginatively transformed, then the association of Yellowstone with hell did not necessarily amount to aesthetic condemnation.

The American fascination with technology expressed itself particularly strongly in an enthusiasm for railroads. Although some people objected to their presence in the landscape, Bayard Taylor reported in *The Home Book of the Picturesque* in 1852 that the "vulgar lament over their introduction is beginning to disappear." "We now more frequently hear of the power and poetic mystery of the steam-engine."[22] Walt Whitman, who shared this popular view, exclaims in describing the Western prairie in "Passage to India": "I hear the locomotives rushing and roaring, and the shrill steam-whistle, I hear the echoes reverberate through the grandest scenery in the world."[23] The bridges built to carry the railroads over America's rivers also attracted admiration. John A. Roebling's railroad suspension bridge built in 1855 over the Niagara Gorge became a common feature in popular illustrations of the Falls, an object which itself evoked the emotion of the sublime. It was the first successful railroad suspension bridge in the world.

The most important early example of industrial technology as a tourist attraction, however, was the town of Mauch Chunk located on the edge of the anthracite coal fields in eastern Pennsylvania and known today as Jim Thorpe. Mauch Chunk thrived as a major coal transportation center throughout the nineteenth century, but it was also a highly successful tourist resort. *Picturesque America*, which found the industrial and commercial features of the Niagara Falls landscape so "vile," called Mauch Chunk "doubtless the most truly picturesque town in the Union."[24] At Niagara Falls industry intruded on visitors' expectations of what they had come to see, but at Mauch Chunk it was an integral part of the scene. Both the natural features of the town and the mining and transportation of coal were among its attractions. Mauch Chunk confirmed the values of many Americans in the nineteenth century— the faith in progress, the pride in America's growing power and wealth—and reconciled the underlying contradictions between their fascination with technology and their love of grand and picturesque scenery.

Mauch Chunk was founded by the Lehigh Coal and Navigation Company as a shipping point for anthracite coal, but tourism was part of its history almost from the beginning. Tourists began visit-

ing the town in the 1820s soon after the coal mines were opened, and the area was described enthusiastically in American guidebooks as early as 1826.[25] The construction of a gravity railroad in 1827, from the mines at Summit Hill to the Lehigh River at Mauch Chunk nine miles away, assured the success of the region as a tourist attraction as well as a transportation center. The railroad provided not only a fascinating example of technological innovation, but a thrilling ride. The completion of the Lehigh Canal in 1829 secured the position of the region as a stopping place on the "Fashionable or Northern Tour."[26]

Both the gravity railroad and the canal evoked from visitors what Leo Marx has called "the rhetoric of the technological sublime."[27] Early travelers, like Maximilian, the German Prince of Wied-Neuwied, were fascinated by the columns of coal cars whizzing by them "with the rapidity of an arrow,"[28] particularly since they moved, as Benjamin Silliman put it, "without apparent cause." The powerful operation of gravity seemed magical and the sublimity of the scene lay both in a demonstration of that natural power and in the human skill of harnessing it. The cars, wrote Silliman, the leading American scientist in the first half of the nineteenth century, "are heard, at a considerable distance, as they come thundering along with their dark burdens and give an impression of irresistible energy."[29] It was as if Niagara Falls had been put to human use.

As for the canal, the historian M. S. Henry summed up the response of travelers to Mauch Chunk when he wrote in 1860 that its "tremendous dams" and "immense guard banks" "all lead one to reflect on the magnitude of its design and the skill, energy, and perseverance of its projectors."[30]

Enthusiasm for Mauch Chunk's technological and natural beauty grew as the town reached maturity. The addition of a back track to the gravity railroad in 1845 not only offered tourists another intriguing example of technological achievement but opened more scenery to view. The pleasure cars as well as the empty coal cars were first drawn by a stationary engine to the top of Mount Pisgah where visitors could look down on the town and out on the surrounding mountains—the Promised Land, presumably, of the anthracite coal industry. The cars then ran by gravity to the base of Mount Jefferson where they were drawn up the second plane and coasted on to Summit Hill. As tourists were whirled about the mountain, said the author of an 1872 guidebook, they were treated to "numerous landscapes stretching about on every side, changing as rapidly and charmingly as the views in the kaleidoscope."[31]

In 1846 another ingenious mechanism called the "switchback"

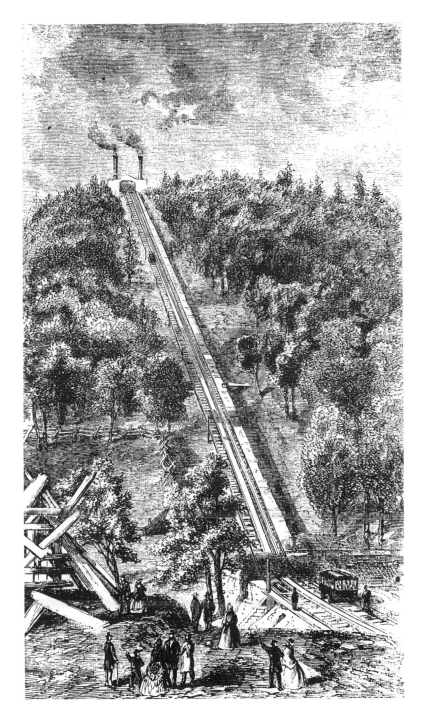

*The Inclined Plane, Mount Pisgah,* from *Harper's Monthly,* 1863. (Courtesy of the Sojourner Truth Library, State University of New York. New Paltz)

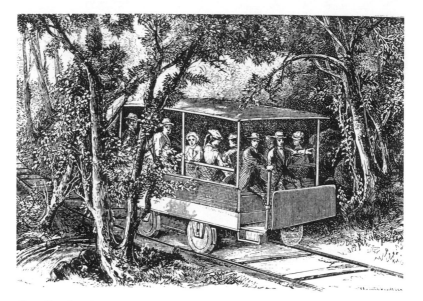

*On the Grade,* from *Lippincott's Magazine,* August 1872. (General Research Division, The New York Public Library, Astor, Lenox and Tilden Foundations)

began returning empty coal cars to the new mines in Panther Creek Valley where they were loaded and drawn back to Summit Hill by another set of inclined planes. This railroad zigzagged back and forth as it descended into the valley, the direction of the cars reversed by self-operating switches. It added still another form of excitement to the circuit made by visitors. The Switchback Railroad, as the whole system came to be called, continued to carry tourists after 1870 when completion of a tunnel made it unnecessary to use the system for transporting coal. By the end of the century, the Switchback Railroad had lost some of the novelty it had once had as rail travel became familiar to everyone. But this did not affect its popularity. Like the roller coasters constructed at Coney Island and elsewhere after 1884, the way it imitated in a more joyful form the familiar machinery of industrial civilization appears to have been part of its appeal.[32]

The conversion of the Switchback to a vehicle solely for the entertainment of visitors corresponded to the introduction of improved rail service after the Civil War. The lower fares, which enabled a growing middle class to travel on vacations to Niagara Falls, brought many people to Mauch Chunk as well. By the 1870s Mauch Chunk could be reached from Philadelphia in about three

hours and from New York in four to five. The town was thus ideally situated to profit by this expanding demand for inexpensive and easily accessible resort areas. An energetic campaign was launched to promote the town and tourists flocked to it in increasing numbers during the last quarter of the century.

Although the gravity railroad and its later elaborations furnished entertainment for tourists, the attractiveness of the town depended ultimately on the visual impression made by the landscape. Not everyone saw this landscape in exactly the same way, but a common view emerges from the reports of travelers and journalists and from nineteenth-century histories and guidebooks that frequently drew upon these accounts. This way of seeing Mauch Chunk is also confirmed by most visual representations of the town, although there are one or two interesting exceptions.

One of the finest depictions of Mauch Chunk was sketched by Karl Bodmer, a Swiss artist who accompanied Prince Maximilian on his travels in America, and is best known for his portraits of the Plains Indians. When Bodmer visited Mauch Chunk in 1832 it was still a frontier town, just emerging from its early years as a mining and lumbering camp. The engraving made from Bodmer's sketch, with bare decaying tree trunks along the river in the foreground and the craggy mountain behind, portrays an outpost of civilization in the wilderness—the upriver settlement of a developing country. The rude coal chute, which emphasizes the steepness of the mountainside and dominates the man-made part of the landscape, reinforces rather than softens the wildness of the scene.

George Lehman's aquatint of Mauch Chunk, drawn in 1829 several years before Bodmer's engraving, represents the town very differently. Although the piles of lumber along the canal and the prevalence of commercial structures along the river testify to the industrial occupations of the town, the overall impression is pastoral. Lehman chose a view from the road below the town, whereas Bodmer stationed himself at the river's edge above the town. From Lehman's perspective the end of the gravity railroad and the coal chutes dwindle into insignificance. Lehman makes them appear like fences dividing a meadow. The cows and the human figures at rest in the foreground reinforce the mood of pastoral order and quiet. These features of Lehman's foreground, as well as the magnified plants in the left corner and the felled tree trunk on which one figure sits, appear frequently in views of American towns in the first half of the nineteenth century.[33] They indicate that Lehman was shaping his vision of Mauch Chunk to a convention rather than highlighting its distinctive features.

Bodmer also took liberties in accenting the wildness of the

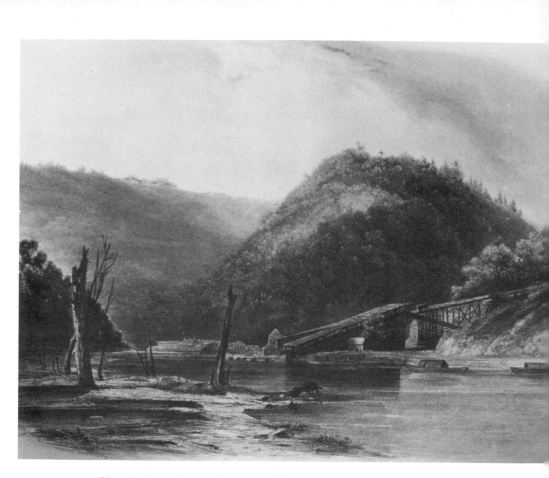

Karl Bodmer, *View of Mauch-Chunk*, 1832. (Special Collection, Lehigh University Libraries)

scenery, but his rendering corresponds much more closely to accounts of early visitors and suggests that he grasped the significance of what was occurring at Mauch Chunk. Lehman, a landscape painter and later lithographer from Philadelphia, drew views of several Pennsylvania towns. He depicts Mauch Chunk as one more American town rapidly transformed from a savage to a pastoral state. Bodmer, on the other hand, came to America to record the land and its people in their aboriginal condition. Thus he focuses on the presence of industrial activity in a wild setting. His version of Mauch Chunk anticipates Hawthorne's description of the mills in North Adams, Massachusetts in 1838 in which Hawthorne discovers "a sort of picturesqueness in finding these factories, supremely artificial establishments, in the midst of such wild scenery." Although Hawthorne expresses anxiety about the industrialization of America at times, in this instance the dramatic

196

George Lehman, *Mauch Chunk*, 1829. (Courtesy of the Museum of Art, Pennsylvania State University)

impression made by the scene excites him, just as other travelers were struck by the contrast between the luxurious Catskill Mountain House and the wild mountain scenery about it.[34] Bodmer, too, appears attracted rather than disturbed by the sight of an industrial structure in the wilderness. America, underdeveloped but rich in resources, was on the verge of a takeoff into rapid industrialization, and Mauch Chunk was about to play a major role in that revolution. Bodmer probably did not understand all the implications of what he saw. Nevertheless, he recorded the infancy of industrial America in the still wild Eastern landscape and depicted it as a visually appealing event.

Despite Lehman's pastoral vision, Mauch Chunk had no "middle landscape" to mediate between nature and civilization, and this remained true throughout its history. Its topography and economy prevented the development of a pastoral landscape. "Along the course of the river, not a single rod of arable land is to be perceived," wrote a visitor in 1844, "The mountains sink sheer to the water's edge."[35] The town consisted of a single street of commercial structures along the Lehigh, a street of fine houses and several hotels running up the narrow valley of Mauch Chunk Creek, and a small street of workers' houses running parallel to the latter. The appearance was urban, as if a tiny portion of Philadelphia had been relocated in this mountainous setting.

Louis Gratacap, a curator of the Museum of Natural History in New York who visited the town in 1880 during its mature phase, wrote in his diary: the town lies

> between hills, whose slopes crowd down upon the houses and tilt up their back yards at all angles. The houses cluster closely together, are clean, and many attractive; the windows are thrown open and you look into rich and elegant interiors. Over their roofs you see the sides and tops of hills and this pressure and contact of wild nature upon and with the conventions and structures of a city give an air of novelty which at first surprises and charms you.[36]

Although Gratacap's account spares us the rhetoric of the picturesque, it suggests why Mauch Chunk appealed to lovers of irregularity, contrast, and variety who wanted objects in the landscape to be grouped and framed as in a picture.

The picturesque often celebrated the gradual fading of structures back into nature. Vines, moss, and dirt brought crumbling castles and decaying cottages into harmony with their surroundings. If American scenery lacked the ruins and romantic associations that accompanied them in the Old World, the industrial age offered picturesque harmony of another, but related, sort.

Nowhere could it be found so vividly as at Mauch Chunk. The entire business of nineteenth-century civilization appeared concentrated by the natural forms surrounding the town. Descriptions of Mauch Chunk occasionally mention the subjugation of nature or, conversely, the ever-present threat of devastating floods, but they persistently emphasize the sights and sounds of human activity contained by the rugged terrain. Mauch Chunk made a picture of bustling human life in a natural theater—the grandeur of American accomplishment framed by the magnificence of American nature.

The favorite points from which to draw Mauch Chunk were on the road that climbed the mountain below the town and at Prospect Rock higher on the same mountain. These positions were popular probably because from them the artist could encompass most of the elements in the landscape within a single frame of vision. Thus the observer could enjoy a moving panorama more exciting than any along the Hudson River.

The classic example of this view of Mauch Chunk is Harry Fenn's drawing in *Picturesque America*. It invites the eye to follow the boats along the canal, the mules on the towpath, the trains along the tracks; to pick out the cars on the Mount Pisgah plane and on the trestle beyond; and to trace their return route. The way Fenn exaggerated the size of Mount Pisgah, as if it were Mount Etna or Vesuvius, aggrandizes both the mountain and the structure on it. He also accentuated the concentration of activity in the valley. As the writer in *Picturesque America* put it, Fenn's drawing "gathers at the feet of the spectator hurrying river, busy canal, railways, and highway, as they lie crowded between the steep hills." Canal boats and coal cars on both sides of the river occupy most of the foreground, and although the text described the trains rather ominously as "huge anacondas," the rest of the language indicates that "this immense traffic in black diamonds" was the object of admiration rather than dread:

> Here there is always the stir of a great traffic. Ceaselessly day and night the long, black coal-trains come winding round the base of the hills, like so many huge anacondas, often with both head and tail lost to the eye, the locomotive reaching out of sight before the last car comes swinging round the curve. These trains are of marvellous length, sometimes, when returning empty, numbering over two hundred cars. So continuous is their coming and going, sweeping now around the foot of the hill opposite, and now around the base of the hill on which we stand, that usually several trains are visible at the same time; and rarely at any moment is the whistle or the puff of the locomotive silent.[37]

Harry Fenn, *Mauch Chunk and Mount Pisgah*, from *Picturesque America*, I, 1872. (Courtesy of Vassar College Library)

Neither Fenn nor the writer regarded this onslaught of locomotives as an intrusion upon nature. By selecting a position from which the congruence of built and natural forms would be most dramatically apparent, Fenn emphasized the integration of the railroad into the scene. Tracks and river, retaining wall and mountainside mimic each other in their corresponding curves.

Tourists did not step out of the booming urban and industrial culture of nineteenth-century America when they went to Mauch Chunk. Rather they entered a more intense and enchanting version of it, grandly framed by a nature whose "mineral treasures" heated their modern homes and fueled their factories. After 1872 tourists enjoyed the rustic pleasure of Glen Onoko, a wooded ravine containing a series of waterfalls that was two miles beyond Mauch Chunk and had been developed by the Lehigh Valley Railroad. But even there the prospect encompassed both "nature and art"—"the thundering of countless trains as they wind majestically and gracefully through the valleys" as Oramel S. Senter wrote in *The Health and Pleasure Seeker's Guide*.[38] These long trains of coal cars, like the mansions of the coal and railroad barons visible beyond the canal and warehouses in Herman Herzog's *Mauch Chunk* (1872), testified to the growing wealth of Eastern cities that this traffic in "black diamonds" was generating.

Coal appeared jewellike to nineteenth-century visitors. Prince Maximilian saw the coals "stand out, shining, and with a beautiful play of colours," and H. C. Sheafer, writing for *Lippincott's Magazine* in 1872, admired the "mass of pure, glittering fuel, forty feet or more in thickness."[39] The romance of anthracite faded as the century passed, but for many years it maintained a positive image in popular treatments of the coal industry. We "trace its useful presence throughout the whole range of both social and industrial life," proclaimed the author of "Coal, and the Coal-Mines of Pennsylvania" in *Harper's New Monthly Magazine* in 1857, "and find it often associated with our national strength and glory."[40]

The mines themselves fascinated nineteenth-century travelers, who marveled at the scale of the operations and found the coal breakers and breaker boys picturesque. In 1830 Silliman estimated that the veins of coal at Summit Hill were as much as fifty-four feet thick and the area covered by the mine was more than eight acres. For people with geological interests, like Silliman, the sublimity of the mine with its "stupendous masses" of coal was reinforced by the conviction that the mines were "inexhaustible," and by the vision of the "upheaving force exerted with vast energy, from below," which had "bent, dislocated, and broken the strata."

Silliman saw the mine as a "vast fort, of which the central area is the parade ground and upper escarpment is the platform for the

Herman Herzog, *Mauch Chunk*, 1872. (Courtesy of the William B. Mollard family)

cannon,"[41] and a later visitor, the author of "Coal, and the Coal-Mines of Pennsylvania," found Silliman's image apt, "for there was employed in the mineral garrison an army by no means insignificant in number or strength, and all equipped and armed with the implements of industrial war." But if humanity was warring against nature, the battle laid bare its grandeur rather than diminished it. The isolated mounds of coal become melancholy ruins, sometimes topped with the decaying tree so common in paintings by Thomas Cole and others, and evoking, in this case, a mythic sense of time. Writers, however, found as much enjoyment in the sights and sounds of human progress as in the natural objects exposed by the mining operations:

> Towering fifty to sixty feet in the air, entirely separated and isolated from the adjacent strata, with their tops still covered with

forest foliage, and the trunk of an old tree occasionally left standing as a kind of monumental relic of the past, these gigantic mural breasts of coal had a dark, sombre, cyclopean aspect; while the ring of the drill, the sharp glance of the miner's pick, the rumbling noise of passing cars, the rattling of coal shovels, and the general buzz and circumstance of activity everywhere around— all awakened in the visitor sensations at once peculiar, novel, and interesting.[42]

The contrast between the wild and the industrial, the pleasurably gloomy past and the bright sounds of progress, was picturesque rather than disturbing, as if this grand fort were the perfect arena for the energies of the human race.[43]

It was much more difficult to incorporate the enormous piles of rubbish or culm banks that accumulated near the mines into a pleasing picture. Benjamin Silliman treated these "artificial hills" as curiosities,[44] but as time went on it became impossible to ignore the devastation caused by mining. The author of the 1872 guidebook, *Mauch Chunk and Vicinity*, recognized that "these mounds give a dreary look to the valley, killing all vegetation, and causing the creeks to run streams as black as ink."[45] Even the writers for

*Coal Mine at Mauch Chunk* (Summit Hill), from *American Journal of Science and Arts*, 1830, after an aquatint by George Lehman, 1829. (Courtesy of Vassar College Library)

*Picturesque America,* with their insatiable appetite for the quaint, had to admit these "masses of *debris*" were "unsightly," though they assured readers that in time the "small mountains" would be entirely covered with vegetation.[46]

Despite the growing wasteland created by the mining operations, however, the mines continued to provide picturesque sights for those accustomed to looking at surfaces and not questioning the social reality beneath. The picturesque often protected tourists from too close an encounter with poverty, misery, and exploitation. In an incident recounted in his essay, "Italy Revisited" (1877), Henry James provides insight into how this protection was provided. James stands at the gate of an Italian hill town, composing and savoring the landscape before him: "I stood in the shadow of the tall old gateway admiring the scene, looking to right and left at the wonderful walls of the little town, perched on the edge of a shaggy precipice; at the circling mountains over against them; at the road dipping downward among the chestnuts and olives." As James watches, he spots a young man moving along the road. The man

> slowly trudged upward with his coat slung over his shoulder and his hat upon his ear in the manner of a cavalier in an opera. Like an operatic performer too he sang as he came; the spectacle, generally, was operatic, and as his vocal flourishes reached my ear I said to myself that in Italy accident was always romantic and that such a figure had been exactly what was wanted to set off the landscape.

The picture completed to his satisfaction, James turns to go. But as he does so, the man overtakes him, asks for a match, and they fall into conversation. The man, it turns out, is "a brooding young radical and communist filled with hatred of the present Italian government, raging with discontent," and willing to "lend a hand to chop off the heads of the king and the royal family." Now that the man has stepped out of James's composition and revealed his "crude political passion," James must admit that it was "very absurd of me to have looked at him simply as a graceful ornament to the prospect, an harmonious little figure in the middle distance. 'Damn the prospect, damn the middle distance!' would have been all *his* philosophy."[47]

As a tourist, James traveled in search of picturesque scenery, not social reality. In this instance, his idealized vision of Italy was interrupted, but as he himself says, it was only because he happened to strike up a conversation with the man approaching the gate. Normally the habit of composing the landscape and the

*Screen Room of a Coal Breaker*, photograph from a souvenir album, ca. 1890. (The Historical Society of Pennsylvania, Philadelphia)

figures in it into a picture, shielded him, like the average tourist, from such knowledge. Probably only a few tourists achieved James's sophisticated consciousness of what they were up to, most remaining content with the distanced, purely visual appreciation of the people in the landscapes they viewed.

In Europe peasants and gypsies often produced the striking visual effect tourists were seeking; in America blacks sometimes served the same function. In the anthracite region the breaker boys, described in *Mauch Chunk and Vicinity* as "merry, bright-eyed, dirty little urchins," played this role.[48] The breaker boys or slate pickers were boys between four and ten years old who worked in the coal-breakers separating the impurities from the coal. To "those who look for the picturesque features of a colliery the slate-picking room is the most interesting of all," said the writer of "The Pennsylvania Coal Region" in *Harper's New Monthly Magazine*.

> Nothing can be more amusing than the expression of countenance and the movements of these little fellows, nothing more ludicrous than their ragged and ungainly habiliments. They seem

205

to be rather amusing themselves than working, as they lazily pick out and drop underneath the pieces of slate-rock, which the casual visitor could not tell from genuine coal, but which they detect by a sort of indolent intuition.[49]

The amusement at their appearance and behavior, the attitude that they were cute in a grotesque way, and the suggestion that they worked joyfully and were indolent (all part of the black stereotype as well) indicate how thoroughly the picturesque could obscure oppression.

In keeping with this trick of transforming unpleasant social realities into humorous caricature, neither guidebook editors nor visitors paid much heed to the conditions of the miners. Journalists and writers of guidebooks frequently spoke of the dangers of mining, but the author of the *Harper's Magazine* article on "Coal, and the Coal-Mines of Pennsylvania" typically attributed most mine explosions to "sheer carelessness on the part of the miners themselves."[50] The Mollie Maguires, who fought a terrorist campaign against the mine operators during the 1860s and 70s, went entirely unmentioned until their leaders were hung at Pottsville and Mauch Chunk in 1877. After that they appeared as local legend: A "gang of desperadoes" who "made murder, rapine and pillage its chief avocation, overrode the law and the authorities, and made the terror-stricken citizens' lives miserable."[51]

It was common for tourists to visit coal mines in the nineteenth century. Even Lydia Sigourney entered a deep mine at Carbondale where she was thrilled by the wall of anthracite that "o'er-canopied our heads, like an arch of polished ebony."[52] But Mauch Chunk was a transportation center, not a coal-mining village. Thus tourists, shielded in any case by their picturesque habit of vision, saw little of the mining landscape. What they did see was in the context of a roller-coaster ride that carried them out to the mines and rapidly back to the comfort of their hotels.

Unlike most of the other major nineteenth-century American tourist attractions, Mauch Chunk did not survive long into the twentieth century. Prosperity is attractive, and Mauch Chunk prospered until World War I. But although people enjoy a thriving city, or even a booming coal mine, they do not enjoy a decaying industrial landscape, at least until the passage of time makes its surviving structures historical. The automobile and cheap oil brought the decline of the railroads and the anthracite industry, and as these declined the special combination of features that brought visitors to Mauch Chunk fell apart. Anthracite production reached its peak during World War I and then began to fail. Mauch Chunk continued to attract excursionists into the 1920s,

Coal-Breaker, and Entrance to Mine, from *Lippincott's Magazine*, August 1872. (General Research Division, The New York Public Library, Astor, Lenox and Tilden Foundations)

but several of its attractions had already disappeared. The town's popular resort hotel, the Mansion House, was torn down in 1915, and by 1917 both the hotel and the railroad station at Glen Onoko had been destroyed by fire. Flagstaff Park, built on the mountain top just south of Mauch Chunk in 1908 and typical of the trolley parks on the outskirts of cities during this period, helped Mauch Chunk maintain its position as a resort for awhile. But the trolley ceased running in 1929, and Flagstaff's best days were over. The final blow to tourism was the closing of the Switchback Railroad in 1933. It was later sold as scrap. In 1954, as Mauch Chunk continued to suffer economically because of the closing of the coal mines, the town sought to revive itself and to attract tourists again by agreeing to become the burial place and namesake of the great

Olympic athlete and football star, Jim Thorpe. But Thorpe did not provide the magnet necessary to make the town a national shrine. Although tourists have now returned in significant numbers, they come to Jim Thorpe because of the Victorian architecture and the natural setting of the town, which still survives from its golden age as an anthracite transportation center, not because of the athletic hero buried there.

In its prize-winning study of Jim Thorpe/Mauch Chunk, published in 1979, the architectural and planning firm of Venturi, Rauch, and Scott Brown reports that the "coal mines, canal and even the railroad, now in decay, seem to form part of the Romantic landscape, even part of the very American wilderness they once stood against. Symbols of human battle against an overwhelming nature now seem to return themselves to nature as Romantic ruins."[53] This is true for Mauch Chunk has achieved in its decay some of the appeal of the old picturesque, the castles in ruins, the vine-clad cottages. But the rhetoric of conquest does not recall the nineteenth-century perception of this landscape. As a sacred place, Mauch Chunk depended on a more optimistic view of the relationship between industrial development and nature. To the nineteenth-century tourist the town presented a moving panorama in which human ambition seemed splendidly embraced by nature's wealth and power.

# Conclusion

THE CULTURAL NEEDS that made tourism so important in the United States before the Civil War and induced many of America's writers and artists to feature American tourist attractions prominently in their work became less urgent toward the end of the nineteenth century and still less so in the twentieth century. Tourism became an expression of the mass consumer culture shared by people of every class, rather than a cultural activity in which the educated elite led the way. Although American tourist attractions have continued to draw the attention of certain writers and artists, like the photographer Ansel Adams, they had ceased to be a major topic for America's creative artists by about 1900. The importance of tourist attractions to American culture as a whole, however, remains enormous. They have multiplied astoundingly in number and variety and many more people visit them each year than buy a serious novel or view a work of contemporary art.

A National Park Service ranger recently told a group of tourists at Mammoth Cave that the cave "will remain important as long as people keep coming here." He was right, of course. The status of tourist attractions depends on their being widely known and visited; their celebrity is in a sense, self-sustaining. As one wag has put it, tourist attractions are like Hollywood stars, "They are famous for being well-known." But the cultural function of tourist attractions, as demonstrated in the preceding chapters, clearly extends beyond the satisfaction people find in associating themselves with a celebrated place. The importance of tourism in the twentieth century has been demonstrated by the sociologist Dean MacCannell in *The Tourist: A New Theory of the Leisure Class*, but his study focuses on the structure of tourist settings and

experiences, not on specific tourist attractions, and in his attempt to formulate a comprehensive theory of tourism and leisure in the modern world, he pays little attention to cultural differences or the meanings embedded in particular tourist attractions. Work remains to be done on America's characteristic twentieth-century attractions. A number of the continuities and discontinuities between today's attractions and those of the nineteenth century, however, are worth noting here.

First, religious and nationalistic symbolism continues to cling to tourist attractions in the twentieth century. Although nineteenth-century Americans probably approached such places with a more conscious and intense religious attitude, and brought with them a more urgent need for cultural reassurance, the nation's principal tourist attractions continue to function, like temples or sacred cities or cosmic mountains, as places where, in Mircea Eliade's words, there is an "irruption of the sacred into the world." At such places tourists hope to enter a world separated from the world of their familiar, daily routine and to contact a transcendent reality.[1]

The Kennedy Space Center at Cape Canaveral in Florida and Graceland, the home and burial place of Elvis Presley in Memphis, serve as shrines for thousands of people, reaffirming the sacred or semisacred function of tourist attractions. "Dream Lives for Pilgrims at Canaveral" read a headline in the *New York Times* shortly after the explosion of the space shuttle *Challenger*, and the article described the thousands of tourists who come to pay their respects to the martyred crew. They stop in front of a framed memorial and "speak in quiet, almost reverent tones": "Many of those who visit here have come as if on a pilgrimage, not only to bear witness to the site of history's worst space disaster but also to reaffirm their essential faith in the nation's space achievements."[2] Graceland, an immensely popular attraction today, appears to be the shrine of an American saint. Elvis is presented both as hero and victim: admired because he was a poor boy who earned and spent an extraordinary amount of money, tragic because he was somehow isolated and destroyed by his wealth and fame. Visitors leave flowers and messages on his grave in the garden. The documentary on Elvis's life shown at Graceland depicts the suffering of his final years and ends with a shot of him on stage with arms outstretched in the pose of the crucifixion.[3] Similarly, Paul Simon's song, "Graceland," plays both ironically and lovingly on the name of Elvis's home and its function as a temple. Simon's Graceland is a heaven where we will all be welcome, whatever we have done or suffered. The Elvis Presley Museum in

Elvis Presley's Grave, Graceland, Memphis, Tennessee. (Author's photograph)

Woodbridge, Virginia, makes the connection between Elvis and Christ still more explicit. The prevailing colors at the museum are white and gold, and a bust of Elvis is surrounded by white Easter lilies. A case displaying "A representative sample of books owned and read by him" contains *The Truth that Leads to Eternal Life, Christian Mission,* and *Crowning Christ King,* among other books.[4]

Twentieth-century tourist attractions also continue to combine the sacred and profane, the religious and the secular, the mythic and the trivial, the spiritual and the commercial. They embody the contradictions of American society in concentrated visual form. The shops and circus entertainment which surrounded Niagara Falls in the nineteenth century, for example, and which Olmsted tried to banish, continue to push at the borders of the reservation today. Henry James's remark that the village is "constantly at your elbow, just to the right or the left of the line of contemplation" still applies.[5] Souvenir shops and sideshows crowd the Falls. On the American side, the attractions include a wax

Rainbow Center Mall, opposite Niagara Falls, on the American side.
(Author's photograph)

museum, the Rainbow Center, and the Turtle (a building in the
tradition of the Coney Island Elephant, shaped like its namesake
and devoted to Native American crafts). The Canadian side fea-
tures the Niagara Falls Museum (the descendant of Barnett's
Museum, a collection of curiosities dating back to the 1830s), a
ferris wheel, and three enormous towers that peer over everything
into the parks. Souvenir shops have even invaded the parks them-
selves, though fairly discreetly, and if the tourist is free to wander
through the parks for free, the *Maid of the Mist* and excursions
to the Cave of the Winds and the caves behind Horseshoe Fall,
all of which cost money, continue to be major attractions. No-
where else in the United States could you find the popular and the
democratically genteel, Coney Island and Central Park, P. T.
Barnum and Frederick Law Olmsted in such vivid juxtaposition.
Such sideshows surround most other modern tourist attractions as
well, or are even incorporated into them, as in the case of Disney-
land and Disneyworld.

Modern tourist attractions also continue to serve as arenas of

consumption. They are places where the cosmic erupts into the consumer culture which everyone shares, and where, too, the consumer culture often co-opts the cosmic for its own ends. It is this dual nature—the function of tourist attractions as sacred places and as arenas of consumption—that induces many tourists to approach them with a double consciousness, with religious awe or poetic rapture on the one hand and a skeptical, sardonic attitude on the other. Recent proposals for further development of the American side of Niagara Falls confirm the association of the "awesome" and the commercial. They include a "mega-mall" similar to the one in Edmonton, Canada, which features an indoor amusement park (including a miniature golf course and submarine rides in waters infested with real sharks) and shopping areas made to resemble European streets. The West Edmonton Mall, which has 800 stores and a concourse a mile long, also contains an indoor lake featuring a rubber beach and waves six feet high.[6]

Although from the beginning shopping malls have shared some of the features of tourist attractions, they have recently incorporated the features and functions of such attractions more directly, indicating that their designers have recognized the connection. This is particularly true of the indoor malls, the first of which— The Southdale Center in Edina, Minnesota—opened in 1956.[7] Indoor malls tend to be monumental, offer a variety of attractions within a unified structure, and create their own self-contained worlds. In a superficial and commercial way, they sometimes attempt to recreate or at least to allude to a vanished past. They imitate European cityscapes or, like Disneyland, create a sanitized version of Main Street. "There is a bit of Disneyland inside every shopping mall, struggling to get out," wrote Paul Goldberger in the *New York Times* not long ago. "In Horton Plaza in the center of downtown San Diego, the struggle is over: Disneyland has burst through with a vengeance." Horton Plaza, in a manner characteristic of American tourist attractions in both the nineteenth and twentieth centuries, blends references to European culture into a scenic environment in which a manufactured culture becomes one of the commodities offered for consumption. "It is best described as a conventional shopping mall on a stage set for an Italian hill town," writes Goldberger. "It is wildly exuberant, a kind of southern California fantasy of a European street. It even has a kind of central tower, an abstract version of the Cathedral in Sienna, to act as a focal point on the main plaza."[8] In keeping with the principle of diversity within a unifying spectacle which operates at tourist attractions, Horton Plaza contains movie theaters designed to imitate the Art Moderne style of the 1930s, a 1950s

diner, a museum of contemporary art, and a live theater. Goldberger criticizes Horton Plaza for being like all other urban malls "almost entirely inward-looking." Although right in the center of San Diego, it is completely disconnected from the streets which surround it. This may be, as Goldberger says, a "crucial flaw" from the point of view of urban design, but is important to the role of the plaza as a tourist attraction. Entering Horton Plaza, like entering Mammoth Cave, is to enter a different world, a world of fantasy that transcends the ordinary, everyday world of the city or the suburb where people live.

Although Horton Plaza is something of a breakthrough in mall design, many of its features can be found elsewhere. It has become quite common for malls to include art galleries, history and natural history exhibits, and legitimate theater, as well as movie theaters. Faneuil Hall Marketplace in Boston held a three-day Museums Fair in 1982 featuring exhibits, demonstrations, and performances.[9] The Potomac Mills Mall in Woodbridge, Virginia, contains the Elvis Presley Museum where visitors can see his stretch limousine, one of his guitars, his blue pajamas, and his hairdryer, among other relics of his life. Conversely, tourist attractions sometimes appropriate the shopping mall as a means of stimulating the consumption of their own product. The tour of Graceland ends at a shopping mall devoted entirely to Elvis Presley souvenirs.

Like the malls, the popular contemporary theme parks also have their roots in the structure of nineteenth-century attractions such as Niagara Falls, but more directly in the Centennial Exposition in Philadelphia in 1876 and the Columbian Exposition in Chicago in 1893, as well as in Buffalo Bill's Wild West show and Coney Island. Dollywood, a theme park created by Dolly Parton in her home town of Pigeon Forge, Tennessee, combines the functions of the Franklin D. Roosevelt Home and Museum with the functions of Disneyland. It is both a shrine to a public figure revered by many people and a recreational park. It includes: the Dolly Parton Story Museum, where the singer's dresses, wigs, and other objects associated with her career are on display; Aunt Granny's Dixie Fixins Restaurant (Aunt Granny being the name given her by her nephews and nieces); a replica of the cabin in which Dolly lived as a child; as well as a white water rafting course and a merry-go-round. Some theme parks are explicitly religious. Just as religious symbolism continues to serve capitalism, capitalism, with its marketing techniques and use of the media to sell its products, has increasingly come to serve religion. Heritage U.S.A., the religious theme park in Fort Mill, South Carolina, also functions as

the home of the PTL television network which sponsored Jim and Tammy Bakker's Christian television show.

Perhaps the most striking difference between nineteenth and twentieth-century American tourist attractions is the recent proliferation of museums that recreate the life of one person or of a whole period. The characteristic nineteenth-century tourist attraction often embodied the power and grandeur of American Nature or some new achievement or promise of achievement in art, technology, or social organization. They expressed a spirit of economic optimism and expansiveness, and because Americans suffered from a sense of cultural inferiority to Europe, they often contained some evidence of equality with or superiority to the Old World. Many twentieth-century American tourist attractions, on the other hand, represent mythologized versions of the American past: the story of "the King of Rock and Roll" or a slain president, or, in the case of Williamsburg and Sturbridge Village, the recreation of an earlier, idealized way of life. Daniel Boorstin points out in his essay "An American Style in Historical Monuments" that "the typical pathway into the grand European past is the carefully preserved ruin; or the museum (often a defunct palace) crammed full of precious *objets d'art*, sculpture, and painting, which had been produced for a small aristocratic class." Older civilizations have preserved monuments to a glorious past. Americans, Boorstin notes, having little in the way of a glorious past to memorialize, have instead recreated early ways of life in the form of working villages like Sturbridge. They have manufactured the past. The typical memorialization of American history attempts to recreate the setting, details, and events of everyday life of an early period. Such places are democratic, not only because they present the life of ordinary people but because the visitor to such places needs no sophisticated education to understand the exhibition.[10]

Even in looking backward, Americans often look forward. At Williamsburg and Sturbridge, as well as at Dollywood, the past is artificially reproduced and then sold as a product and in this way becomes part of the present, another commodity to be consumed in order to enhance a person's "lifestyle." In some cases, like the restoration of the Quincy Market area in Boston, where a historic place has been rescued from decay and gentrified, the place becomes a symbol of progress and thus the past becomes, in a sense, part of the future. Americans love not the past itself but bright new reconstructions of the past created by technology. As Umberto Eco suggests in *Travels in Hyperreality*, Americans appear to crave a past "preserved and celebrated in full-scale authentic copy," like the recreated Oval Office at the Lyndon B. Johnson Library which

was built "using the same materials, the same colors, but with everything obviously more polished, shinier, protected against deterioration." "The American imagination," concludes Eco, "demands the real thing and, to attain it, must fabricate the absolute fake."[11]

Tourists as a species have a bad name; they are regarded as superficial, crass, insensitive to their surroundings. Many people are uncomfortable being identified as tourists. They would rather regard themselves as "travelers." Nonetheless, we are all tourists at some time. It is part of the condition of living in modern, mass society. Dean MacCannell quotes an Iranian revolutionary who said at a lecture MacCannell gave in Paris, "Let's face it, we are all tourists. Even *I* am a tourist!"[12] Moreover, as MacCannell points out, tourism plays a significant role in the modern world. "Sightseeing," he writes, "is a kind of collective striving for a transcendence of the modern totality, a way of attempting to overcome the discontinuity of modernity, of incorporating its fragments into unified experience."[13]

Tourism is a particularly democratic form of popular culture, more so than rock and roll or even TV, perhaps, for it allows a greater range of people to participate in a wider variety of ways. It offers more opportunity for active involvement, both in the form of the superficial consumption of products and experience and at more profound levels. An important part of the symbolic life of the nation centers around Disneyland, Graceland, the Kennedy Space Center, Williamsburg, the Franklin D. Roosevelt Home and Museum, and Dollywood, as well as older sights like Niagara Falls and Yosemite. People of all classes and backgrounds visit these attractions, participate in tours, take snapshots, buy souvenirs or postcards, and make a point of being present at special events like the launching of a rocket or the blasting away of a piece of Terrapin Point at Niagara Falls. These are among the important rituals of modern, democratic culture. Like our great national pastime, baseball, they unify us, and provide us with a common experience which appears at once mythical and trivial and thus provokes us to both awe and irreverence.

# Notes

## Introduction

1. James Kirke Paulding, *The New Mirror for Travellers; and Guide to the Springs* (New York: G. & C. Carvill, 1828), 4–6.
2. Nathaniel Parker Willis, *Health Trip to the Tropics* (New York: Scribner, 1854), 168, 184.
3. Victor and Edith Turner, *Image and Pilgrimage in Christian Culture* (New York: Columbia University Press, 1978), 241, 20.
4. Patrick McGreevy, "Niagara as Jerusalem," *Landscape*, 28, no. 2 (1985), 27–32.
5. Mircea Eliade, *The Sacred and the Profane* (New York: Harcourt, Brace, 1959), 44; *The Myth of the Eternal Return or, Cosmos and History* (Princeton, N.J.: Princeton University Press, 1954), 16; *The Sacred and the Profane*, 61.
6. Annette Kolodny, *The Land Before Her: Fantasy and Experience of the American Frontiers, 1630–1860* (Chapel Hill: University of North Carolina Press, 1984), 3–12.
7. McGreevy, 31.
8. Neil Harris, "On Vacation," in Architectural League of New York and the Gallery Association of New York State, *Resorts of the Catskills* (New York: St. Martin's Press, 1979), 102.
9. Few studies have been made of American tourism. "The Poetry of Traveling" and "Summer Migration," in Hans Huth, *Nature and the American* (Berkeley: University of California Press, 1957); "The Itinerant Eye" and "The American West," in Paul Shepard, *Man in the Landscape* (New York: Alfred A. Knopf, 1967); and the essays by Neil Harris and others, in *Resorts of the Catskills*, provide brief introductions to the history of tourism in the United States. Dean MacCannell's *The Tourist: A New Theory of the Leisure Class* (New York: Schocken Books, 1976), which draws its data almost exclusively from the twentieth century, offers a sociological interpretation of the

behavior of tourists and the structure of tourist sights. John A. Jakle's *The Tourist: Travel in Twentieth-Century North America* (Lincoln, Nebr.: University of Nebraska Press, 1985) provides a history of tourism in the age of the automobile.

### 1. "Doing" Niagara Falls in the Nineteenth Century

1. In discussing Niagara's special attraction for honeymooners, McKinsey notes the association in Western iconography between waterfalls, passion, and creative force. As she observes, however, Niagara's wildness had been domesticated in many of the literary and artistic versions of the Falls by the 1830s and 1840s. Rather than unrestrained passion, she writes, "containment and control of great power seems to be the key to the imaginative appeal of Niagara Falls as a honeymoon resort." In the domesticated treatment of the Falls, "male and female principles" were united and Niagara became a "visual metaphor for the passion channeled into marriage" [Elizabeth McKinsey, *Niagara Falls: Icon of the American Sublime* (New York: Cambridge University Press, 1985), 179, 183, 188]. Patrick McGreevy, who approaches the subject somewhat differently, suggests that Niagara provided an appropriate site to celebrate marriage as a rite of passage. In going to the Falls, the newly married couple passed out of the familiar pattern of their lives and experienced the transforming power of a "pilgrim shrine" [Patrick McGreevy, "Niagara as Jerusalem," *Landscape*, 28, no. 2 (1985), 31–32]. His interpretation corresponds to the language of Caroline Gilman who visited the Falls in the late 1830s and observed "a young married couple, who had come to pay true homage to nature, by consecrating their new happiness to this shrine" (quoted by McKinsey, 179).

2. Mircea Eliade, *The Sacred and the Profane* (New York: Harcourt, Brace, 1959), 38–39.

3. Nathaniel Hawthorne, "My Visit to Niagara," in *The Centenary Edition of the Works of Nathaniel Hawthorne* (Columbus, Ohio: Ohio State University Press, 1974), II, 281–83.

4. Alexander Wilson, *The Foresters* (Bucks County, Pa.: S. Tomlinson, 1853), 73–78.

5. Timothy Dwight, *Travels in New England and New York*, ed. Barbara Miller Solomon (Cambridge, Mass.: Harvard University Press, 1969), IV, 61–63.

6. J. W. Orr, *Pictorial Guide to the Falls of Niagara: A Manual for Visitors* (Buffalo, N.Y.: Salisbury and Clapp, 1842), 155.

7. Caroline Gilman, *The Poetry of Travelling* (New York: S. Colman, 1838), 114.

8. Hawthorne, "My Visit to Niagara," 285.

9. Quoted in *Hackstaff's New Guide Book of Niagara Falls* (Niagara Falls, N.Y.: W. E. Tunis, 1853), 80.

10. *Table Rock Album, and Sketches of the Falls and Scenery Adjacent* (Buffalo, N.Y.: E. R. Jewett, 1859), 21.

11. McGreevy, 31.

12. Victor and Edith Turner, *Image and Pilgrimage in Christian Culture* (New York: Columbia University Press, 1978), 27.

13. William Hunter, *Hunter's Panoramic Guide From Niagara to Quebec* (Boston: J. P. Jewett, 1857), 15.

14. S. De Veaux, *The Falls of Niagara or Tourist's Guide to the Wonder of Nature* (Buffalo, N.Y.: William B. Hayden, 1839), 32.

15. De Veaux, 73.

16. Margaret Fuller, *Summer on the Lakes* (New York: Haskell House, 1970), 7.

17. William Dean Howells, *Their Wedding Journey* (Boston: James R. Osgood, 1878), 143.

18. See John F. Kasson, *Amusing the Million* (New York: Hill & Wang, 1978).

19. Edward Hingston, *The Genial Showman, Being Reminiscences of the Life of Artemus Ward* (London: J. C. Hotten, 1870), I, 11–12.

20. Orr, 164.

21. Lydia H. Sigourney, *Scenes in My Native Land* (Boston: James Munroe, 1845), 12, 11.

22. Henry James, "Niagara," in *The Art of Travel* (Garden City, N.Y.: Doubleday Anchor Books, 1958), 88, 90–91.

## 2. Mammoth Cave: Theater of the Cosmic

1. "A Tour in the Mammoth Cave," *All the Year Round*, 4 (1861), 343.

2. Barnwell, "The Mammoth Cave," *The Knickerbocker*, 33 (1849), 301.

3. Nathaniel Parker Willis, *Health Trip to the Tropics* (New York: Scribner, 1854), 149.

4. Harold Meloy provides a brief history of the early years of Mammoth Cave in his introduction to Alexander Clark Bullit, *Rambles in the Mammoth Cave, during the year 1844, by a visiter* (1845; rpt. New York: Johnson Reprint Corporation, 1973), v–xxix.

5. Bayard Taylor, *At Home and Abroad* (New York: G. P. Putnam, 1860), 224.

6. H. C. Hovey, *Guide Book to the Mammoth Cave of Kentucky* (Cincinnati: R. Clarke, 1882), 15.

7. Taylor, 205.

8. Willis, *Health Trip*, 151–52.

9. Charles Moreno, unpublished journal for 1857, typescript, Mammoth Cave National Park Library (Sunday, June 29, 1857), 5–6.

10. Willis, *Health Trip*, 153; "The Mammoth Cave," *National Magazine*, 9 (1856), 514.

11. Nathaniel Parker Willis, *Rural Letters* (New York: Baker and Scribner, 1849), 351.

12. "My Gropings Nine Miles Underground," *National Magazine*, 7 (1855), 62.

13. "Mammoth Cave of Kentucky," *Dublin University Magazine*, 57 (1861), 313.

14. Willis, *Health Trip*, 171.

15. N. S. Shaler, "Caverns and Cavern Life," *Scribner's Magazine*, 2 (1887), 460.

16. Taylor, 203.

17. Willis, *Health Trip*, 204.

18. [Robert Montgomery Bird], "The Mammoth Cave of Kentucky," *The American Monthly Magazine*, 9, n.s. 3 (1837), 526; rpt. in *Peter Pilgrim; or, a Rambler's Recollections*, 2 vols. (Philadelphia: Lea and Blanchard, 1838), II, 47ff.

19. Barnwell, "The Mammoth Cave," 302.

20. "A Tour in the Mammoth Cave," 345.

21. Ralph Seymour Thompson, *The Sucker's Visit to the Mammoth Cave* (1879; rpt. New York: Johnson Reprint Corporation, 1970), 77.

22. Taylor, 214–15.

23. [Bird], "The Mammoth Cave of Kentucky," 423.

24. Mircea Eliade, *The Sacred and the Profane* (New York: Harcourt, Brace, 1959), 36; *The Myth of the Eternal Return or, Cosmos and History* (Princeton, N.J.: Princeton University Press, 1954), 12.

25. Taylor, 199.

26. "My Gropings Nine Miles Underground," 59.

27. Eliade, *The Myth of the Eternal Return*, 17.

28. Taylor, 193, 182.

29. Eliade, *The Sacred and the Profane*, 65, 41.

30. Willis, *Health Trip*, 157.

31. "My Gropings Nine Miles Underground," 61.

32. Taylor, 220.

33. See Edmund Burke, *A Philosophical Enquiry into the Origin of our Ideas of the Sublime and Beautiful* (London: Routledge & Kegan Paul, 1958), Part II, Sections III and VI.

34. Barnwell, "The Mammoth Cave," 309.

35. [Bird], "The Mammoth Cave of Kentucky," 542.

36. Willis, *Health Trip*, 174.

37. Nahum Ward, "Western Wonder. Description of the Great Cave In Kentucky In Which Was Found the Indian Mummy Which Is Now Exhibited in Mr. Scudder's Museum, New York," in appendix to Francois Chateaubriand, *The Interesting History of Atala* (New York: Oram and Mott, 1818), 140–41.

38. Lady Emmeline Stuart Wortley, *Travels in the United States, etc., during 1849 and 1850* (New York: Harper & Brothers, 1851), 97.

39. Mircea Eliade, *Myth and Reality* (New York: Harper & Row, 1963), 5.

40. Alexander von Humboldt, *Cosmos* (London: H. G. Bohn, 1849–58), I, 54–55.

41. [Bird], "The Mammoth Cave of Kentucky," 424.

42. Barnwell, "The Mammoth Cave," 310.

43. Benjamin Silliman, Jr., "On the Mammoth Cave of Kentucky," *American Journal of Science and Arts*, 61 (1851), 337.

44. W. P. Fishback, *Indianapolis Daily Journal*, quoted in "The Mammoth Cave and Its Inhabitants," *The American Naturalist*, 5 (1871), 741.

45. Harriet Martineau, *Society in America* (1837); rpt. New York: AMS Press, 1966), I, 210.

46. Thompson, 73–74.

47. "My Gropings Nine Miles Underground," 60.

48. Ralph Waldo Emerson, "Illusions," in *The Conduct of Life* (Boston: Houghton, Mifflin, 1904), 310.

49. Taylor, 215.

50. Eliade, *Myth and Reality*, 30.

51. Taylor, 196.

52. Bullit, 92.

53. John Burroughs, "In Mammoth Cave," *Longman's Magazine*, 10 (1887), 637.

54. Henry Howe, "Mammoth Cave," in *Historical Collections of The Great West* (1855), 254.

55. Taylor, 210–11.

56. Barnwell, "The Mammoth Cave," 304.

57. Emerson, 310.

58. Taylor, 201.

59. Emerson, 310–11.

## 3. Panoramas of American Civilization: The Connecticut and the Hudson

1. Wolfgang Born, *American Landscape Painting* (New Haven, Conn.: Yale University Press, 1948), 77–78. Robert Barker, a Scotsman, introduced circular panoramas of London and Edinburgh to London audiences in the 1790s. See Jeremy Elwell Adamson, *Niagara: Two Centuries of Changing Attitudes: 1697–1901*, (Washington, D.C., The Corcoran Gallery of Art, 1985), 33.

2. Alexander von Humboldt, *Cosmos* (London: Henry G. Bohn, 1849–58), II, 457.

3. Hans Huth, *Nature and the American: Three Centuries of Changing Attitudes* (Berkeley.: University of California Press, 1957), 137–38. See also Adamson, 58.

4. Quoted in Born, 78.

5. Barbara Novak, *Nature and Culture: American Landscape Painting, 1825–1875* (New York: Oxford University Press, 1980), 23.

6. Timothy Dwight, *Travels in New England and New York* (1821–22; rpt. Cambridge, Mass.: Harvard University Press, 1969), II, 232–33.

7. Dwight, II, 233.

8. Dwight celebrates this same configuration of elements—picturesque variety that pleases the eye plus signs of economic and social well-being—in "Greenfield Hill." See Part I, "The Prospect," in *The Connecticut Wits*, ed. Vernon Louis Parrington (1926; rpt. Hamden, Conn.: Archon Books, 1963), especially 184–87 and 193–94.

9. See Edward Johnson, *Johnson's Wonder-Working Providence* (1654; rpt. Delmar, N.Y.: Scholars' Facsimiles & Reprints, 1974).

10. Dwight, I, 257.

11. There are at least two Mount Pisgah's in the United States, one in Mauch Chunk, Pennsylvania (see Chapter 8) and one at Tallulah Gorge, Georgia, both important nineteenth-century tourist attractions.

12. Dwight, I, 258–59.

13. Dwight, II, 282.

14. Nathaniel Parker Willis, *American Scenery* (1840; rpt. Barre, Mass.: Imprint Society, 1971), 14.

15. Nathaniel Parker Willis, *Rural Letters* (New York: Baker and Scribner, 1849), 199.

16. William Wade, *Panorama of the Hudson River from New York to Albany* (New York: William Wade, 1845).

17. Roland Van Zandt, *Chronicles of the Hudson* (New Brunswick, N.J.: Rutgers University Press, 1971), 197.

18. James Kirke Paulding, *The New Mirror for Travellers; and Guide to the Springs* (New York: G. & C. Carvill, 1828), 98–100.

19. Bayard Taylor, *At Home and Abroad* (New York: G. P. Putnam, 1860), 483.

20. James Fenimore Cooper, "American and European Scenery Compared," in *The Home Book of the Picturesque* (1852; rpt. Gainesville, Fla.: Scholars' Facsimiles & Reprints, 1967), 62–63.

21. George W. Curtis, *Lotus-Eating* (New York: Harper & Brothers, 1852), 23, 22.

22. Sarah Josepha Hale, "The Romance of Travelling," in *Traits of American Life* (Philadelphia: E. L. Carey & A. Hart 1835), 189.

23. Washington Irving, *The Sketch Book of Geoffrey Crayon, Gent.* (Boston: Twayne Publishers, 1978), 9.

24. Irving, 273, 274.

25. James Fenimore Cooper, *The Last of the Mohicans* (New York: W. A. Townsend, 1859), 59, 68n.

26. Bayard Taylor, *At Home and Abroad: Second Series* (New York: G. P. Putnam, 1886), 323.

27. Henry James, *The American Scene* (1907; rpt. New York: Horizon Press, 1967), 150, 154.

28. Taylor, *At Home and Abroad: Second Series*, 322.

29. Andrew Jackson Downing, "Beacon Hill," *New York Mirror*, 12 (March 1835), 294.

30. For the history of the Mountain House, see Roland Van Zandt, *The Catskill Mountain House* (New Brunswick, N.J.: Rutgers University Press, 1966).

31. Quoted in Charles Rockwell, *The Catskill Mountains and the Region Around* (New York: Taintor Brothers, 1867), 220.

32. William Cullen Bryant, *The American Landscape* (New York: E. Bliss, 1830), 10.

33. Henry T. Tuckerman, "Over the Mountains, or the Western Pioneer," in *The Home Book of the Picturesque* (1852; rpt. Gainesville, Fla.: Scholars' Facsimiles & Reprints, 1967), 115–16.

34. James Fenimore Cooper, *The Pioneers* in *The Leatherstocking Tales* (New York: The Library of America, 1985), I, 295.

35. Paulding, 143.

36. Taylor, *At Home and Abroad*, 11.

## 4. The Making of an American Tourist Attraction: The Willey House in the White Mountains

1. Many of the contemporary accounts are reprinted in Kenneth W. Cameron, "The Genesis of Hawthorne's 'The Ambitious Guest,'" *Historiographer of the Episcopal Diocese of Connecticut*, 14 (1955), 2–36. Cameron comments briefly on Hawthorne's use of his sources.

2. Theodore Dwight, Jr., *Things As They Are; or, Notes of a Traveller Through Some of the Middle and Northern States* (New York: Harper & Brothers, 1834), 150; Harriet Martineau, *Retrospect of Western Travel* (London: Saunders and Otley, 1838), III, 62.

3. Benjamin Silliman, "Miscellaneous Notices of Mountain Scenery and of Slides and Avalanches in the White and Green Mountains," *American Journal of Science and Arts*, 15 (1829), 221n.

4. "Excerpts from the Diary of Joseph T. Buckingham," *New England Galaxy*, August 4, 1826; rpt. *Boston Courier*, September 9, 1826; rpt. in large part in *New-Hampshire Journal*, September 11, 1826, and *Essex Register*, September 11, 1826; rpt. in Cameron, "The Genesis of Hawthorne's 'The Ambitious Guest,'" 7.

5. Lucy Crawford, *History of the White Mountains* (1846; rpt. Hanover, N.H.: Dartmouth Publications, 1966), 101, 92.

6. Hawthorne stayed at Crawford's inn. He gives a brief account of his visit to the White Mountains in a letter to his mother dated September 16, 1832. See *The American Notebooks*, ed. Randall Stewart (New Haven: Yale University Press, 1932), 283.

7. See, for example, James R. Mellow, *Nathaniel Hawthorne In His Times* (Boston: Houghton Mifflin, 1980), 52.

8. J.C.P., "The Late Storm in the White Mountains," *Christian Spectator* 8 (December 1826), 630.

9. "The Ambitious Guest," in *Twice-Told Tales, The Centenary Edition of the Works of Nathaniel Hawthorne*, ed. Fredson Bowers and J. Donald Crowley (Columbus, Ohio: Ohio State University Press, 1974), IX, 325, 332.

10. Sarah Josepha Hale, *Traits of American Life* (Philadelphia: E. L. Carey & A. Hart, 1835), 189.

11. "The Ambitious Guest," 333.

12. Isaac McLellan, *The Avalanche of the White Hills: August 28th, 1826* (Boston: Jones Power Press Office, 1846), 4.

13. Curtis Dahl, "The American School of Catastrophe," *American Quarterly*, 11 (1959), 380. Cameron also mentions the current fascination with ruin.

14. J.C.P., "The Late Storm," 331.

15. Dahl mentions John Trumbull, "The Last Family Who Perished from the Deluge" (1838–39) and Paul Allen, "Noah, A Poem" (1821).

16. Silliman, "Miscellaneous Notices," 222.

17. J.C.P., "The Late Storm," 331.

18. "The Ambitious Guest," 332–33.

19. Genesis 7:11.

20. W. H. Bartlett's drawing of the Willey House which appeared in N. P. Willis's *American Scenery* (1840) reflects the importance that structure had assumed as an American ruin with native associations.

21. Nancy F. Cott, *The Bonds of Womanhood, "Woman's Sphere" in New England, 1780–1835* (New Haven: Yale University Press, 1977), 64.

22. Grenville Mellen, "Buried Valley," in *The Martyr's Triumph; Buried Valley; and Other Poems* (Boston: Lilly, Wait, Colman, and Holden, 1833), 277. In Lydia Sigourney's poem, "The White Mountains. After the descent of the Avalanche in 1826," even the moss clings to the granite mountain sides "like the arms / Of some sweet infant, twining the rude neck / Of its proud giant sire, to win his soul / From a stern purpose." *Ladies Magazine*, I (1828), 340–41.

23. Theodore Dwight, Jr., *Sketches of Scenery and Manners in the United States* (1829; rpt. Delmar, N.Y.: Scholars' Facsimiles & Reprints, 1983), 63–64.

24. Letter of Thomas C. Upham to John Farmer, *New Hampshire Historical Society Collections*, 3 (1832), 266–80; rpt. in Cameron, "The Genesis of Hawthorne's 'The Ambitious Guest,' " 19.

25. "The Ambitious Guest," 324, 327.

26. Letter of Upham to Farmer; rpt. in Cameron, 18; Thomas C. Upham, *American Cottage Life; A Series of Poems Illustrative of American Scenery, and of the Associations, Feelings and Employments of the American Cottager and Farmer; Designed to Show the Value of Religion in American Homes* (Boston: American Tract Society, 1862), 13–14.

27. "The Ambitious Guest," 327.

28. Barbara Berg, *The Remembered Gate: Origins of American Feminism: The Woman and the City, 1800–1860* (New York: Oxford University Press, 1978), 66.

29. "The Ambitious Guest," 325.

30. "The Ambitious Guest," 329–32.

31. "The Ambitious Guest," 328.

32. "The Ambitious Guest," 333.

33. "The Ambitious Guest," 333, 325.

34. *Boston Courier*, September 9, 1826; rpt. in Cameron, 4.

35. *The White Mountain and Winnepissiogee Lake Guide Book* (Boston: Jordan and Wiley, 1846), 45, 44, 47.

36. Thomas Starr King, *The White Hills: Their Legends, Landscape, and Poetry* (Boston: Crosby, Nichols, 1859), 204.

## 5. Prisons, Asylums, Cemeteries, Parks

1. Harriet Martineau, *Society in America* (1837; rpt. New York: AMS Press, 1966), I, 210.

2. Margaret Fuller, *At Home and Abroad* (Boston: Crosby, Nichols and Company, 1856), 59 .

3. For a discussion of the establishment of asylums during this period see David J. Rothman, *The Discovery of the Asylum: Social Order and Disorder in the New Republic* (Boston: Little, Brown, 1971).

4. Fanny Kemble, *Journal* (Philadelphia: Carey, Lea & Blanchard, 1835), II, 201, 208–9.

5. Martineau, *Society in America*, III, 179–80.

6. Charles Dickens, *American Notes* (1846; rpt. London: Oxford University Press, 1957), 28.

7. Lydia H. Sigourney, *Scenes in My Native Land* (Boston: James Munroe, 1845), 256.

8. Rothman, 142.

9. Harriet Martineau, *Retrospect of Western Travel* (London: Saunders and Otley, 1838), I, 201.

10. "Insanity, and Treatment of the Insane," *The National Magazine*, 11 (1857), 522.

11. "Insanity, and Treatment of the Insane," 520, 522.

12. "New-York Institution for the Deaf and Dumb," *The National Magazine*, 7 (1855), 10.

13. Martineau, *Society in America*, III, 180.

14. R. A. Smith, *Philadelphia As It Is* (Philadelphia: Lindsay and Blakiston, 1852), 261.

15. Caroline Gilman, *The Poetry of Travelling* (New York: S. Colman, 1838), 48–49, 35, 176.

16. Gilman, 60, 51. The quotation is from "The Released Convict's Cell," a poem inspired by Gilman's visit to the Philadelphia Penitentiary.

17. "Insanity and the Treatment of the Insane," 523.

18. Lydia Maria Child, *Letters from New-York* (New York: Charles S. Francis, 1843), 188.

19. Smith, 255. "If it were not for the name of being crazy, one would be better off there than at home," the visitor of one institution remarked. "Insanity and the Treatment of the Insane," 522.

20. "Sketches of Humane Institutions," *National Magazine*, 9 (1856), 386.

21. Martineau, *Retrospect of Western Travel*, III, 123, 117.

22. Smith, 260.

23. For background on Howe see *Letters and Journals of Samuel Gridley Howe*, ed. Laura E. Richards (Boston: Dana Estes, 1906–9).

24. Dickens, 33, 44.

25. James Leiby, "The Promise of the Institution, 1815–1845," in *A History of Social Welfare and Social Work in the United States* (New York: Columbia University Press, 1978), 53.

26. Martineau, *Society in America*, III, 182; *Retrospect of Western Travel*, I, 200, 207.

27. Dickens, 101, 99, 102, 109. Although Pairpoint found the Cherry-Hill State Prison in Philadelphia well managed and the cells well lighted, well heated, and clean, he felt that society had "no right to exclude a fellow-creature from all society." Each cell seemed to him a "living tomb." Alfred J. Pairpoint, *Uncle Sam and His Country* (London: Simkin, Marshall & Co., 1857), 292–93.

28. Fredrika Bremer, *The Homes of the New World* (New York: Harper & Bros., 1853), II, 609.

29. Gilman, 52.

30. Rothman, 128.

31. See John Higham's analysis of the profound shift in attitude which took place in the 1850s in *From Boundlessness to Consolidation: The Transformation of American Culture, 1848–1860* (Ann Arbor, Mich.: William L. Clements Library, 1969), particularly page 21.

32. Rothman, 237.

33. See, for example, W. H. Davenport, "Blackwell's Island Lunatic Asylum," *Harper's New Monthly Magazine*, 32 (February, 1866). Davenport has no interest in methods of treatment or promises of cure. For him—and no doubt for many tourists before him—Blackwell's is purely a grotesque spectacle, a series of sideshows featuring such attractions as a woman who is a "paragon of hideousness" and another who "seems to imagine herself a steamboiler." Davenport takes his readers behind the scenes where the "ordinary pleasure seeker" doesn't go (279–80).

34. T. D. Woolsey, "Cemeteries and Monuments," *New Englander* 7 (1849), 491; Andrew Jackson Downing, "Public Cemeteries and Public Gardens," in *Rural Essays* (New York: G. P. Putnam, 1853), 157; A. D. Gridley, "Cemeteries," *New Englander* 22 (1863), 606.

35. Henry Dearborn, "General Dearborn's Report to the Massachu-

setts Horticultural Society on the Establishment of an Experimental Garden and Rural Cemetery," in Appendix I of *The Picturesque Pocket Companion, and Visitor's Guide, Through Mount Auburn* (Boston: Otis, Broaders, 1839), 48.

36. *Guide to Laurel Hill Cemetery* (Philadelphia: C. Sherman, 1844), 13.

37. Henry Francis Walling, *The City of New York. A Complete Guide* (New York: Taintor Brothers & Company, 1867), 20.

38. *The Picturesque Pocket Companion*, 193.

39. Emmeline Stuart Wortley, *Travels in the United States, etc. during 1849 and 1850* (New York: Harper & Brothers, 1851), 77.

40. Cornelia W. Walter, *Mount Auburn Illustrated* (New York: R. Martin, 1847), 34.

41. John A. Elkinton, *The Monument Cemetery of Philadelphia* (*Late Père la chaise*). (Philadelphia: Rackliff & King, 1837), 23, 31.

42. Joseph Story, "An Address Delivered on the Dedication of the Cemetery at Mount Auburn, September 24, 1831" (Boston: Joseph T. & Edwin Buckingham, 1831), 12–13.

43. Nehemiah Cleaveland, *Green-Wood Illustrated* (New York: R. Martin, 1847), 2.

44. "Thoughts Connected with Rural Cemeteries," *Christian Review*, 13 (1848), 20.

45. Martineau, *Retrospect of Western Travel* III, 276–77.

46. Cleaveland, 14.

47. Gridley, 607.

48. *Guide Through Mount Auburn: A ... ind-book for Passengers over the Cambridge Railroad* (Boston: Bricher & Russell, 1864), 38.

49. Walter, 16.

50. Kevin Wolfe, "Visible City," *Metropolis* (September 1985), 44.

51. Gridley, 607.

52. Alexander Wadsworth, who laid out Mount Auburn Cemetery, also designed several developments in Newton, Massachusetts, one of the first American commuting suburbs.

53. William G. McLoughlin, *The Meaning of Henry Ward Beecher* (New York: Knopf, 1970), 109–16.

54. Jonathan F. Stearns, "Respect for the Remains of the Dead." An Address Delivered at the Consecration of Oak Hill Cemetery, in Newburyport, July 21, 1842 (Newburyport, Mass.: A. Augustus Call, 1842), n.p.

55. "Thoughts Connected with Rural Cemeteries," 13.

56. Nehemiah Adams, "Mount Auburn," *American Quarterly Observer*, 3 (July 1834), 156.

57. Downing, *Rural Essays*, 155.

58. Gridley, 606. The landscaping of the rural cemeteries anticipated, in fact, the designs of planned garden suburbs and parklike developments in other American suburbs. When Henry Winthrop Sargent wrote a supplementary essay for a new edition of Downing's *Treatise on the Theory and Practice of Landscape Gardening* in

1875, he called rural cemeteries the first step in the development of landscape gardening in America: "The next great step onward, which is now exciting much attention throughout the land, is the establishment of Parks." As examples, he cited both public parks, like Central Park, and semi-public parks, like Llewellyn Park, the suburban development Olmsted designed for Orange, New Jersey. See Henry Winthrop Sargent in Andrew Jackson Downing, *A Treatise on the Theory and Practice of Landscape Gardening* (1875; rpt. Little Compton, R.I.: Theophrastus, 1977), 561.

59. Wilson Flagg, *Mount Auburn: Its Scenes, Its Beauties, and Its Lessons* (Boston: James Monroe, 1861), 8–9.

60. Adams, 158, 157, 160.

61. Woolsey, 491–92.

62. Woolsey, 496, 490, 496.

63. Woolsey, 495.

64. Cleaveland, 94, 65.

65. Flagg, 72.

66. William B. Peabody, "Mount Auburn Cemetery," *North American Review*, 33 (1831), 406.

67. Walter, 38.

68. Cleaveland, 51.

69. Flagg, 293, 232, 234.

70. Flagg, 34.

71. Nathaniel Parker Willis, *Rural Letters* (New York: Scribner, 1849), 154.

72. Gilman, 163.

73. Downing, *Rural Essays*, 144.

74. James J. Farrell, *Inventing the American Way of Death, 1830–1920* (Philadelphia: Temple University Press, 1980), 113–19.

## 6. Scenery as Art: Yosemite and the Big Trees

1. Albert D. Richardson, *Beyond the Mississippi* (Hartford, Conn.: American Publishing Co., 1867), 420.

2. Samuel Bowles, *Across the Continent* (Springfield: Mass.: Samuel Bowles & Company, 1866), 223.

3. By 1872, the Englishman Thomas Cook had opened offices in the United States. The Boston firm of Raymond and Whitcomb arranged its first tour to the West Coast in 1881. See Earl Pomeroy, *In Search of the Golden West* (New York: Knopf, 1957), 14–15.

4. *San Francisco Chronicle*, August 18, 1855; rpt. of article in *Mariposa Gazette*, quoted in David Robertson, *West of Eden: A History of the Art and Literature of Yosemite* (Yosemite, Calif.: Yosemite Natural History Association and Wilderness Press, 1984), 4.

5. Thomas Starr King, *A Vacation Among the Sierras: Yosemite in 1860*, ed. John A. Hussey (San Francisco: Book Club of California,

1962), 49. I am indebted to Hussey's introduction for facts about King's career.

6. Fitz-Hugh Ludlow, "Seven Weeks in the Great Yo-Semite," *The Atlantic Monthly*, 13 (June 1864), 740.

7. Quoted in Hussey, xix–xx.

8. Alfred Runte, *National Parks: The American Experience* (Lincoln, Neb.: University of Nebraska Press, 1979), 28.

9. The original grant included only the Yosemite Valley itself and its rim. The area around the valley was made into a national park in 1890 through the efforts of John Muir and others and the valley itself incorporated into the national park system in 1906.

10. In looking back on the origins of the movement to preserve natural scenery, Frederick Law Olmsted wrote that in response to the "danger to treasures of natural scenery that is more and more growing out of modern developments of commerce and modern habits of travel," some began to realize that "a sentiment needs to be cultivated such as would appear in any crisis threatening a national treasure of art." See *Governmental Preservation of Natural Scenery* (Brookline, Mass.: n.p., March 8, 1890), Circular, Yosemite National Park Library, 1.

11. Raymond was also on the first Yosemite Commission appointed by the governor of California in 1864. The commission also included: Frederick Law Olmsted; William Ashburner, a well-known mining engineer; E. S. Holden, who was involved in the construction of railroads in California; Alexander Deering, a Mariposa lawyer; George W. Coulter, who had helped build the Coulterville Free Trail to Yosemite in 1856; and Galen Clark, Yosemite guide and innkeeper. See Laura Wood Roper, Introduction to Frederick Law Olmsted, "The Yosemite Valley and the Mariposa Big Trees: A Preliminary Report (1865)," *Landscape Architecture*, 43 (October 1952), 12 n. Kathryn Funk writes in her introduction to *Yosemite: The Last Stance of the Romantic Landscape* (Fresno, Calif.: Fresno Art Center, 1982): "The works of art produced in these early years were instrumental in influencing Congress to pass legislation to set aside for public use the area we know today as Yosemite Valley" (4).

12. Olmsted, "The Yosemite Valley and the Mariposa Big Trees," 17.

13. See Runte, 5, 59.

14. In 1864, the year Yosemite was set aside as a park, the *New York Times* published an editorial supporting the construction of a railroad into the Adirondacks and suggesting that it would transform the area into "a Central Park for the world" [Philip G. Terrie, *Forever Wild* (Philadelphia: Temple University Press, 1985), 92–93]. A few people, at least, thought the Central Park idea could be extended to remote areas.

15. Olmsted, "The Yosemite Valley and the Mariposa Big Trees," 16, 14.

16. Ludlow, 740.

17. Clarence King, *Mountaineering in the Sierra Nevada* (Philadelphia: J. B. Lippincott, 1963), 147. Many of the chapters in *Mountaineering* were first published as articles in the *Atlantic Monthly*.

18. *San Francisco Alta*, August 4, 1867, quoted in Robertson, 23.

19. Clarence King, 210.

20. Caroline M. Churchill, *Over the Purple Hills, or Sketches of Travel in California* (Denver, Colo.: Mrs. C. M. Churchill, 1881), 137, 185.

21. "The Yo-hamite Valley of California," *Littell's Living Age*, 64 (1860), 63.

22. James M. Hutchings, *Yo Semite and the Big Trees: What to See and How to See It* (San Francisco: J. M. Hutchings, 1894).

23. W. F. Butler, "The Yosemite Valley," *Good Words*, 19 (1878), 613.

24. Starr King, 49, 42.

25. John Burroughs, "The Spell of the Yosemite," *Century Magazine*, n.s. 81 (November 1910), 47.

26. Starr King, 61.

27. John Ruskin, *Modern Painters* (Boston: Dana Estes, 1880), IV, 464, 299.

28. Starr King, noting that Nathaniel Willis had complained that there were no mountains at Niagara to frame it and provide dramatic emphasis, wrote that

> The great Nevada cataract is arranged on Mr. Willis's principles. The Sierras have put their exclamation point at precisely the right spot. For on the northwest, immediately over it, springs an obelisk of bare granite two thousand feet high, utterly unscaleable on the front, and on its backline, repeating with surprising exactness the contour of the Matterhorn on its longer side, as drawn in the fourth volume of Ruskin's *Modern Painters*, and in Hinchcliff's *Summer Among the Alps* (Starr King, 64).

29. Josiah D. Whitney, *The Yosemite Guide-Book* (Cambridge, Mass.: University Press, 1870), 123. Bowles wrote of Yosemite, "Niagara alone divides honors with it in America. Only the whole of Switzerland can surpass it,—no one scene in all the Alps can match this." (Bowles, 224).

30. Ruskin, II, 258, 27, 25.

31. Thomas Cole, "Essay on American Scenery" (1835), in John W. McCoubrey, *American Art, 1700–1960: Sources and Documents* (Englewood Cliffs, N.J.: Prentice-Hall, 1965), 109.

32. Lydia H. Sigourney, *Scenes in My Native Land* (Boston: James Munroe, 1845), 119–21.

33. Therese Yelverton, *Teresina in America* (1875; rpt. New York: Arno Press, 1974), II, 73.

34. Bayard Taylor, *At Home and Abroad: Second Series* (New York: G. P. Putnam, 1862), 177.

35. Horace Greeley, *An Overland Journey: From New York to San Francisco in the Summer of 1859* (1860; rpt. New York: Knopf, 1964), 264.

36. Starr King, 36.

37. Starr King, 29.

38. Francis P. Farquhar, *Yosemite, The Big Trees, and the High Sierra* (Berkeley, Calif.: University of California Press, 1948), 7–11.

39. Taylor, *At Home and Abroad: Second Series*, 187.

40. Whitney, 120. The Geological Survey of California conducted its work in Yosemite in the years 1863–67. J. T. Gardiner and Clarence King made surveys in 1864 in order to establish the boundaries of the park encompassing the Yosemite Valley and the Mariposa Big Tree grove. Other surveys were then made in preparation for developing the area as a resort. From these surveys, Whitney concluded that, in addition to Yosemite and the Big Trees the area "possessed many features which should make it particularly desirable as a resort for pleasure travellers" (Whitney, 12).

41. *The Yosemite Guide-Book* was published under the auspices of the Geological Survey of California.

42. See, for example, John S. Hittell, *Yosemite: Its Wonders and Beauties* (San Francisco: H. H. Bancroft, 1868), 43, and Samuel Kneeland, *The Wonders of Yosemite Valley* (Boston: Alexander Moore, 1871), 45.

43. Ruskin, IV, 217.

44. See, for example, Yelverton, II, 58. Hutchings's 1894 guidebook to Yosemite also adopts the glacial theory.

45. John Muir, "Studies in the Sierra," *Overland*, 12 (1874), 490.

46. Ruskin, IV, 432.

47. John Muir, "Studies in the Sierra," *Overland*, 13 (1874), 67, 79.

48. John Muir, "Yosemite in Flood," *Overland*, 8 (1872), 349–50.

49. Farquhar, 62.

50. Samuel Kneeland, *The Wonders of Yosemite Valley* (Boston: Alexander Moore, 1871), 42. A few of the Indian names associated with Yosemite appear to be entirely inauthentic. "Bah!" wrote Starr King about "The Sisters." "One is named Udola, the other Tulula, not Indian namings, but white men's sentimental nonsense" (Starr King, 49).

51. Starr King, 47–48.

52. Lafayette H. Bunnell, *Discovery of the Yosemite, and the Indian War of 1851* (Chicago: Fleming H. Revell, 1880), 201.

53. Bunnell, 214, 199, 214, 217, 216, 235–36.

54. Bunnell, 237. Ten-ie-ya's response may also reflect the fact that the Indians, although they might attach a tribal name to a river, did not normally confer a person's name on a place since it suggested the possession of land as property, a concept that was foreign to them.

55. Bunnell, 237, 238.

56. Bunnell, 238–39.
57. Bowles, 231.

## 7. Yellowstone and "The Wild West"

1. William F. Cody, *Life and Adventures of Buffalo Bill* (New York: Willey Book Company, 1927), 321–22.

2. Windham Thomas, Earl of Dunraven, *The Great Divide: Travels in the Upper Yellowstone in the Summer of 1874* (London: Chatto & Windus, 1876), 294.

3. Ferdinand Hayden, *The Great West* (Philadelphia: Franklin Publishing, 1880), 29.

4. The written account of the expedition was rejected by the *New York Tribune* and *Scribner's* (or *Harper's*) because they were not sure of its veracity. It was finally published by the *Western Monthly Magazine* of Chicago in July 1870. See Aubrey L. Haines, *The Yellowstone Story* (Yellowstone National Park, Wyo.: Yellowstone Library and Museum Association, 1977), I, 101. I am indebted to Haines for many of the facts relating to the history of the discovery of Yellowstone.

5. Haines, I, 141.

6. Haines, I, 155. The earliest suggestion that the Yellowstone region should be set aside as a public park was made by Acting Governor Thomas Meagher of the Montana Territory in 1865. David Folsom, leader of the 1869 expedition, appears to have proposed the same idea (see Haines, I, 103, 163–64). Langford later claimed that Cornelius Hedges suggested the idea of reserving the Yellowstone region as a national park while members of the Washburn expedition were discussing the future of the area as a tourist resort. The group agreed to work toward that end. But the idea, if they had it, was not recorded in any of the diaries of the expedition written at the time (see Haines, I, 130). Hedges did propose in an article in the *Helena Herald* that Yellowstone be annexed to Montana and be appropriated "to the public use." It is not clear exactly what he had in mind (Haines, I, 134–35).

7. Nathaniel P. Langford, "The Wonders of the Yellowstone," *Scribner's Monthly*, 2 (May and June, 1871), 7. Hereafter cited as Langford, *Scribner's*. Folsom remarked that he was happy to have seen Yellowstone Lake "before its primeval solitude should be broken by the crowds of pleasure seekers which at no distant day will throng its shores" (Haines, I, 99).

8. Quoted in Haines, I, 172; Haines, I, 105, 137, 164, 142.

9. Richard Bartlett, "From Imagination to Reality: Thomas Moran and the Yellowstone," *Prospects*, 3 (1977), 114; Alfred Runte, *National Parks: The American Experience* (Lincoln, Neb.: University of Nebraska Press, 1979), 45.

10. U.S. Congress, House Committee on the Public Lands, *The*

*Yellowstone Park*, 42nd Cong., 2nd sess., H. Rept. 26 to accompany H. R. 764, February 27, 1872.

11. Dunraven, xxiii.

12. Haines, I, 169.

13. Ferdinand V. Hayden, "The Wonders of the West—II: More About the Yellowstone," *Scribner's Monthly*, III (February 1872), 396.

14. Quoted in Haines, I, 170.

15. Haines, I, 172; quoted in Haines, I, 178.

16. Rudyard Kipling, *From Sea to Sea: Letters of Travel* (1910); rpt. in Paul Schullery, ed., *Old Yellowstone Days* (Boulder, Colo.: Associated University Press, 1979), 112.

17. M. M. Ballou, *The New Eldorado* (Boston: Houghton Mifflin, 1889), 27.

18. Dunraven, 220–21.

19. John Muir, "The Yellowstone National Park," *Our National Parks* (1901); rpt. in *Old Yellowstone Days*, 48. Muir's article originally appeared in *The Atlantic Monthly*, 81 (January 1898; April 1898) and was based on a visit he made in 1885.

20. Nathaniel Langford, *Annual Report of the Superintendent of the Yellowstone National Park for the Year 1872*, U.S., 42d Cong., 3d sess., Senate Ex. Doc. 35, February 4, 1873, 9. Hereafter cited as Langford, *Annual Report, 1872*.

21. Almon Gunnison, *Rambles Overland* (Boston: Universalist Publishing House, 1884), 34.

22. Dunraven, 196, 275–76.

23. Margaret Andrews Cruikshank, "Notes on the Yellowstone Park" (1883), Yellowstone National Park Library TS, 26.

24. Gunnison, 37.

25. Owen Wister, "Hank's Woman," in *The West of Owen Wister* (Lincoln, Nebr.: University of Nebraska Press, 1972), 21.

26. Wister, "Hank's Woman," 37.

27. Charles Dudley Warner, "Editor's Study," *Harper's* (January 1897); rpt. in *Old Yellowstone Days*, 160, 161.

28. Gunnison, 72.

29. Kipling, 95–96, 103.

30. C. F. Gordon-Cumming, "The World's Wonderlands in Wyoming and New Zealand," *Overland Monthly*, 5 (1885), 7.

31. Langford, *Scribner's*, 10.

32. Ballou, 40–41.

33. Kipling, 98.

34. Dunraven, 259.

35. Kipling, 106.

36. Cruikshank reported that when her party discovered a little bubbling of water coming from a crevice, "Dr. Bergman took my stick . . . and poked a little crater for it to play in. It shot up its little fountain a few inches into the air, behaving quite like a full grown geyser. Such changes go on here from time to time that we may

have aided in the development of a mighty geyser for the future. We named it Geyser Bergman" (Cruikshank, 27).

37. George W. Wingate, *Through the Yellowstone Park on Horseback* (New York: O. Judd, 1886), 107.

38. William O. Owen, "The First Bicycle Tour of Yellowstone National Park," *Outing* (June 1891); rpt. in *Old Yellowstone Days*, 35.

39. Kipling, 105.

40. Cruikshank, 23.

41. Owen Wister, "Old Yellowstone Days," *Harper's Monthly Magazine* (March 1936); rpt. in *Old Yellowstone Days*, 72.

42. Cruikshank, 22.

43. Dunraven, for example, discusses the geyser theories of Bunsen and Forbes (Dunraven, 288–89).

44. Muir, 53–54, 41, 43.

45. Muir, 44, 45, 55.

46. Gordon-Cumming, 9. Maturin Ballou reported in 1889 that Mammoth Hot Springs was becoming a sanitarium for people with rheumatism and skin diseases who came to drink the waters and bathe in the springs. The water, he noted, "is thought to be a wholesome tonic, with blood-purifying power" (Ballou, 21, 17).

47. Gordon-Cumming, 13.

48. Langford, *Scribner's*, 118.

49. Dunraven, 53–54.

50. Wingate, 10, 137. John Muir urged tourists to stay in the park longer than the usual three to five days, to get off the wagon roads into the country beyond, and to camp: "The winds will blow their own freshness into you, and storms their energy, while cares will drop off like autumn leaves" (Muir, 52).

51. Haines, I, 276. In 1873 Dunraven found that the Mammoth Hot Springs Hotel bore little resemblance to the "gorgeous description" of it in the Helena and Virginia newspapers. It would someday become a resort, he wrote, but at the moment it was merely "the last outpost of civilisation,—that is the last place where whisky is sold" (Dunraven, 207).

52. Cruikshank, 23, 37, 55, 3, 56. Nevertheless, Mary Dexter wrote to her father and mother in 1889 that a woman of 70 in her party had ridden eight miles on horseback after completing a 42-mile wagon ride and that another woman of 89 had done the entire tour of the park the year before. See Mary Dexter (Reeves), "Letters to her Father and Mother," Yellowstone National Park MS.

53. Mary B. Richards, *Camping Out in Yellowstone* (Salem, Mass.: Newcomb & Gauss, 1910), 54.

54. Gunnison, 15.

55. Wingate, 137.

56. Gunnison, 229.

57. Mrs. George F. Cowan, "Reminiscences of Pioneer Life: A Trip to the National Park in 1877—An Account of the Nez Perce

Raid from a Woman's Standpoint—Incidents and Accidents," *Wonderland*, 12 (March 1904); rpt. in *Old Yellowstone Days*, 6.

58. Wister, "Old Yellowstone Days," 67.

59. Kipling, 88–89.

60. Langford, *Annual Report*, 1872, 9.

## 8. Tourism and the Industrial Age:
## Niagara Falls And Mauch Chunk

1. Windham Thomas, Earl of Dunraven, *The Great Divide: Travels in the Upper Yellowstone in the Summer of 1874* (London: Chatto & Windus, 1876), 270.

2. Charles W. Cook, "The Valley of the Upper Yellowstone," *Western Monthly*, 4 (1870), 63.

3. "Steam enough," wrote Charles Dudley Warner, "is wasted here to run all the Western railways." See "Editor's Study," *Harper's* (January 1897); rpt. in Paul Schullery, ed., *Old Yellowstone Days* (Boulder, Colo.: Associated University Press, 1979), 161.

4. Harry J. Norton, *Wonder-Land Illustrated* (Virginia City, Mont.: Harry J. Norton, 1873), 29.

5. Rudyard Kipling, *From Sea to Sea: Letters of Travel* (1910); rpt. in *Old Yellowstone Days*, 102.

6. Warner, 161.

7. Owen Wister, "Old Yellowstone Days," *Harper's Monthly Magazine* (March 1936); rpt. in *Old Yellowstone Days*, 71.

8. Dunraven, 263.

9. See John F. Kasson, *Civilizing the Machine: Technology and Republican Values in America, 1776–1900* (New York: Grossman Publishers, 1976), 161–65.

10. *Picturesque America* (New York: D. Appleton, 1872–74), I, 435.

11. Henry Norman, *The Preservation of Niagara Falls* (New York, 1881), 13.

12. See John F. Kasson, *Amusing the Million: Coney Island at the Turn of the Century* (New York: Hill & Wang, 1978).

13. Frederick Law Olmsted, "Notes by Mr. Olmsted" in *Special Report of the Commissioners of the New York State Survey of 1879* (Albany, N.Y.: C. Van Benthuysen, 1880), 28.

14. Frederick Law Olmsted and Calvert Vaux, *General Plan For the Improvement of the Niagara Reservation* (Niagara Falls, N.Y.: Gazette Book and Job Office, 1887), 4.

15. Olmsted and Vaux, *General Plan*, 4.

16. Olmsted, *Special Report*, 27–28.

17. Olmsted and Vaux, *General Plan*, 8.

18. William Howard Russell, *My Diary North and South* (New York: Harper and Brothers, 1863), 136.

19. Kasson, *Amusing the Million*, 11–28.

20. J. B. Harrison, *The Condition of Niagara Falls, and the Measures to Preserve Them* (New York: n.p., 1882), 8.

21. *Picturesque America*, I, 222; II, 153–54.

22. Bayard Taylor, "The Erie Railroad" in *The Home Book of the Picturesque* (1852; rpt. Gainesville, Fla.: Scholars' Facsimiles & Reprints, 1967) 143–44.

23. Walt Whitman, "Passage to India," stanza 3.

24. *Picturesque America*, I, 109.

25. See Theodore Dwight, Jr., *The Northern Traveller; Containing the Routes to Niagara, Quebec, and the Springs, with the Tour of New-England, and the Route to the Coal Mines of Pennsylvania* (New York: A. T. Goodrich, 1826).

26. Gideon Miner Davison, *Traveller's Guide: Through the Middle and Northern States* (Saratoga Springs, N.Y.: G. M. Davison, 1833), 17.

27. Leo Marx, *The Machine in the Garden* (New York: Oxford University Press, 1964), 195.

28. Maximilian, Prince of Wied-Neuwied, *Travels in the Interior of North America, 1832–1834* in Reuben Gold Thwaites, *Early Western Travels* (Cleveland, Ohio: A. H. Clark, 1906), XXII, 120.

29. Benjamin Silliman, "Notes On A Journey From New Haven, Conn., To Mauch Chunk and Other Anthracite Regions of Pennsylvania," *American Journal of Science and Arts* 19 (1831), 14.

30. M. S. Henry, *History of the Lehigh Valley* (Easton, Pa.: Bixler & Corwin, 1860), 362.

31. *Mauch Chunk and Vicinity* (Mauch Chunk, Pa.: Boyle, Reed & Gihon, 1872), 59.

32. See Kasson's discussion of the Switchback Railroad at Coney Island and other amusement park rides in *Amusing the Million*, 73–78.

33. See, for example, *Pennsylvania Prints From the Collection of John C. O'Connor and Ralph M. Yeager* (University Park, Pa.: Pennsylvania State University, Museum of Art, 1980), plate numbers 12, 15, 22, 23, 24.

34. Nathaniel Hawthorne, *The American Notebooks*, ed. Randall Stewart (New Haven, Conn.: Yale University Press, 1932), 34. Leo Marx seems to me mistaken in interpreting the violence in this passage as the violent destruction of nature by industry. The "rough and untamed" stream is "tamed down to the purposes of man" by the factories and it is "heavy rains or the melting snows" which tumble the tall pines headlong down the mountainside. The destructive violence is nature's, not man's. See Marx, *The Machine in the Garden*, 267–68.

35. [Israel] Daniel Rupp, *History of Northampton, Lehigh, Monroe, Carbon, and Schuylkill Counties* (1845; rpt. New York: Arno Press, 1971), 185.

36. Diary of Louis Gratacap, MS, September, 1880, 219. The New York Public Library.

37. *Picturesque America*, I, 110.

38. Oramel S. Senter, *The Health and Pleasure Seeker's Guide, or, Where To Go, and What To See* (Philadelphia: James B. Rodgers, 1874), 33.

39. H. C. Sheafer, "A Swtichback Excursion," *Lippincott's Magazine*, 10, no. 9 (1872), 140.

40. "Coal, and the Coal-Mines of Pennsylvania," *Harper's New Monthly Magazine*, 15 (1857), 451.

41. Silliman, 12, 14, 19.

42. "Coal, and the Coal-Mines of Pennsylvania," 458, 457.

43. As John Kasson points out, the sublimity of such scenes was celebrated in the popular depictions of blast furnaces and other features of the industrial age which appeared in journals like *Harper's Weekly* and even in the work of some serious artists, as in John Ferguson Weir's *The Gun Foundry* (1866). See Kasson, *Civilizing the Machine*, 168, 171.

44. Silliman, 13.

45. *Mauch Chunk and Vicinity*, 56.

46. *Picturesque America*, I, 116.

47. Henry James, *Italian Hours* (Boston: Houghton Mifflin, 1909), 165–66.

48. *Mauch Chunk and Vicinity*, 55.

49. "The Pennsylvania Coal Region," *Harper's New Monthly Magazine*, 27 (1863), 460.

50. "Coal, and the Coal-Mines of Pennsylvania," 465.

51. Theodore Mumford, *The Switzerland of America* (New York: American Bank Note Co., 1883), 33.

52. L. H. Sigourney, *Scenes in My Native Land* (Boston: J. Munroe, 1845), 220.

53. Venturi, Rauch & Scott Brown, *Historic Jim Thorpe: Historic Preservation and Commercial Revitalization* (Philadelphia: Carbon County Planning Commission, 1979), 6–7.

## Conclusion

1. Just as tourism continues to retain aspects of pilgrimage, modern religious pilgrimages contain elements of tourism. "The most characteristic modern pilgrimage," say Victor and Edith Turner, "is blended with tourism, and involves a major journey, usually by modern means of transportation, to a national or international shrine." See Victor and Edith Turner, *Image and Pilgrimage in Christian Culture* (New York: Columbia University Press, 1978), 240.

2. *New York Times*, February 6, 1986, A1, A19.

3. This presentation of Elvis's life parallels in important ways the presentation of Christ's life at pilgrim shrines as described by the Turners, 10–11.

4. For information on the Elvis Presley Museum I am indebted to

Tammy Frey, "The Temple of the Saint of Capitalism: The Elvis Presley Museum" (unpublished paper).

5. Henry James, "Niagara," in *The Art of Travel* (Garden City, N.Y.: Doubleday Anchor Books, 1958), 88.

6. Elizabeth Kolbert, "Niagara Falls Romances a Builder," *New York Times*, June 24, 1986, B1–2; Jan Hoffman, "How I Became an American Tourist," *Village Voice*, June 24, 1986, 23–24.

7. "Indoor Shopping Malls 30 Years Old," *New York Times*, October 9, 1986, C13.

8. *New York Times*, March 19, 1986, A12.

9. Pamela Rogow, "History at the Mall," *History News*, 38 (March 1983), 36.

10. Daniel J. Boorstin, "An American Style in Historical Monuments" in *America and the Image of Europe* (New York: Meridian Books, 1960), 82–91.

11. Umberto Eco, *Travels in Hyperreality: Essays* (San Diego: Harcourt Brace Jovanovich, 1986), 6, 8.

12. Dean MacCannell, *The Tourist: A New Theory of the Leisure Class* (New York: Schocken Books, 1976), 9.

13. MacCannell, 13.

# Index

# Index

Commercialization. *See also* Consumerism; Tourist attractions, cultural production of
and the preservation of Niagara Falls, 184–89
and public space, 115–16
and the structure of sacred places, 17–18, 84, 211–13
Coney Island. *See* Amusement parks
Connecticut River Valley, 49–56
Consumerism
and the American suburb, 107
and the development of American tourist attractions, 9–10
and "doing" Niagara Falls, 22–30
and panoramas, 51
and rural cemeteries, 110–15
and the sublime, 18
and twentieth-century tourist attractions, 212–15
Cooper, James Fenimore, 34, 60, 62, 69
Cott, Nancy F., 80
Crawford, Ethan Allen, 74–75
Crawford Notch, 72
Cropsey, Jasper F., 186
*Catskill Mountain House,* 68
*Niagara Falls,* 187
Curtis, George W., 23, 60, 63

Dahl, Curtis, 78
Darwin, Charles, 44
Dickens, Charles, 88–89, 95–96, 97, 102, 186
Disneyland, 212, 213, 214, 216
Dix, Dorothea, 91, 96
Downing, Andrew Jackson
and landscape of the Hudson Valley, 65
and rural cemeteries, 109, 116
and trees as emblems of civilization, 142
Dunraven, Earl of. *See* Windham, Thomas
Dwight, Theodore, Jr., 75, 80
Dwight, Timothy, 14, 52–56, 65, 169

Eco, Umberto, 215–16
Eliade, Mircea, 6, 12–13, 38–39, 42, 44
Emerson, Ralph Waldo, 44, 47–48, 149
Erie Canal, 4, 12
Expositions
and the Big Trees, 146–47
and the origin of malls and theme parks, 214

and the structure of Niagara Falls, 28, 188

Fenn, Harry, 199
Fuller, Margaret, 27, 87
Fulton, Robert. *See* Steamboats

Genesee Falls, 88
Geology
as creation myth, 42–44, 147–49, 173–76
and ruins, 79–80
and sublimity, 201
Gilman, Caroline, 14, 89, 92–93, 98, 116, 218 *n.*1
Graceland, 210
Grand Tour, American, 4, 12, 53, 56
Greeley, Horace, 127, 144
Greenwood Cemetery (Brooklyn, N.Y.), 99, 100, 102, 104, 107, 108–9, 111, 116

Hale, Sarah Josepha, 61, 78
Hawthorne, Nathaniel, 5
"The Ambitious Guest," 75, 76–77, 78, 80, 81–84
and industrialization, 196–98, 236 *n.*34
"My Visit to Niagara," 13, 15–16
Hayden, Ferdinand, 159–61, 163, 173
Herzog, Herman, 201
*Mauch Chunk,* 202
Higham, John, 116, 124
Hill, Thomas, 136–37, 158
Holmes, Oliver Wendell, 127, 128
Home
and asylums, 93–94
and the Catskill Mountain House, 66–67, 71
and rural cemeteries, 105–11
symbolically tied to tourist attractions, 8
and Willey Disaster, 80–86
Howe, Samuel Gridley, 95–96
Howells, William Dean, 23
*Their Wedding Journey,* 27
Hudson River Valley, 49–50, 56–66
Humboldt, Alexander von, 42, 51
Hutchings, James Mason, 124–28, 137

Indian, American. *See also* Ahwahneechees
and American need for a past, 32, 78
displacement by white culture, 124, 149–55

240

# Index

Niagara Falls Reservation, 184–89
Novak, Barbara, 52

"Old Faithful," 5–6
Olmsted, Frederick Law
  and Central Park, 117–21, 142
  and the preservation of Niagara
    Falls, 184–89, 212
  and Yosemite, 130, 131–33
Orr, J. W., 14

Panoramas, 50–52
  and the Connecticut and Hudson
    Rivers, 56–60, 65, 66
  and Mauch Chunk, Pa., 199
  *Panorama of the Hudson River
    from New York to Albany*
    (William Wade), 58
  and resort hotels, 66
Parks. *See also* Central Park; National Parks; Niagara Falls
    Reservation; Theme parks
  rural cemeteries as, 100
Pastoral, the
  absence in much of the American
    landscape, 66, 165, 195–98
  as the ideal middle ground between nature and civilization,
    49, 53, 65–66, 99, 117, 133
Patch, Sam, 23
Paulding, James Kirke, 4, 59–60, 63,
    71
Père Lachaise, 100
Picturesque, the
  absent at Yellowstone, 165, 169,
    182
  as aesthetic category inherited from
    England, 3, 4, 10, 186
  and the industrial landscape, 189–
    90, 196, 198–206, 208
  as a means of ignoring unpleasant
    social realities, 204–6
  as a principal of composition, 34–
    35, 53–56, 65, 69, 100, 117,
    186–89
  and social and economic order,
    53–55, 65, 186–89
  *Picturesque America* (William Cullen
    Bryant), 189, 191
Pilgrimage, 5–6, 13–19, 25–27, 36–
    37, 144, 210
Pratt, Henry C., 75, 78
Presley, Elvis, 210–11, 214
Prisons, 87–93, 96–99

Railroads
  as entertainment, 194–95

enthusiasm for, 87, 191, 192, 199–
    201
Resorts, 3 ,10, 12, 57. *See also* Tourist attractions, as health resorts
Rhine River Valley, 60–61
Roosevelt, Theodore, 179–80
Rosa, Salvator, 34
Rothman, David, 92, 94, 99
"Roughing it," 8, 157, 176–81
Ruins, 78–80, 144, 154–55, 202
Runte, Alfred, 130
Ruskin, John
  influence on John Muir, 148–49
  and mountains as works of art,
    140–42

Sacred space. *See also* Sublime, as religious experience; Tourist attractions, role in the establishment of a national culture;
    Tourist attractions, as sanctums
    of creation
  concept of, 6, 12–13, 38–39, 44,
    210
Scott, Sir Walter, 4, 61, 62, 77
*Sequoia gigantea. See* Big Trees
Sigourney, Lydia, 29–30, 80, 89, 142,
    206
Silliman, Benjamin, 33, 79–80, 192,
    201–2, 203
Silliman, Benjamin, Jr., 43
Spring Grove Cemetery (Cincinnati,
    Ohio), 117
Steamboats, 3–4
  and panoramas, 50–51, 57–60, 87
Stereographs, 123, 125, 128
Story, Joseph, 102, 103
Sublime
  as aesthetic category inherited from
    England, 3, 4, 10, 13
  as cliché, 137
  and coal mines near Mauch Chunk,
    201
  and John Muir's vision of Yosemite, 149
  rejected by Olmsted, 132–33, 186,
    188
  as religious experience, 13–16, 29,
    95, 122–23, 152, 165
  as sensationalism, 18–19, 40–42,
    186
  "technological sublime," 182, 192
  and underground forces at Yellowstone, 182
Suburbs, 93
  and rural cemeteries, 102–11, 114–
    15, 227 *n*.58.

242